The Medieval Treasury

THE ART OF THE MIDDLE AGES IN THE VICTORIA AND ALBERT MUSEUM

Edited by Paul Williamson

Victoria and Albert Museum

© The Trustees of the Victoria and Albert Museum
ISBN 0948107 38 3
Published by the Victoria and Albert Museum, 1986

Designed by Paul Sharp
Set in Monophoto Ehrhardt and
printed by Balding + Mansell Limited,
Wisbech, Cambridgeshire

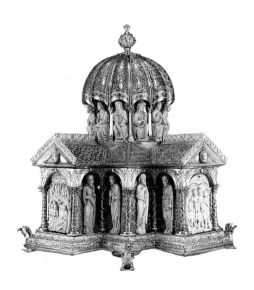

Cover illustration
Detail from the Eltenberg Reliquary
7650-1861 see page 144

Foreword

It has long been recognised by scholars that the holdings of Medieval Art in the V&A are amongst the most important in the world: the Museum is especially rich in ivory carvings, metalwork, textiles and stained glass from this period. These collections stand at the entrance to the Museum, in the first gallery which most visitors pass on their way through the building, and they present a splendid introduction to the history of the decorative arts in Europe, preparing the visitor for the treasures to be seen throughout the Museum. It is therefore essential that this gallery should make an impression and that the objects displayed therein should be shown to their maximum advantage. With the new design of the gallery we hope that this has been achieved and that the small-scale precious works of art from the Middle Ages will once again bear eloquent testimony to the consummate craftsmanship of the medieval artist.

The planning of the gallery and its organisation has been shared by a small team comprising Paul Williamson of the Department of Sculpture, Garth Hall of the Exhibitions Section of the Department of Museum Services, and Robert Wood of the Property Services Agency of the Department of the Environment, and a considerable curatorial contribution has been made by Marian Campbell of the Department of Metalwork and by Santina Levey and Linda Woolley of the Department of Textile Furnishings and Dress. The gallery has been designed by Paul Williams with all his customary flair, working to a tight schedule.

I am grateful to Paul Williamson for editing this book and for writing the introduction, and to our colleagues in the various departments for their contributions.

This project has been made possible by a very generous grant from Trusthouse Forte, given through the Associates of the Museum.

Roy Strong
DIRECTOR
VICTORIA AND ALBERT MUSEUM

The objects illustrated in this book, ranging in date from the third to the middle of the fifteenth century, have been chosen to provide a survey of the art of the medieval world. Some of the later works of art are not actually displayed in the Medieval Treasury (Room 43) but it was felt desirable to include them in this publication so that a more complete picture of the art of the time could be presented. However, monumental sculpture has not been included: some of this material has recently been published (Paul Williamson, *Catalogue of Romanesque Sculpture*, Victoria and Albert Museum, London, 1983) and is displayed in the adjoining gallery, Room 23, and work is in progress on a publication covering Gothic sculpture. Medieval art is not only displayed in the Medieval Treasury and Room 23; later Gothic art is shown in Room 24 and there are displays of medieval ivories, metalwork, textiles and stained glass in the relevant departmental study collections.

CONTRIBUTORS

Department of Ceramics (Stained Glass)	Michael Archer Anna Somers Cocks
Department of Furniture and Interior Design (Woodwork)	Simon Jervis
Department of Metalwork	Marian Campbell (assisted by Mary Ambrose)
Department of Designs, Prints & Drawings	Michael Kauffmann
Department of Sculpture	Paul Williamson Catherine Phillips
Department of Textile Furnishings and Dress	Santina Levey Natalie Rothstein Wendy Hefford Linda Woolley

The editor has been greatly assisted by Lucy Cullen and Deborah Sinfield.

Introduction

Paul Williamson

At first sight, it might appear that displaying medieval works of art in a museum gallery was an act which, in separating the objects from their original context and intended function, would render them as no more than expensively wrought and precious trinkets. But this is not the case. The exhibiting of small-scale, costly works of art, produced for the Church in the Middle Ages, actually does less violence to the original concept of how these objects were meant to be seen than the exhibition of, say, Italian Baroque paintings. This is because the candlesticks, censers, book-covers, vestments and so on were in very many cases originally meant to be openly displayed in the sacristy or a secure treasury area. Of course, most of the objects contained therein had specific liturgical functions and were brought out to serve those purposes for which they were made: first and foremost they were utilitarian, albeit sumptuous. But alongside these functional objects the cathedrals and abbey churches usually contained reliquaries, which by their very nature were intended to be venerated by the faithful and on which the most valuable materials were lavished. These reliquaries were often the focal point of the whole church in which they were housed, sometimes occupying a position of supreme importance behind the high altar as the Shrine of the Three Kings does today in Cologne Cathedral.

It should be remembered that the relics of saints were the most important possessions of medieval churches, often drawing pilgrims from far afield who would usually make donations before the shrines containing the holy remains. It is not surprising then that with the acquisition of the relics of the Three Magi in 1164, the city of Cologne was transformed into one of the most important pilgrimage centres of Northern Europe and that as a result of the consequent influx of visitors it rapidly became one of the most prosperous cities of the Romanesque and Gothic periods. Similar riches were attracted to Westminster, Bari and Canterbury – to name only three – where the bodies of St. Edward the Confessor, St. Nicholas and St. Thomas Becket were venerated after 1066, 1087 and 1170 respectively; and of course probably the major pilgrimage city of all – apart from Rome – Santiago de Compostela, owes its fame solely to the presence there of the body of the apostle James. With their attendant prestige it is little wonder that relics were at such a premium, with the result that throughout the Middle Ages there was illicit trade in stolen relics (the catacombs were repeatedly plundered for the remains of the Roman martyrs) and that bogus relics abounded. There are several saints who, if one took the trouble to assemble all their putative remains, would end up with more than one head and a most irregular number of limbs. Once important relics had been acquired it was to be expected that they would be displayed as prominently and as ostentatiously as was possible, and that the most renowned craftsmen of the day would be called upon to execute the shrines and smaller reliquaries. The cult of relics

supplied the goldsmith, the enameller and the ivory carver with ample opportunities to practise their art, and the likes of Nicholas of Verdun, Roger of Helmarshausen and Hugo d'Oignies owed their livelihood to the burgeoning industry surrounding the cathedral treasures and to the piety and generosity of the patrons who gave them their commissions.

Setting aside the actual works of art contained in them, today's major displays of medieval art in museums in London, Paris, New York and elsewhere have a perhaps surprising number of connections with their illustrious predecessors, the cathedral and church treasuries of the Middle Ages. Just as the medieval treasuries were enriched with gifts from visiting dignitaries or rich pilgrims paying homage to the relics normally held at any cathedral or important church, so the museums of today have benefited enormously from the generous benefactions of donors, usually private collectors in their own right. The Victoria and Albert Museum's greatest donor of medieval objects was undoubtedly the learned and shrewd Dr W.L. Hildburgh, who showered the Museum with gifts of ivory carvings, enamels, metalwork, alabasters and stone sculpture, but he was by no means a lone figure in the history of late nineteenth- and twentieth-century collecting: the British Museum inherited the Maskell Collection of medieval ivories, which at a stroke converted their collection into one of the most important in the World; the Metropolitan Museum of Art in New York was immensely fortunate to be given the J. Pierpont Morgan collection of medieval works of art in 1917, while the same man's stupendous collection of illuminated manuscripts formed the basis of the library in New York carrying his name; and the Walters Art Gallery in Baltimore, containing one of the best collections of medieval art in the world, would be no more than a provincial museum but for the comprehensive collecting of the man after whom it was named, Henry Walters.

The approach of Suger, the famous abbot of St. Denis in Paris in the first half of the twelfth century, was certainly not far from that of present-day museum directors in his keenness for the objects in his care to be appreciated by the faithful (for 'faithful' read the general public today). Erwin Panofsky, in his brilliant essay on Suger's account of St. Denis and its contents, summed up his attitude admirably:

> 'Nothing could be further from Suger's mind than to keep secular persons out of the House of God: he wished to accommodate as great a crowd as possible and wanted only to handle it without disturbances – therefore he needed a larger church. Nothing could seem less justified to him than not to admit the curious to the sacred objects: he wished to display his relics as "nobly" and "conspicuously" as he could and wanted only to avoid jostling and rioting – therefore he transferred the relics from the crypt and the nave to that magnificent upper choir which was to become the unsurpassed model of the Gothic cathedral chevet. Nothing, he thought, would be a graver sin of omission than to withhold from the service of God and His saints what He had empowered nature to supply and man to perfect: vessels of gold or precious stone adorned with pearls and gems, golden candelabra and altar panels, sculpture and stained glass, mosaic and enamel work, lustrous vestments and tapestries.'[1]

1 *Abbot Suger on the Abbey Church of St. Denis and its Art Treasures*, edited, translated and annotated by Erwin Panofsky, 2nd edition (edited by Gerda Panofsky-Soergel), Princeton, 1979, pp 13–14.

Clearly, in the case of St. Denis at the time of Suger the treasures were displayed openly within the church, but there is ample evidence to show that even at this time certain rooms were reserved, either inside the church or nearby, for the safekeeping and display of precious objects. Such was the case at St. Mark's, Venice, where two

2 G. Perocco, 'History of the treasury of San Marco' in *The Treasury of San Marco, Venice* (exhibition catalogue), British Museum, London, 1984, pp 65–68.

3 *The Vatican Collections: The Papacy and Art* (exhibition catalogue), Metropolitan Museum of Art, New York, 1982, p 66.

rooms were specially designated as a treasury area. We even happen to know that the treasury of St. Mark's had occasional special exhibitions, when the contents of the two rooms were laid out for the delectation of the public and notable visitors.[2] St. Peter's in Rome was similarly served by a treasury from a very early date – the fourth century – but it was consistently plundered throughout the Middle Ages and later so that its contents today reflect mostly the good services of the comparatively recent, post-Renaissance donors, and it has more the character of a museum.[3]

By the beginning of the eighteenth century the treasury of St. Denis had also assumed very much the appearance of a small museum today. In engravings published in 1706, Dom Michel Félibien illustrated the five large cases or *armoires* in which were contained the remarkable objects commissioned and collected by Abbot Suger. In one of them (fig 1) it is possible to see several works of art which survived the destruction of the French Revolution and eventually entered public collections: for example, the Eagle Vase at the bottom left (EE) and the Ewer (E) are now in the Musée du Louvre in Paris, the so-called Coupe de Ptolémées (F) is in the Cabinet des Medailles of the Bibliothèque Nationale, Paris, and one of the most splendid of all the objects in the treasury of St. Denis may be seen at the right in the illustration: the *Escrain* of Charlemagne (C), a fabulous shrine comprised of jewels and rock crystal which perished in the Revolution; only a small fragment of the *Escrain*, the cresting at the top, survives today, and is kept in the Bibliothèque Nationale. What does the engraving show us of interest, other than a tantalising glance at these treasures?

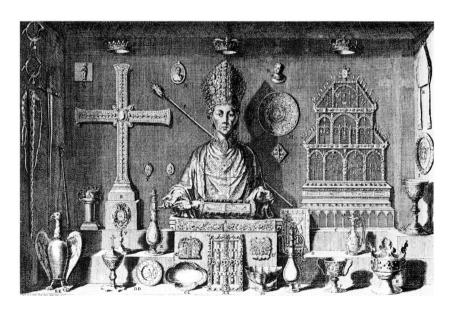

Fig 1 Plate IV from Dom Michel Félibien, Histoire de l'abbaye de Saint-Denis en France, Paris, 1706.

It shows us first, not surprisingly, that many of the most splendid works of art in that particular treasury were given by one particular man, Abbot Suger, and that relatively little was added in subsequent centuries. But more significantly for the history of art, it illustrates the great importance of the medieval treasury as a repository of *ancient* objects, sometimes given to a cathedral or church long after their time of manufacture. It will be seen that these objects often had a profound

7

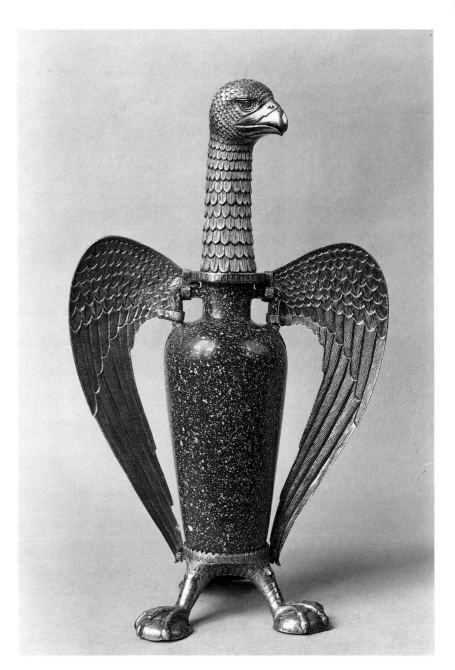

Fig 2 Abbot Suger's Eagle Vase; Late Antique porphyry vase with twelfth-century additions (Musée du Louvre, Paris).

effect upon later craftsmen and that as well as being incorporated into later ensembles, the older artefacts often affected the design or even the style of an object of which they were made to form a part.

In this instance, in Suger's Eagle vase (fig 2) we are lucky to have not only the visual evidence of the vase itself but the written testimony of Suger, describing the circumstances of its manufacture:

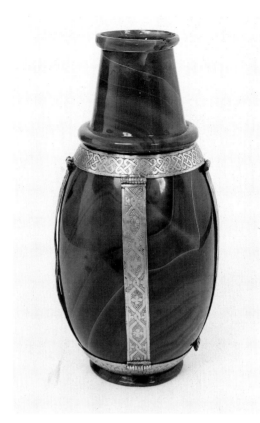

Fig 3 Onyx vase; Late Antique vase, French twelfth-century mounts (Victoria and Albert Museum, 397-1872).

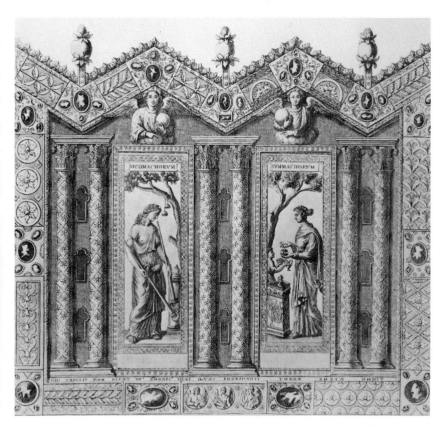

Fig 4 Photomontage from engravings in Martène et Durand, Voyage littéraire de deux réligieux bénédictins de la congregation de Saint-Maur, *Paris, 1717.*

'. . . we adapted for the service of the altar, with the aid of gold and silver material, a porphyry vase, made admirably by the hand of the sculptor and polisher, after it had lain idly in a chest for many years, converting it from a flagon into the shape of an eagle; and we had the following verses inscribed on this vase:

"This stone deserves to be enclosed in gems and gold.

It was marble, but in these [settings] it is more precious than marble."'[4]

4 Panofsky, *op cit,* p 79.

Suger's re-use of this porphyry vase points to the key to the survival of large numbers of Antique and Early Christian treasures: unless they had been incorporated into later medieval objects it is doubtful whether they would have survived. A more modest version of a much earlier vase being modified in the late twelfth century, this time an onyx example, may be seen in the V&A's collection (fig 3). In the same way, the largest and most impressive collection of Late Antique, Islamic and early Byzantine vases to survive from the Middle Ages were preserved and adapted, mainly in the thirteenth century, in the treasury of St. Mark's in Venice.

Sometimes Late Antique works of art were incorporated into much larger ensembles: such was the case of the Symmachi panel (p 44) which together with the companion leaf of the Nicomachi now in the Cluny Museum in Paris was used to serve as a door for a large reliquary shrine, probably made at the beginning of the thirteenth century in the circle of the metalworker Nicholas of Verdun (fig 4).

Fig 5 Shrine of St. Anno; Cologne, about 1183 (St. Michael, Siegburg).

Although this particular shrine was destroyed at the time of the French Revolution, a good number of similar shrines have survived, mostly in the region of Cologne (fig 5): the Museum also possesses some tantalising fragments from shrines such as this, including a small, beautifully made and intricately patterned finial (fig 6) and a short section of cresting from the sloped roof at one end (fig 7). Clearly then, such earlier works of art as the Symmachi panel were considered worth preserving by the medieval sacristans, even if they had no knowledge of whether these objects were connected with specific saints. Quoting Suger again it is interesting to note his attitude to some presumably Late Antique ivory panels which had long since been forgotten at St. Denis:

> 'We also caused the ancient pulpit, which – admirable for the most delicate and
> nowadays irreplaceable sculpture of its ivory tablets – surpassed human evaluation also
> by the depiction of antique subjects, to be repaired after we had reassembled those
> tablets which were moldering all too long in, and even under, the repository of the money
> chests.'[5]

5 *Ibid*, p 73.

Although this pulpit has not survived it is likely that it resembled the pulpit made for the Emperor Henry II (1002–14) in Aachen Cathedral, which also incorporates sixth-century ivory tablets with classical figures (fig 8). Why were these Late Antique objects, often with pagan imagery, used at all by the Christian artists of the ninth century onwards?

They were utilised partly for practical reasons, as there was probably not enough ivory available to furnish the newly revived ivory carver's art. Several Carolingian ivory panels were carved from Late Roman consular diptychs, planed-down and carved on the reverse or even on the same side as the original carving. There are also many instances of consular diptychs being used as they stood, unmodified, for the services of the church: the panel from the Anastasius diptych (p 53) was treated as a

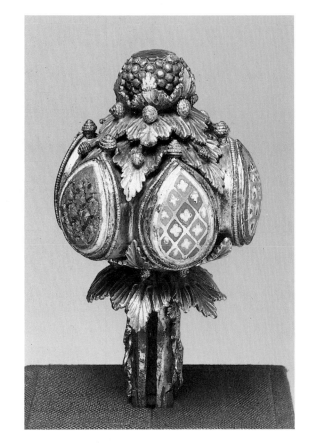

Fig 6 Cresting finial; Cologne, about 1180–1200 (Victoria and Albert Museum, 4525-1858).

Fig 7 Fragment of a crest; Cologne, about 1180–1200 (Victoria and Albert Museum, 7237-1860).

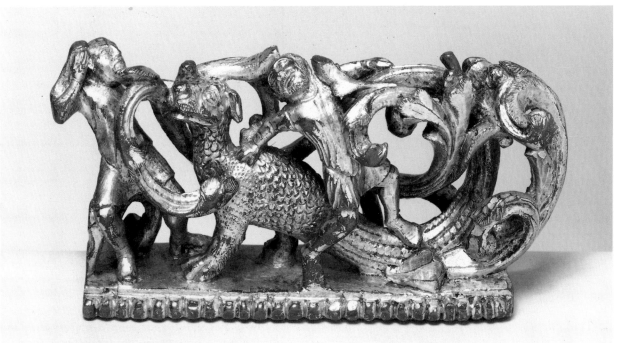

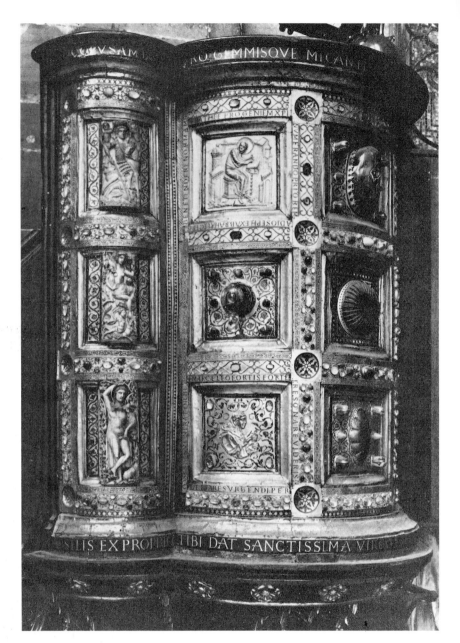

Fig 8 Pulpit of Henry II; early eleventh-century, with sixth-century ivory panels (Aachen Cathedral).

sort of ecclesiastical notebook between the seventh and thirteenth centuries, when lists of names, presumably the dead, were written in ink on the reverse. These lists were recited during the mass. The presence of these Late Antique ivories in church treasuries was to be deeply influential, especially upon the Carolingian ivory carvers at the court of Charlemagne in Aachen at the beginning of the ninth century: in form, style and iconography the early ninth-century works are based on the sixth-century prototypes, as is shown clearly by the cover of the Lorsch Gospels (p 65).

Apart from earlier ivories, the most common embellishment to the shrines, bookcovers and reliquaries of the early Middle Ages were classical gems: literally hundreds of these small-scale antique sculptures, both in cameo and intaglio, were utilised on works of art from between the ninth and thirteenth centuries. By the ninth century the art of gem carving was dead in the West, but there remained ample supplies of Roman material. Ancient gems had a flawless appearance and were usually resistant to damage and wear (which ensured that their original shape was retained) – qualities which were in harmony with medieval ideas of the beautiful. But they were not just used because they were beautiful. They represented a link with the world of the caesars which the secular rulers in the Middle Ages were more ready to embrace than was the Church. At the same time, the Church recognised the power of the designs on the classical gems – their magical nature – and took suitable precautions before inserting them into their new Christian settings.[6] There can be no doubt that the classical repertoire illustrated on the gems and other antique objects was an important storehouse of imagery which the medieval artist plundered rapaciously, as may be seen by comparing a relief from the 'Kaiserpokal' of about 1300 in Osnabrück, showing *Hercules Musarum*, with an antique cameo of the same subject (figs 9 and 10). Another telling example of the overwhelming influence of the classical remnants stored in the medieval treasuries is the classical style of some of the reliefs on the façade of Auxerre Cathedral, executed in the second half of the thirteenth century, which must have been very much influenced by the antique silver service of Saint Didier, 115 pieces of probably Hellenistic silver with a huge variety of classical motifs, which unfortunately were destroyed in the sixteenth century. Once again we rely on documentary evidence to give us an idea of the form of the now-lost treasure.[7]

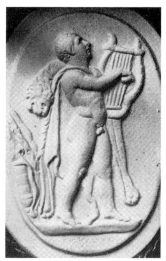

6 For a fascinating discussion of the use of ancient gems on medieval works of art, see W.S. Heckscher, 'Relics of Pagan Antiquity in Medieval Settings', *Journal of the Warburg Institute*, I, 1937–38, pp 204–20.

7 See F. Nordström, *The Auxerre Reliefs. A Harbinger of the Renaissance in France during the Reign of Philip le Bel*, Uppsala, 1974, pp 128–31.

Fig 9 Detail from the 'Kaiserpokal'; about 1300 (Town Hall, Osnabrück).

Fig 10 Hercules Musarum; *classical cameo (plaster cast) (formerly Roger Collection, Paris).*

Of course, the breaking-up of many of the treasuries in France at the time of the Revolution and earlier contributed directly to the availability of works of art of medieval origin in the late nineteenth and early twentieth centuries, when the major museums made most of their purchases. Many of the pieces illustrated in this book once belonged to a cathedral treasury – the Anastasius leaf (p 53) was at Liège, the late Carolingian comb (p 72) comes from Pavia Cathedral, the Veroli Casket (p 89) from the Cathedral of Veroli, south of Rome, and many of the other pieces come

from monasteries or smaller churches: the Symmachi panel (p 44) from Montier-en-Der, the Eltenberg Reliquary (p 144) from the Benedictine nunnery of Hoch Elten on the Rhine, and the serpentine roundel of the Virgin (p 90) from the abbey of Heiligenkreuz in Austria. But because of the nature of the precious objects held in them, the treasuries have at all times been open to attack, whether from marauding raiders, or, more nobly, from well-meaning abbots or bishops selling the objects of gold and silver to feed their congregation in hard times, or simply from thieves. The most famous example in England of the destruction of a cathedral treasury, and a vivid illustration of the vast wealth contained therein, is the contemporary account of the confiscation of the treasury of Canterbury Cathedral, which needed twenty-four carts to transport it to the London Mint, where it was presumably broken up and melted down between the years 1536 and 1540. The embellishments to the shrine of St. Thomas Becket alone filled two huge chests which needed half a dozen men to lift.[8] There are also descriptions of much earlier seizures of the Church's wealth: the Viking incursions are well-known but the Normans were also responsible for dispersing much of the Anglo-Saxon works of art they found in the church treasuries on their arrival in England in 1066. In many cases they gave the most valuable pieces as gifts to foundations abroad, but they also caused those responsible for the safekeeping of the treasures to sell many of their objects in order to be able to pay the extra taxes levied against them. For a different reason, during a particularly harsh famine in the twelfth century the abbot of Abingdon had an Anglo-Saxon reliquary melted down and the monks at St. Albans, Canterbury, Evesham and Ely also sold some of their treasures to feed the poor.[9] As a result, we are left with only the smallest idea of what was certainly one of the most accomplished arts of pre-Conquest England – that of the goldsmith and metalworker. What survives, as set against the contemporary descriptions of the most splendid works of art, are mostly rather humble objects.[10]

Luckily, this does not apply for other periods in the Middle Ages. Although only a small fraction of the original output of the medieval artist has survived to this day, we are fortunate to be able to study works of art which must always have been viewed with the utmost wonder and an admiration for the craft of the artist who produced them. In the Pantheon of great works of art who would not include the Symmachi panel (p 44), the Gloucester Candlestick (p 108) or the Syon Cope (p 190)? With masterpieces from every era of the Middle Ages from the Late Antique to the Late Gothic, the Victoria and Albert Museum's collection is second to none. To call it a Medieval Treasury is not a trite exercise in labelling but an accurate and fitting assessment of its character and worth.

8 C.E. Woodruff and W. Danks, *Memorials of the Cathedral and Priory of Christ in Canterbury*, London, 1912, p 82.

9 C.R. Dodwell, *Anglo-Saxon Art: A new perspective*, Manchester, 1982, p 7.

10 To gain an impression of the magnificence of the Anglo-Saxon contribution to the art of the metalworker, see the contemporary accounts cited in Dodwell, *op cit*, pp 1–23, 188–215.

The Colour Plates

1 Tabula from a tunic; Graeco-Roman, 4–5th century

2 Early Germanic jewellery; 5–8th century

3 The Basilewsky Situla; Ottonian, c.980

4 Silk fragment; Byzantine, 10–11th century

5 Four cameos; Byzantine, 9–12th century

6 The Gloucester Candlestick; English, early 12th century

7 Stained and painted glass; French, c.1140

8 Leaf from a Psalter; English, c.1140

9 Griffin Ewer; German, c.1150

10 The St. Nicholas Crozier; English, c.1150

11 Leaf from a Bible; French, c.1160

12 The Temptation of Christ; French, c.1170

13 Stained and painted glass; English, c.1180–1200

14 Leaf from a Gospel Book; Constantinople, second half 12th century

15 The Annunciation; Byzantine, c.1320

16 Figures of Prophets; French, first half 13th century

17 The Flagellation of Christ; French, early 13th century

18 The Valence Casket; Limoges or English, c.1300

19 The Steeple Aston Cope; English, 1310–40

20 Diptych; English, c.1325

21 Devotional Booklet; German, c.1330–50

22 The Mérode Cup; French, early 15th century

23 The Erpingham Chasuble; Italian/English, early 15th century

24 Tapestry; Arras, early 15th century

The objects illustrated in colour are shown again in
black and white in the main part of the book, when
different views or details are given. A page reference to
the detailed description of the object is given at the
end of each plate caption.

1 Tabula from a tunic; Graeco-Roman, 4–5th century page 46

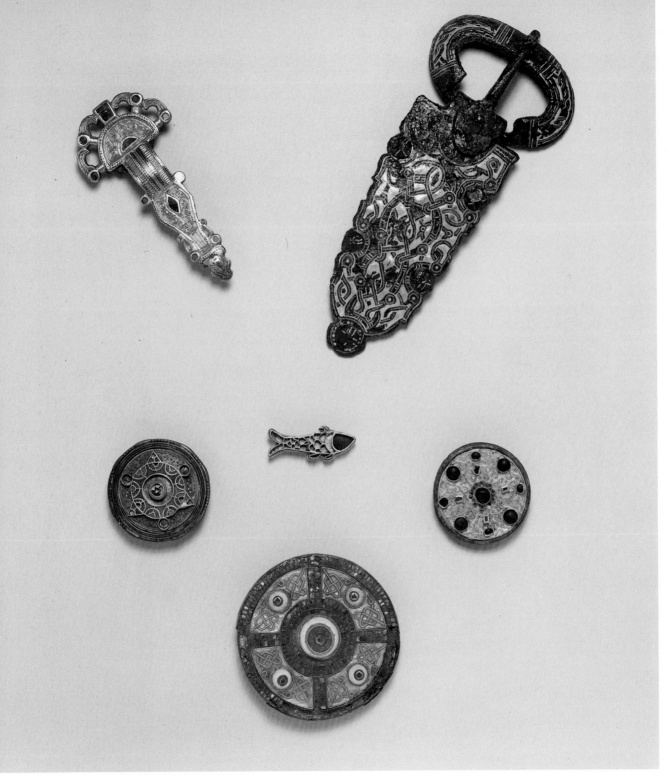

2 Early Germanic jewellery; 5–8th century page 60

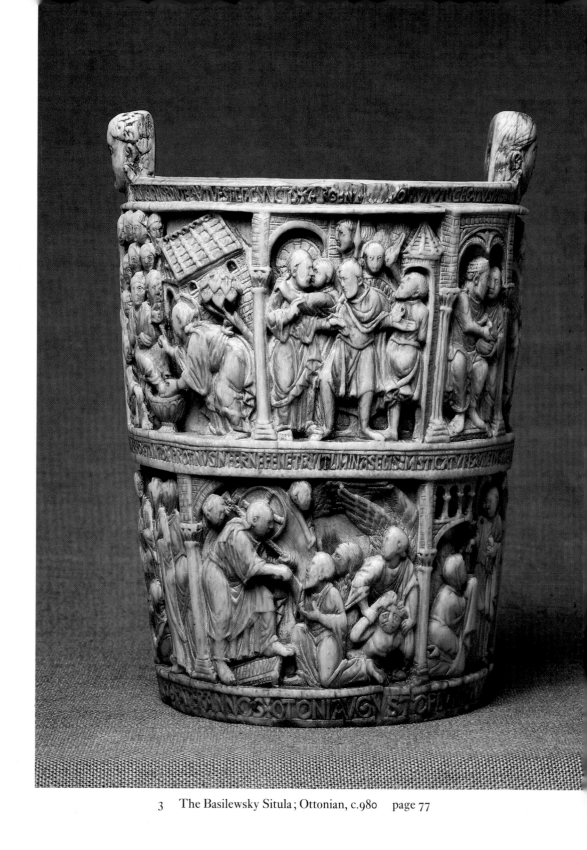

3 The Basilewsky Situla; Ottonian, c.980 page 77

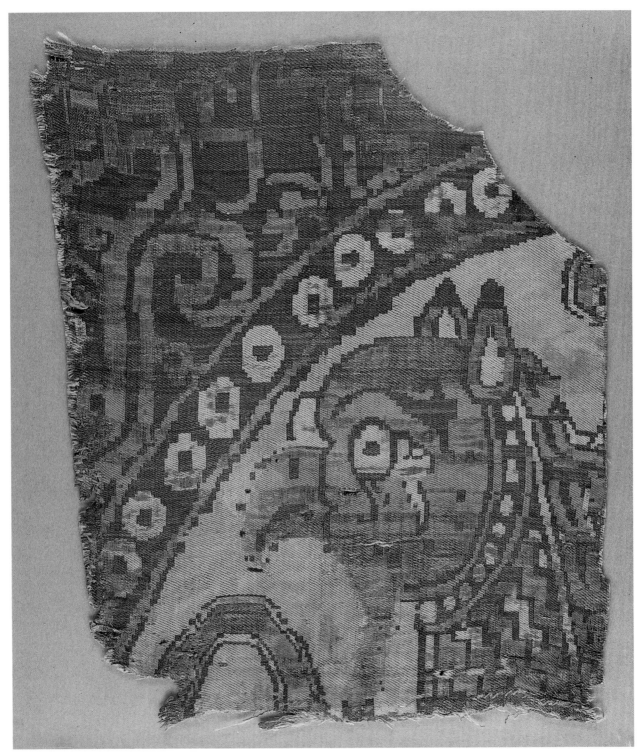

4 Silk fragment; Byzantine, 10–11th century page 85

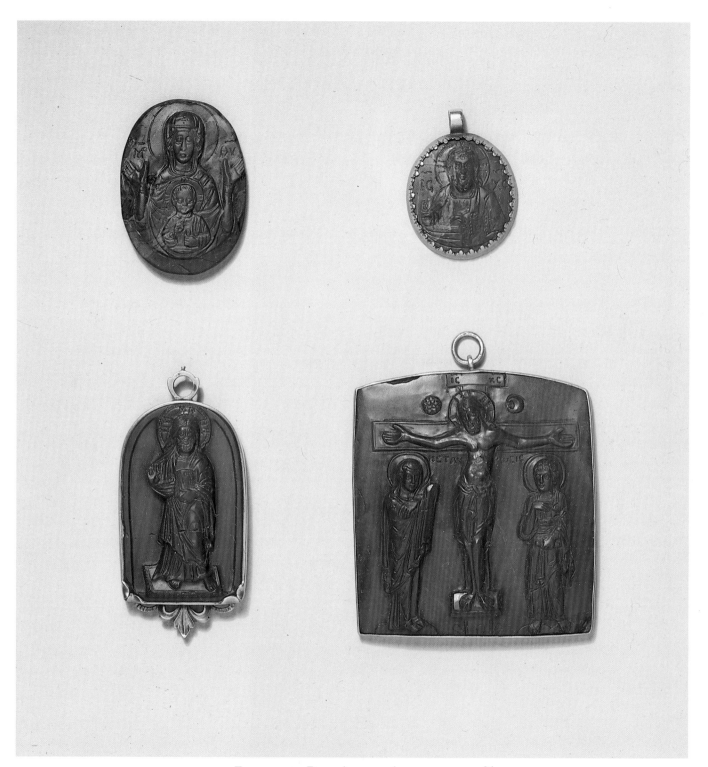

5 Four cameos; Byzantine, 9–12th century page 86

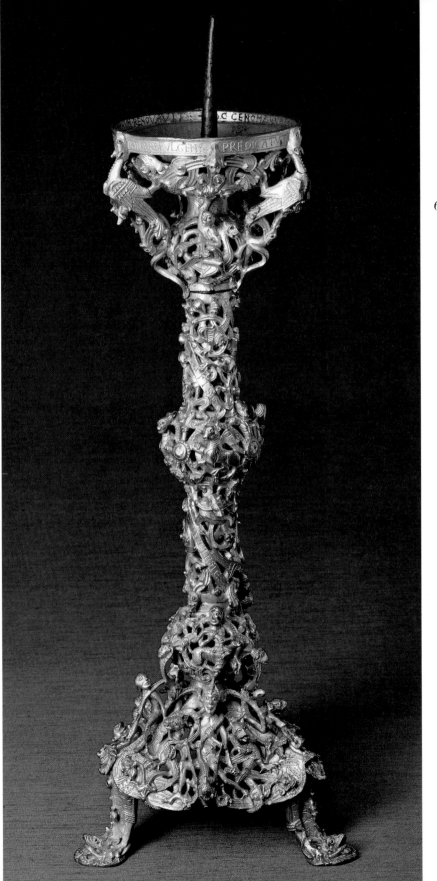

6 The Gloucester Candlestick
English, early 12th century
page 108

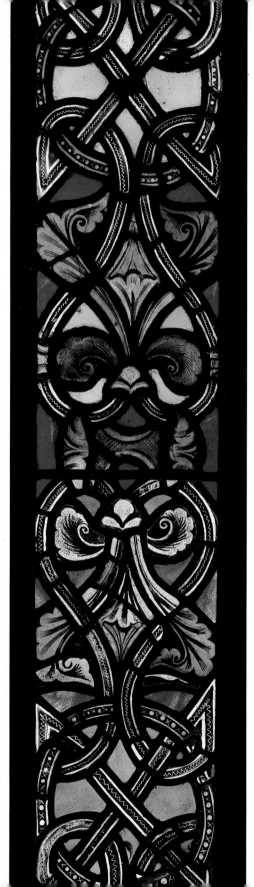

7 Panel of stained and painted glass
 French, c.1140 page 118

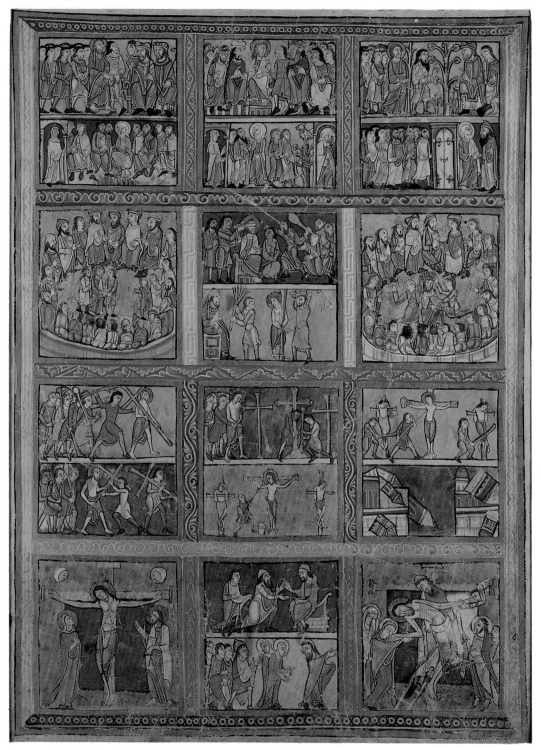

8 Leaf from a Psalter; English, c.1140 page 120

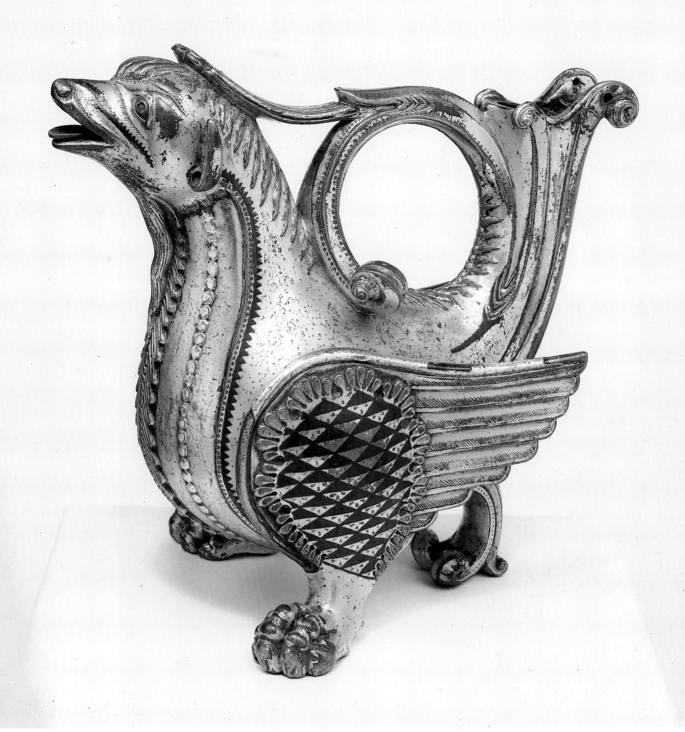

9 Griffin Ewer; German, c.1150 page 137

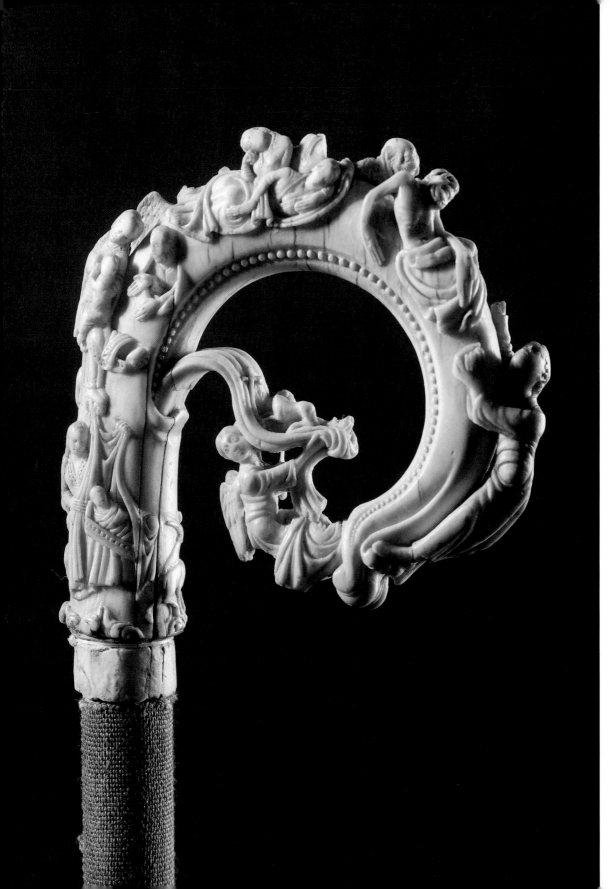

10 The St. Nicholas
 Crozier; English
 c.1150 page 141

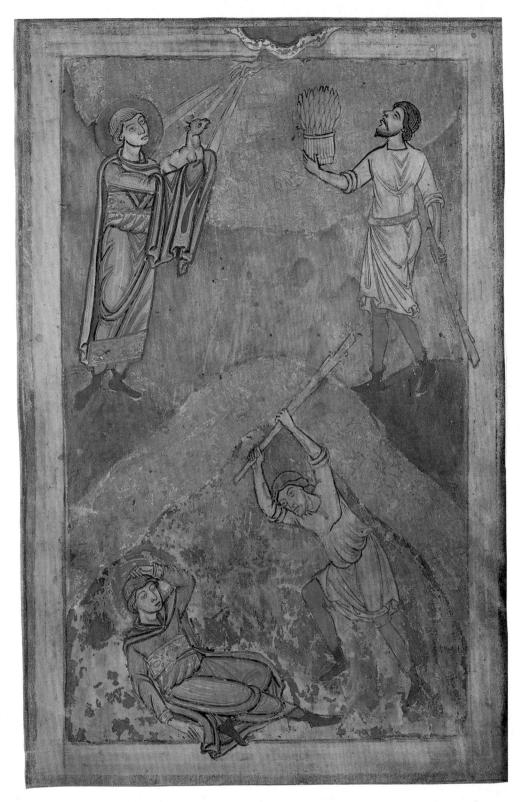

11 Leaf from a Bible
 Mosan, c.1160
 page 142

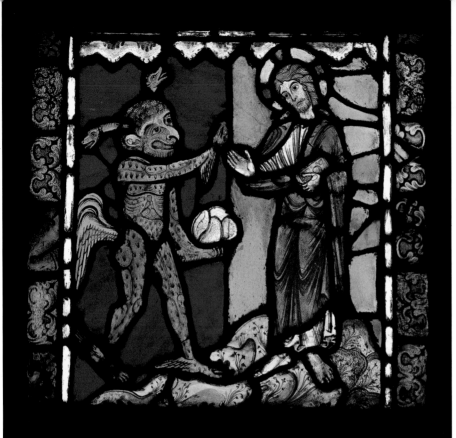

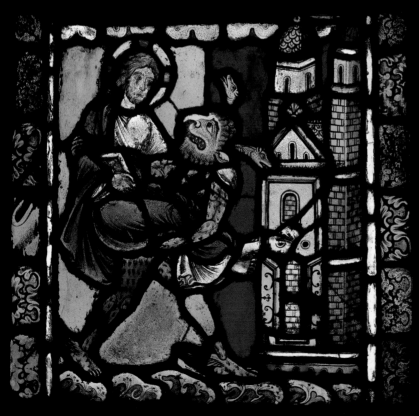

12 The Temptation of Christ
French, c.1170
page 152

13 Stained and painted glass
English, c.1180–1200
page 154

14 Leaf from a Gospel Book; Constantinople
second half of 12th century page 159

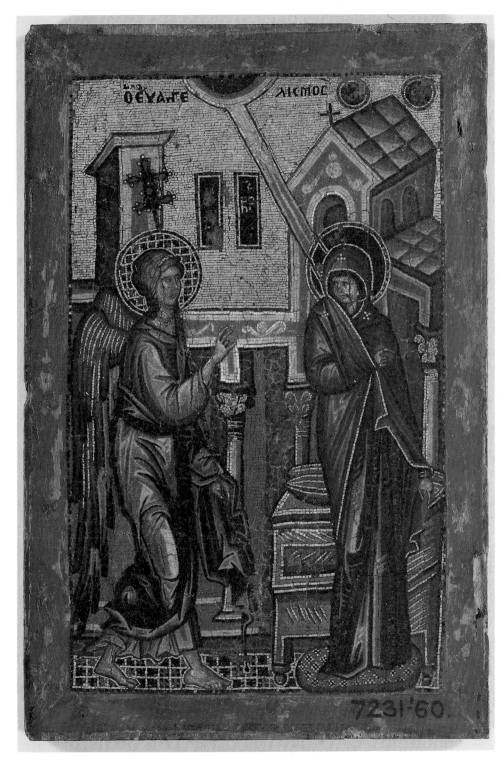

15 The Annunciation; Byzantine
c.1320 page 170

16 Figures of Prophets; French, first half 13th century page 183

17 The Flagellation of Christ; French, early 13th century page 184

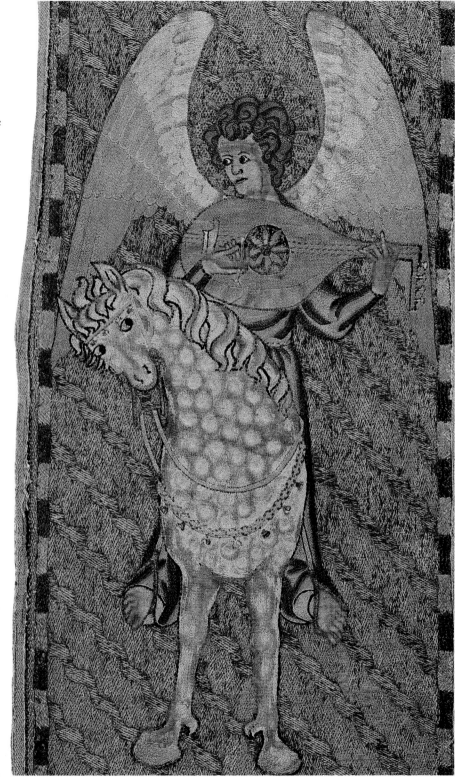

19 The Steeple Aston Cope
(Detail); English
c.1300 page 198

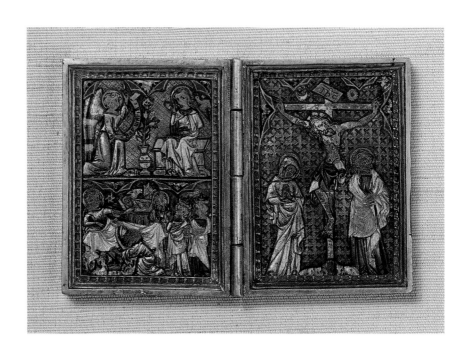

20 Diptych; English, c.1325 page 206 Enlarged slightly

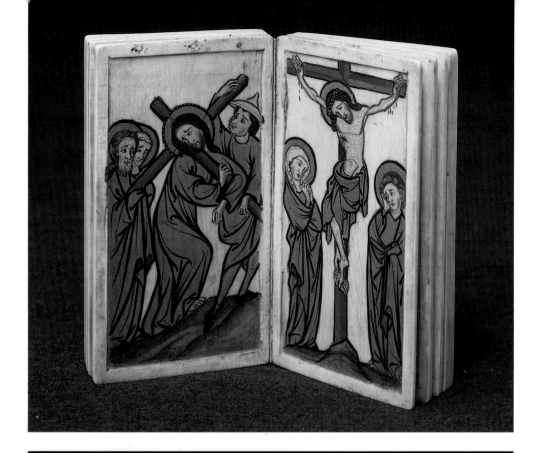

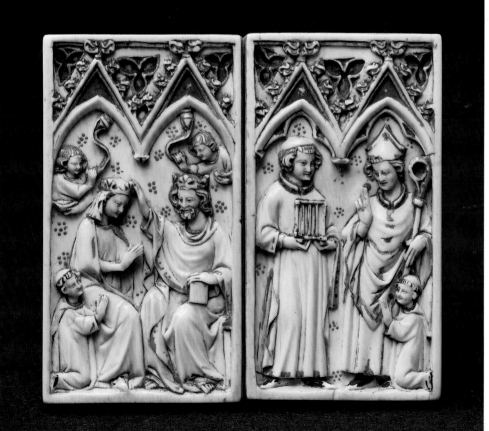

21 Devotional Booklet
 German, c. 1330–50
 page 212

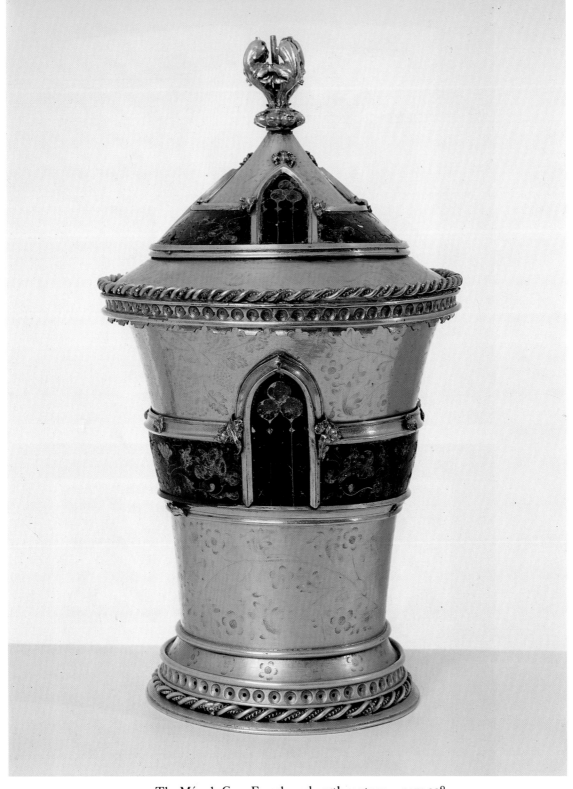

22 The Mérode Cup; French, early 15th century page 228

23 The Erpingham Chasuble
 Italian/English
 early 15th century
 page 231

24 Tapestry (Detail); Arras, early 15th century page 234

The
Medieval
Treasury

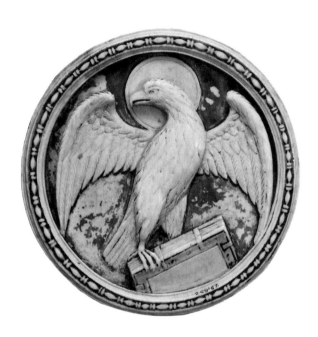

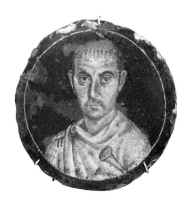

Gold Glass Portrait

Roman; third century AD
Diam; 4.4 cm
1052-1868

This is a very fine example of the technique known as 'gold-glass', which was practised in Rome in the third and fourth centuries AD. Gold leaf was stuck to a layer of glass and the design then scratched on to it, sometimes, as here, with the addition of unfired paint. The back was then covered with another layer of glass, which in this case is dark blue, but could be almost colourless, or green, red or purple. The surviving pieces are nearly always circular, and while some of the smaller ones were complete in themselves, to be used decoratively – as pendants, for example – most were the bases of bowls and cups, and the main reason for their survival is that they were broken out of the vessel and set into the plaster which closed the burial niches in the catacombs. This is probably why so many examples with Christian subject matter exist, although pagan, mythological and Jewish representations, drinking toasts and good luck mottoes also occur. The second most common category are those with portraits, whether single, or of husband and wife together, or, occasionally, of a larger group.

This roundel shows a beardless man dressed in tunic and *chlamys*, with a *fibula* on his right shoulder and a scroll(?) or stick under his left arm. There is pinkish-red paint between his neck and the left-hand side of his neckline. The hatching of the ground is executed with the greatest care to achieve subtle modelling and considerable realism. The dating of it is rather uncertain, as there is nothing about his clothing or hairstyle to assist in this, but scholars generally agree that gold-glass of such quality was made in the third rather than the fourth century AD.

Leaf of a Diptych (The Symmachi Panel)

Rome; c.AD 400
Ivory; h 29.5 cm; w 12 cm
212-1865

A priestess or initiate, her head bound with ivy (the plant of Bacchus), standing beneath an oak tree (sacred to Jupiter), takes some corns of incense to sprinkle on the fire of an altar. A boy (or possibly a girl?) behind the altar holds a wine jar and a bowl of fruit or nuts. At the top the panel bears the name 'Symmachorum'. Evidence on the left side of the panel indicates that it formed the right half of a diptych. The other half, now in the Musée de Cluny, Paris, shows a similar figure making an offering before an altar, and is inscribed with the name 'Nicomachorum'.

The purpose of the diptych is uncertain: it has been suggested that it was made to mark the assumption of the priesthood of the four cults of Ceres, Cybele, Bacchus and Jupiter by women of the Symmachi and Nicomachi families (or that it was issued to commemorate the death of Q. Aurelius Symmachus in 402), but it is more generally thought that it was made to celebrate a marriage, either in 393/4 or 401, between members of the Symmachi and Nicomachi families. It could also simply signify these noble families' adherence to the ancient cults.

At the end of the fourth century there was a pagan revival among members of the old senatorial families in Rome, and both the Symmachi and the Nicomachi were late adherents to the ancient Roman religions. Pride in the Roman past led to a revival not only of classical subject matter as here, but also of the forms of the neo-attic style of the time of Hadrian. This panel can be compared with the so-called 'Amalthea' relief in the Vatican, one of several second-century replicas of what seems to have been a well-known Greek original. Parallels can be found for the setting, composition, figure and drapery motifs of the Symmachi panel. It seems clear, however, that artists did not work exclusively for the adherents of one particular cult: a Christian ivory in the Castello Sforzesco in Milan showing the three Maries at the Sepulchre may have been produced in the same workshop as the Symmachi leaf.

The statuesque elegance of the figure is emphasised by the cold purity of the carving, typical of the neo-attic style. Especially noteworthy are the fine folds of the tunic around her legs and the fine detail of the leaves and acorns of the oak-tree. Despite the low relief there is still an attempt to create the illusion of depth in, for instance, the oblique placing of the altar, and the way that the back of the principal character's foot projects out and across the frame in the bottom right hand corner. Particularly effective is the way that the folds of drapery across her back curve up and around, disappearing as if back into space and behind the figure. The shape and volume of the body are suggested by the contrast of the smooth rounded areas such as the right calf or left arm and breast with the areas of looped and hanging folds.

Formerly in the abbey of Montier-en-Der.

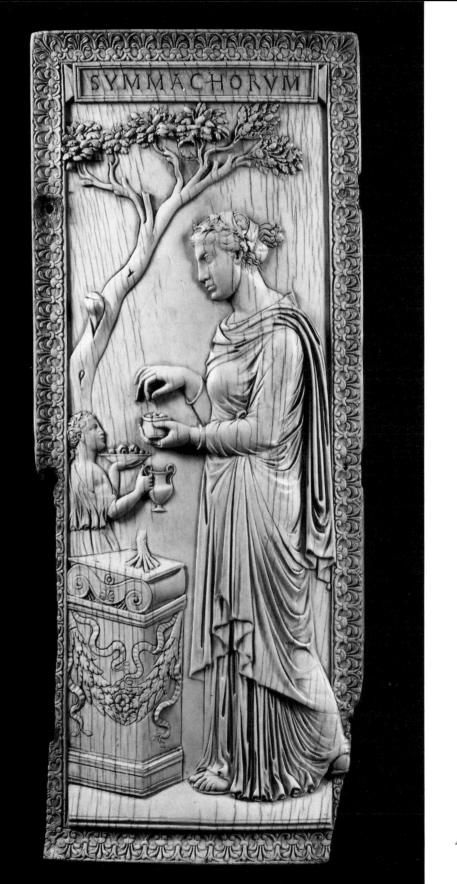

Tabula (Square Panel) from a Tunic

Colour plate 1

Graeco-Roman; fourth-fifth century
16.5 cm square
651-1886

From a burial site at Akhmîm (Panopolis) in Upper Egypt. This panel for the shoulder or skirt of a linen tunic was applied to the main garment after it was woven. Fragments of the linen remain attached to the piece, which is tapestry woven in wool on a linen warp. There are only a few extant pieces found at Akhmîm from this period which are of such outstanding quality both by virtue of the high standard of workmanship and the fineness of the threads used.

Represented within the floral border is the God Hermes, whose name is indicated in Greek characters to either side of his head. He is clothed in a pink *chlamys*, or short cloak, and on his head is a *petasus*, or winged cap, surrounded by a nimbus. In his left hand, Hermes holds a *caduceus*, the messenger's wand with which he is traditionally associated, having been appointed herald by his father Zeus. His other hand holds a purse, which is a symbol of commerce, Hermes being the God of gain and riches as well as messenger of the Gods and guide to travellers.

In the style of the panel, both classical and Christian Coptic influences can be detected. The character and his costume reflect Hellenistic iconography, while the slightly clumsy execution of the figure and the large soulful eyes give a foretaste of the later fully developed Coptic style. Figure subjects depicted on textiles at this period were almost invariably drawn from Greek and Roman mythology. Although the representation of heathen deities on garments was officially suppressed at the end of the fourth century, their portrayal diminished only gradually.

The floral border of the textile still retains some elements of classical naturalism, but here too the tendency towards a more stylised and cruder form can be seen, which is typical of the transitional period in textile design between the Graeco-Roman and Coptic eras. Other works of art of approximately the same period as the panel show this transition between two styles: a series of late fourth-century mosaics in the Louvre, representing the months, the seasons and the winds still show classical influence while contemporary sculptures, such as a marble relief of St. Menas, which came from a monastery near Alexandria (now in the Graeco-Roman Museum in Alexandria), are already Coptic in style.

This panel and two others in the Collection, one showing Apollo and the other Orpheus(?) (652 and 653-1886), resemble in style, colour and detail two pieces in Soviet museums, although the latter are roundels and are larger. The Pushkin Museum in Moscow has one example with a representation of Neilos (the Nile), while the Hermitage in Leningrad has a second piece which portrays Ge (the Earth). Both were excavated at Akhmîm in 1888. The existence of a large number of small woven ornaments, the majority of which were removed at the time of excavation from the costumes and hangings to which they were originally attached, gives a distorted impression of the range and size of the textiles which existed in the Late Antique and Coptic periods. The fortunate survival of some complete costumes and a few large hangings goes some way to correcting this inaccurate picture.

Enlarged detail

The Nativity

Egyptian; fifth-sixth century
Resist-dyed linen; h 45.7 cm; w 86.3 cm
1103-1900; Given by Dudley B. Myers

Found in Akhmîm, Upper Egypt. This is one of a series of textiles, often crudely printed but with a vigorous and lively style, found in both Akhmîm and Antinoë and now scattered in many different museums. A number of those which were found were already old when they were used to pad out mummy wrappings. Several substances including wax could have been used to form the resist which would have been block-printed before the textile was dipped in indigo. The choice and disposition of the subject reflect both the tradition of late Roman art and the newer innovations taking place in the Eastern Roman Empire. When the Roman Empire was divided in AD 395, Egypt became part of the Eastern Empire, under increasing attack until its conquest by Islam in 640. The couch on which the Virgin reclines and her comfortable pose are those of many a Roman matron and the rectangular form of the scene is reminiscent of the side of a sarcophagus, even to the columns at the corners. In the eastern tradition angels attended the Nativity rather than simply appearing to the shepherds in the fields, according to the second-century *Protevangelium* of James and the fourth-century Gospel of Nicodemus. In this tradition the Nativity takes place in a cave illuminated by a star which can just be seen before the damaged inscription 'MAPIA' (Maria). A few lines indicate the presence of the ox and the ass above the raised crib, itself not unlike a Roman altar. This presumably contained the Christ Child.

Lamp

Byzantine; fifth century(?)
Cast bronze; h 13 cm; w 17 cm
M.27-1970

The lamp takes the form of a dove. In its back the aperture, through which the oil was poured, is covered by a leaf-shaped lid, while the dove's tail ends in a spout, to hold the wick. The circular disc on which the dove stands is pierced with a square aperture so that it could be mounted on the spigot of a stand.

Such lamps, perhaps deriving from Oriental prototypes, may themselves have inspired the enamellers of medieval Limoges, one of whose most distinctive products were enamelled pyxes in the shape of doves (known as eucharistic doves), which were suspended by chains above the altar.

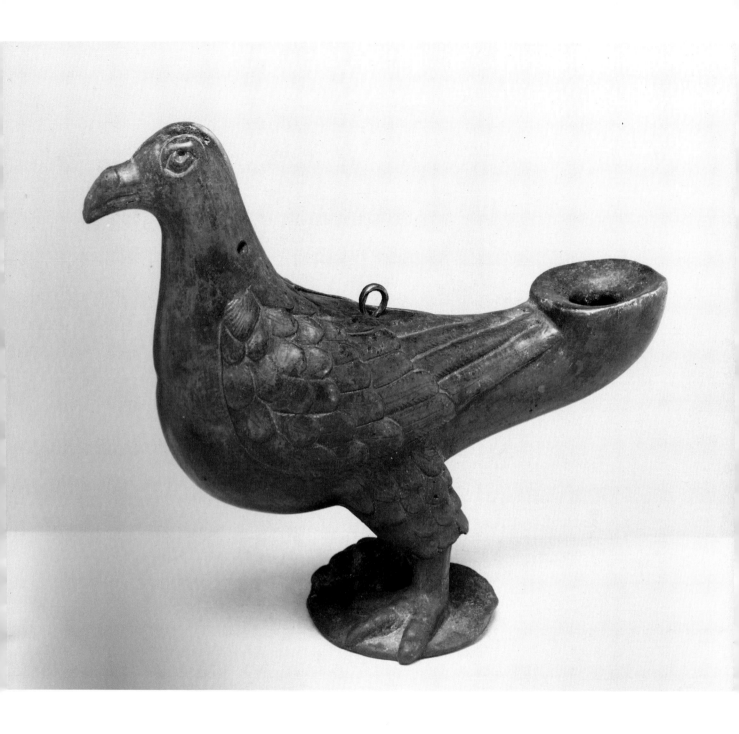

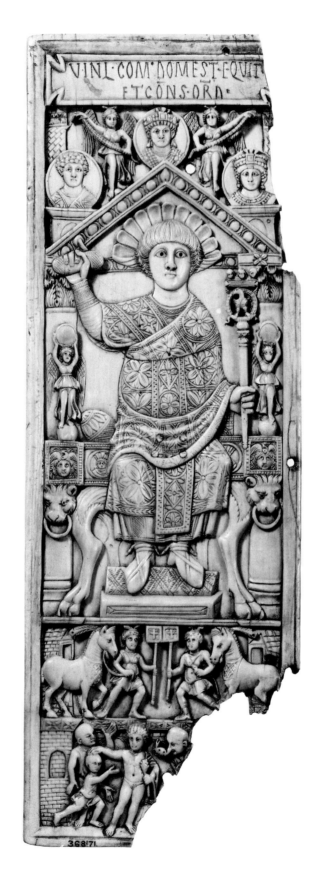

Leaf of a Diptych of the Consul Anastasius

Constantinople; AD 517
Ivory; h 36.5 cm; w 13 cm
368-1871

Leaf of a consular diptych of Flavius Anastasius, consul at Constantinople in AD 517. The other leaf bearing the consul's name, formerly in Berlin, was lost in the Second World War.

The seated Anastasius is shown with a sceptre in his left hand, and the *mappa circensis*, with which he gave the signal for the games to begin, in his right. He wears the *trabea*, a sumptuous ceremonial costume. The inscription above refers to his office. The busts are, right to left, the Empress Ariadne, the Emperor Anastasius I, and the other consul or Pompeius, a relative of Anastasius. The sides of the throne show two *Gorgoneia* and personifications of Rome and Constantinople. There is a contrast between the solemn representation of the consul and the lively figures below, where in the lower section two servants (or Amazons?) lead horses, with two men and a boy at the bottom left, and to their right is the head of an elderly man with a crab attached to his nose. An engraving made before the leaf was damaged shows that there was another man in a similar unfortunate position beside him. The exact interpretation of these scenes is uncertain; it has been suggested that they refer to games in the circus, a possibility which is supported by the scenes on the lower section of the lost Berlin leaf. This had acrobats and men fighting bears and the heads of spectators could be seen over a balustrade, while in the corner the doors to the arena were visible. This might explain the so far unidentified scene in the bottom left corner of the present leaf as a symbolic freeing of slaves, a ceremony which could be performed on these occasions.

Consular diptychs were a form of highly decorated writing tablet, given on the day the consul took office, to friends and those who had helped him reach his post. On the back of each panel was a raised border, the sunk enclosed field being filled with wax which could be written on; the front could be decorated as required, either with a representation of the consul or with simple ornament. About fifty examples survive from c.AD 400–AD 540, nearly all dateable to the first year of the consul's office, and thus very important in helping to date other works.

From the fifth century no more than one diptych survives for an individual consul, and they all show a greater freedom in composition and general character, but from the sixth century there are several diptychs for some consuls, at least four for Anastasius and as many as eight for Areobindus (AD 506); as the custom of giving these diptychs grew, they seem to have been produced almost wholesale ready to meet the demand, many showing little variation on the format seen on this example.

There are traces of writing on the back of this leaf, and the Berlin leaf had a list of Apostles, Fathers of the Church, Popes, Bishops and martyrs, none of them later than the seventh century. Often at an early date pagan diptychs were adapted for liturgical use, the blank insides used to record the names of saints and those for whom prayers were asked, these lists to be recited during the Mass – this would explain why the diptych was kept in the treasury of Liège Cathedral until the end of the eighteenth century.

Linen Tunic

Coptic; sixth–eighth century
h 120 cm; w 104 cm
136-1891

Probably from a burial site at Akhmîm (Panopolis) in Upper Egypt. This tunic is woven from undyed linen with applied tapestry woven woollen ornaments and exemplifies Coptic textile design. Tunics were the principal garments found in the burial grounds of Egypt. They were the basic costume worn in Graeco-Roman and Coptic times together with an outer cloak or mantle when this was needed as extra covering, and probably also occasionally for ceremonial purposes. Normally tunics were woven in one piece which would take the form of a cross if spread out. The upright portion was the width of the garment. The transverse portion, consisting of two narrower pieces of equal lengths formed the sleeves at the middle. Under the Romans, certain types of ornament were used to identify the status of the wearer. In particular, the number of *clavi* or shoulder bands could be significant. By about the end of the first century these features were purely decorative, and in this example, the delicacy and ordered disposition of the ornaments of the Graeco-Roman tunics has given way to less carefully positioned and more irregularly shaped panels. The decorative effect is achieved by the use of vivid colours and a densely packed design consisting of crudely defined but lively human figures, animals and birds as well as stylised floral patterns. The neck-opening is a deep oblong shape, unlike that on earlier examples which was usually a simple horizontal slit.

Tunics were worn by both men and women, women generally wearing longer and fuller ones than men, although the latter might wear either knee-length or longer garments. Early illustrations of these garments, particularly those in the sixth-century Rossano Gospels, show women wearing long tunics and men both long and short ones. Comparison with the style and decoration of costumes represented on mosaics, carvings and paintings such as those depicted on sections of the paintings in the Catacombs of Priscilla in Rome (dating from the third century) suggest that such garments were not peculiar to Egypt.

Although the site from which this particular garment was excavated is unknown, Akhmîm is the most likely provenance. Of all the Egyptian excavations it was the burial grounds there which yielded the most prolific finds of textiles. Situated on the right bank of the Nile, about 300 miles south of Cairo, Akhmîm occupied the site of the Greek city of Khemmis or Panopolis, becoming an important town and one of the chief centres of linen manufacture for which Egypt was famous at this period. From the first excavation carried out at Akhmîm in 1884, and in successive years, a large number of textiles and costumes were discovered, belonging to successive generations from the early Graeco-Roman period through the Christian era to that of Arab domination. The Museum acquired about 300 pieces from there in 1886, and this was augmented in later years by further acquisitions both from Akhmîm and other sites including Antinoë and El A'zâm.

Tunics dating from the Coptic period and earlier can be found in the larger textile collections in Museums in Europe and the United States, although they are rare by comparison with the number of ornaments which survive.

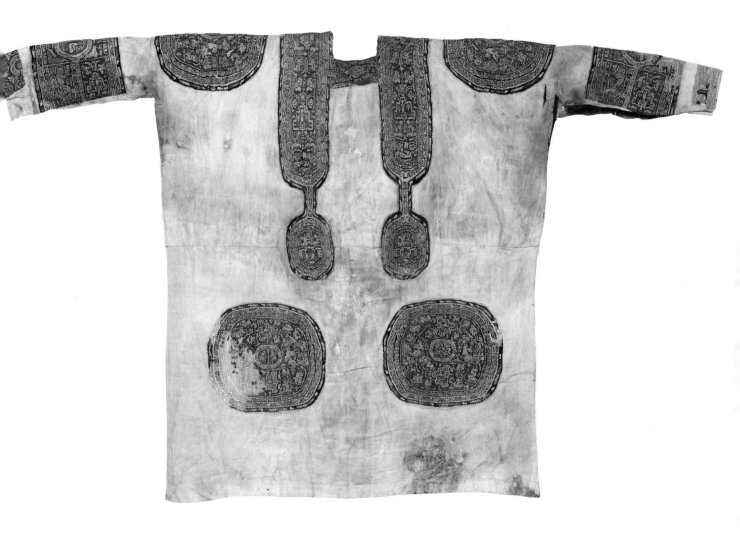

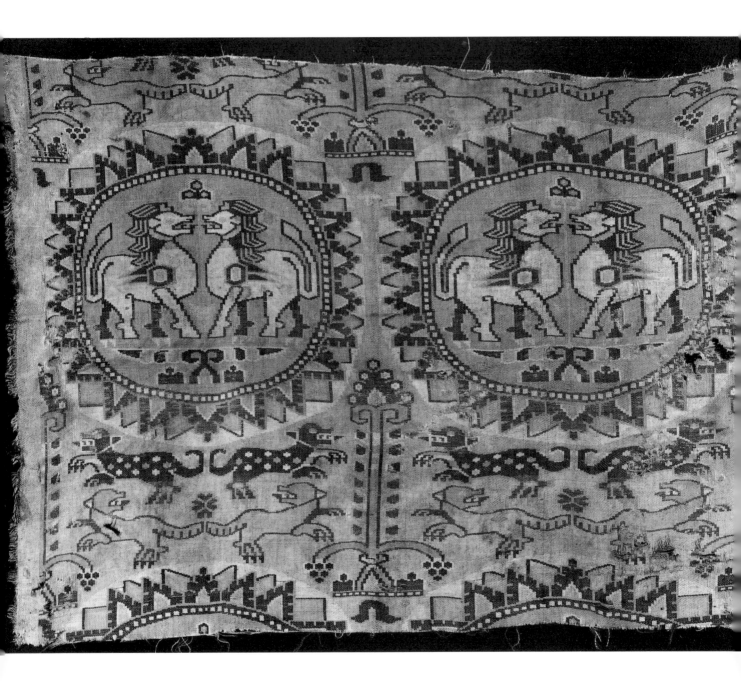

Woven Silk

Western Asia (Sogdiana); seventh–eighth century
62 cm × 46.3 cm
763-1893; Bought in Paris (previously in the Cathedral of Verdun)

This bold and striking silk is an early example of an important group of silks dating from the seventh to eleventh centuries. There are other pieces of the same silk in the Cooper-Hewitt Museum in New York and the Museo Nazionale in Florence. One silk in the group, in the Collegiate church of Notre-Dame, Huy, has a contemporary inscription in ink on the back in Sogdian, the language of a people who lived in the region of Bokhara at the time, mentioning a place named 'Zandaniji'. When this group was first published in 1959 by Dorothy Shepherd of the Cleveland Museum only eleven silks had been traced but by 1981 her own research and that of Russian scholars had brought to light many more examples both in western Europe and in Russian excavations (see *Further Reading*). These are among the rarest of ancient textiles, since they can be assigned to a particular historical place, one known to have been making textiles later in its history. They share, moreover, quite definite stylistic and technical features which differ from other Near and Far Eastern silks. It is not so much the structure of their weave – compound twill – which is peculiar to them, but the way in which it is carried out. All have thick, strong, coarse threads (perhaps explaining their survival), which are dyed in rather poor colours and have deteriorated more than those of contemporary fabrics: these dyes may have been Chinese and the relationship of this group with China has recently been investigated.

Elements in the design can be traced to a remote archaeological past. The rudimentary trees between the roundels appear in the art of many ancient civilisations. The influence of Sassanian art is evident and one textile in the group has an Old Testament subject. There are features common to all groups which can be seen in this textile: the toothed border to the roundel and its dotted form, for example, while the leopards and foxes below and the lions themselves all have a stylised cardboard cut-out appearance enhanced by the jagged outline. The latter is the result of the very coarse weaving. Animals in combat as well as human huntsmen were favourite subjects in the antique world. By the time these themes had reached a provincial centre on the silk road from China much of the repertoire had become distorted. Silks in the group have been found in Egypt sewn to tunics of the eighth–tenth centuries, in the tombs of western Europe and in graves in the North Caucasus, illustrating the importance of textiles in international trade and underlining their role as disseminators of artistic styles across the world; however, the wide distribution of these silks has provoked controversy in their dating and attribution.

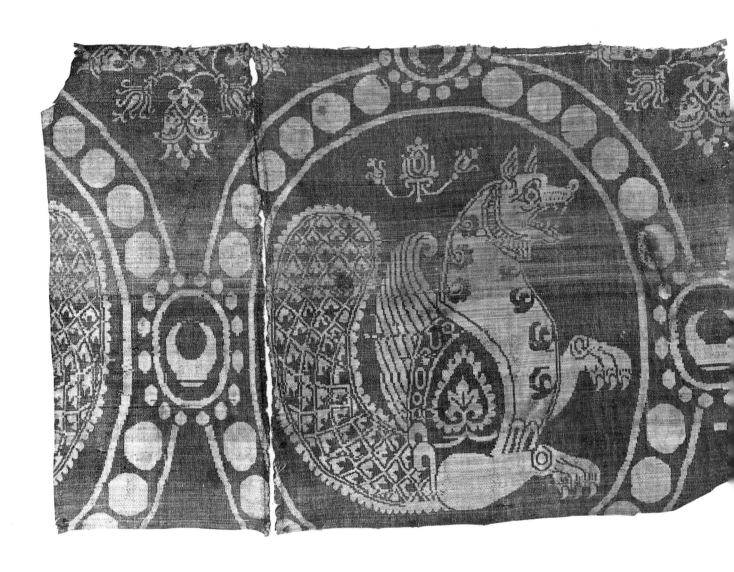

Woven Silk

Western Asia, Iran(?); eighth–ninth century
h 51.5 cm; w 35.5 cm
8579-1863; From the Bock Collection; said to have been found in the reliquary of the head of St. Helena in the church of St. Leu, Paris

The legacy of Sassanian Persia (AD 226–632) lasted for at least another four centuries after its actual demise. Carvings show that Sassanian garments were decorated with bold decorative schemes with ducks, for instance, in and outside roundels. The circles, stylised trees, and mythical monsters formed ready-made and dramatic textile patterns, easily carried out in the technique of these centuries: compound twill.

While in Persia itself the Sassanians drew upon both the cultures which preceded them in their own country and upon the motifs of classical Greek art, the textile traditions which they inspired spread to producers across Western Asia and the Eastern Mediterranean. With a common tradition and a common technique it is difficult to assign these silks to any one centre, although a very detailed technical study may at least form them into definable groups. Among the popular beasts in Sassanian mythology seem to have been both winged horses and winged lions but the most striking was the 'senmurv'. This creature has the head and forepaws of a lion – or a mastiff – the wings of an eagle and the tail of a peacock. A senmurv was carved on the tomb of Chosroes II at Taq-i-Bustan and there are several surviving examples on Sassanian silver vessels as, for instance, on a silver jug in the Hermitage in Leningrad and a later silver dish from the seventh-eighth centuries, originally found in Northern India, in the British Museum. Instantly recognisable, they are usually framed in roundels even when depicted on silver. Sometimes the roundels are formed from leaves but they are also made from pearls, a decorative scheme which could be transformed into a textile motif without any adaptation.

Two other silks with such large senmurvs are known, one in the Musée des Arts Decoratifs in Paris and one used for the chasuble of St. Mark at Abbadia S. Salvatore in Italy. Much more common are the smaller-scale senmurvs, like the one on a silk also exhibited in the V&A (761-1893), which is said to have come from the cathedral of Verdun. Its decorative details suggest a slightly later date.

Sassanian and Byzantine silks of this type were often used in western graves and through them eastern iconographic types were transmitted to Romanesque artists. The senmurv seen here is essentially the same fantastic creature as the griffin, which was to be so popular in three-dimensional form in the West, as may be seen by referring to the splendid Mosan ewer of about 1150 in the Museum (p 137)

Early Germanic Jewellery
Colour plate 2

a) Looped *fibula* (brooch)
Frankish, sixth century
Silver gilt inlaid with niello, set with garnets;
l 10.2 cm, w 5.1 cm
M.114-1939 (from Herpes, Charente)

b) Buckle
Merovingian, fifth to eighth century
Iron inlaid with silver; l 13.3 cm, w 6.4 cm
M.325-1927

c) Fish *fibula* (brooch)
Frankish, sixth century
Gold set with garnets; l 4.4 cm, w 1.6 cm
M.120-1939

d) *Fibula* (brooch)
Anglo-Saxon (Kentish), seventh century
Silver set with gold filigree, garnets and lapis
lazuli inlay; diam 4.7 cm
M.110-1939 (found at Faversham)

e) *Fibula* (brooch)
Anglo-Saxon (Kentish), seventh century
Gold and silver with garnet inlay, on a backing of
copper and compositions; diam 7.6 cm
M.109-1939 (found at Milton, near Abingdon, in 1832; the
pair to this brooch is in the Ashmolean Museum, Oxford)

f) *Fibula* (brooch)
Frankish, seventh century
Bronze and gold set with pastes and garnets; diam
4.7 cm
M.119-1939

The Germanic tribes which overran the Roman Empire after its fall
produced jewellery technically of very high quality. Striking features of this
jewellery are its polychromy – an effect gained largely by the use of cut and
polished garnets set over gold foil and lapis lazuli – and the dominance
of zoomorphic motifs: stylised eagle heads (a), interlaced snakes (b) and (e),
and fish (c).

In Anglo-Saxon England the tribe of Jutes, who had settled in Kent,
produced much rich and technically excellent jewellery between the late
sixth and early seventh centuries, and the most famous Anglo-Saxon
jewellery, that found at Sutton Hoo (now in the British Museum) is also of
about this date. Faversham seems to have been an important centre of
production (d and e). In Gaul the Franks used rather less sophisticated
methods of stone-cutting (a, c and f). The Merovingians (descended from
Meroveus, reputed ancestor of the dynasty) were the line of kings founded
by Clovis, first king of the Franks (466–511), and they reigned over various
parts of Gaul and Germany between c.500–750: their art was confined
largely to work in precious metals, and large buckles such as (b) are highly
distinctive examples of their skill.

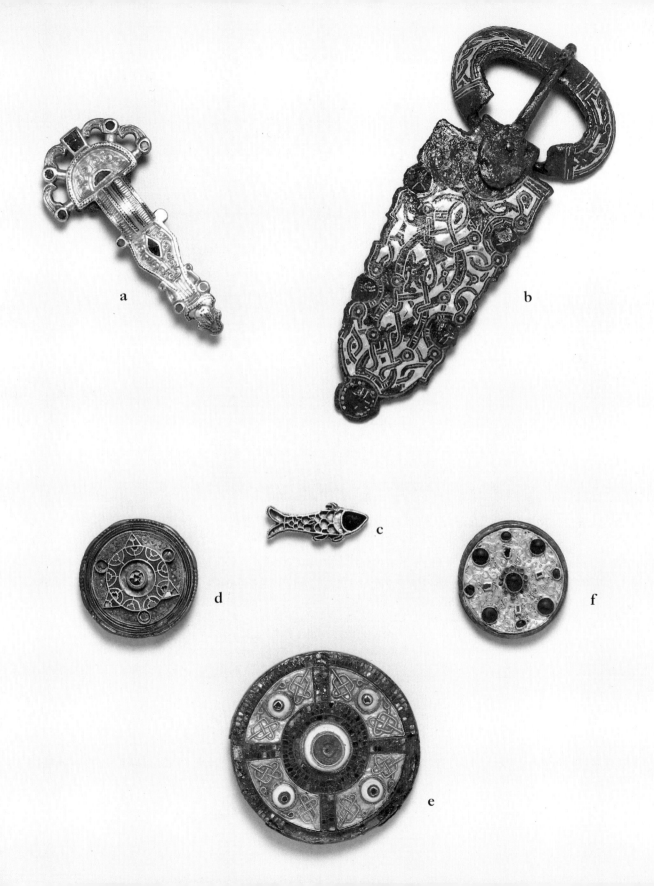

a

b

c

d

e

f

Pendant Cross (The Beresford Hope Cross)

Italian(?); ninth century(?)
Cloisonné enamel mounted in gold, the frame silver-gilt
h 8.5 cm; w 5.5 cm
265-1886

The front plaque of the cross shows the crucified Christ between busts of the Virgin and St. John with a contracted Greek inscription for 'Behold thy son' and 'Behold thy mother'. On the back is a standing figure of the Virgin with hands raised in prayer, who is surrounded by busts of Saints John, Peter, Andrew and Paul. Although now empty, the cross would originally have contained relics; these small reliquary-crosses seem to have been popular amongst the Byzantines, but enamelled examples are very rare.

The limitations which the use of the cloisonné technique imposes upon the graphic powers of the artist are felt most severely when both subject and background are shown in enamel. The consequent absence of the mannerisms of any precise period have caused prolonged disagreement about the date of this cross amongst writers on Byzantine art and on enamelling. The prevailing tendency has been to consider it as not strictly Byzantine but Roman work of the early ninth century, because of its resemblance to the Reliquary of the True Cross, from the Sancta Sanctorum, now in the Vatican Museum. This reliquary bears an inscription which seems to refer to Pope Paschal I (817–824). Recently, however, it has also been compared with the enamelled reliquary of the True Cross in the Metropolitan Museum, New York, dating to c.AD 700.

Over a hundred and thirty years ago the cross was in the possession of M Debruge Duménil, but nothing was recorded about its antecedents when the great French antiquary Jules Labarte published his catalogue of the collection of his late father-in-law in 1847. Not long afterwards it was acquired by Mr J.H. Beresford Hope and when his collection was dispersed at Christie's in May 1886 the cross was bought for the Museum.

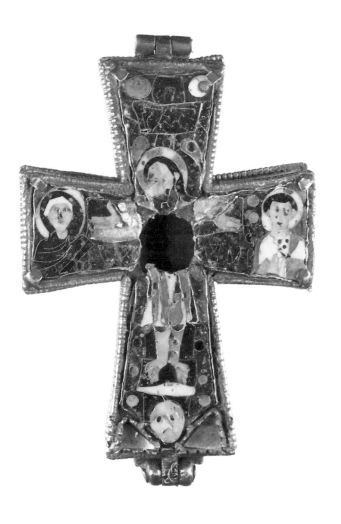 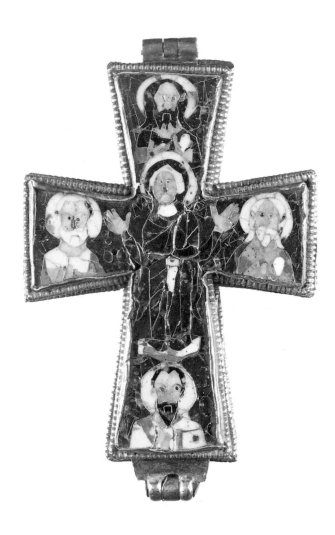

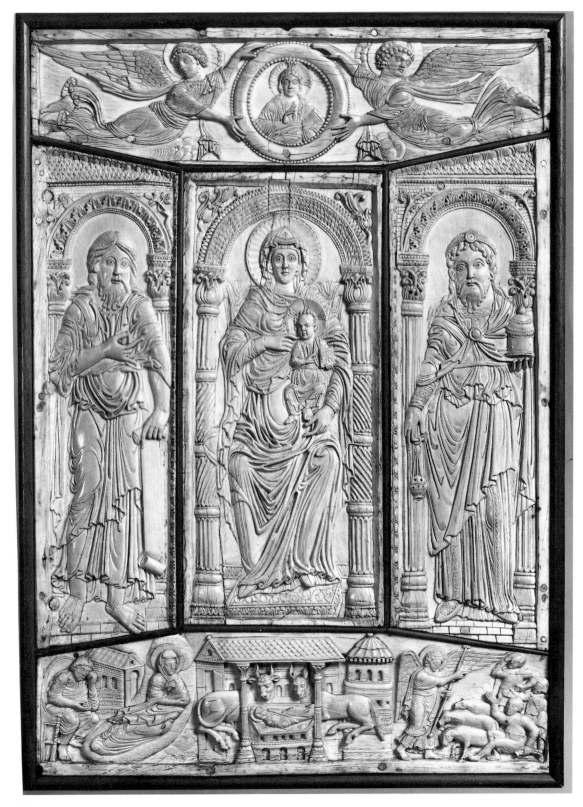

64

Front Cover of The Lorsch Gospels

Aachen; c.810
Ivory; h 38.1 cm; w 26.7 cm
138-1866

The Virgin and Child with, to the left, St. John the Baptist and, to the right, Zacharias holding a censer and an incense box. Above, two flying angels hold a medallion of Christ, and below are the Nativity and the Annunciation to the shepherds. This ivory formed the front cover of an early ninth-century copy of the Gospels from Lorsch Abbey. The back cover, now in the Vatican, shows Christ treading the beasts between two archangels, with two flying angels above holding a medallion with a cross, and below, the Magi before Herod and the Adoration of the Magi. This is the largest and most splendid of Carolingian bookcovers to have survived.

The presence of John the Baptist, and his pose – pointing to the Virgin and Child – are explained by his words (John 1, 29) 'Behold the lamb of God, which taketh away the sin of the world'. The presence of Zacharias is more problematic, but may be due to his prophecy (Luke 1, 78–9) 'The dayspring from on high hath visited us, To give light to them that sit in darkness and in the shadow of death'.

This ivory is one of the major representatives of the so-called 'Court School' of Charlemagne. Carolingian art looked not only to the past imperial traditions of Rome but also to the more nearly contemporary imperial tradition of the East. This piece would seem to have been based on a sixth-century Constantinopolitan imperial diptych, formed of five panels, such as the Barberini diptych in the Louvre. A stylistic comparison can be made with surviving sixth-century works such as the throne of Maximianus (Archbishop of Ravenna, 545–53) in Ravenna.

The book cover is, of course, even closer to the major illuminated manuscripts of Charlemagne's Court School – plump faces, staring eyes, scalloped haloes, the long curved fingers, and the decorative arcade – and it seems that illuminators and carvers used identical models. In this style illusionism is subordinated to a love of pattern. This is seen not only in the elaborate columns and arches but also in the deep folds such as those around the Virgin's legs or John the Baptist's stomach, which are used as devices to create not so much an effect of three-dimensionality as an intricate surface pattern.

It has been suggested that the panel with two angels holding the medallion at the top of the Vatican book cover is in fact Late Antique, and that the rest of the book cover was cut to fit it. Stylistically this seems likely, but the irregularity of the cutting of the different panels on both book covers – various parts have clearly been cut back – implies that the planning and construction of the book cover was rethought at different stages. Exactly why this happened remains uncertain.

Diptych with Miracles of Christ
(The Andrews Diptych)

Carolingian(?); ninth century(?)
Ivory; h 30 cm; w 10 cm
A.47/a-1926

This diptych shows six miracles of Christ. From top right these are the Raising of Lazarus, the Marriage at Cana, the Healing of the Leper, the Miracles of the Loaves and Fishes, the Healing of the Blind Man, and the Healing of the Man sick of the Palsy. The scenes are divided by acanthus borders (different on left and right leaves) and each leaf has a narrow border of egg and dart ornament.

The dating and localisation of this ivory are highly controversial subjects. It has been viewed by many scholars as a Late Antique work, related to fifth-century ivories such as the Venatio (or elk fight) panel in Liverpool, which provides the only close parallel for the form of the acanthus strips between the scenes. The stocky proportions of the figures, their round heads on short necks, with heavy drapery folds, seem to connect it with other fifth-century North Italian plaques. Recently, however, most have favoured the attribution to the ninth-century Carolingian Renaissance. The shallowness of the picture space, the lack of depth in the ornament, and the flatness of the architectural background (despite the detailed rendering of the brickwork) are put forward as reasons for a later date.

While the iconography of each scene has its precedent in Early Christian works, the diptych is unusual for the Late Antique period in its restriction to representations of Christ's Miracles. The only scene not found in Early Christian Art is the Healing of the Leper, but here it closely resembles fifth-century representations of Job's sufferings in the Old Testament. The sequence of scenes can be seen in such works as the sixth-century mosaics of S. Apollinare Nuovo in Ravenna, and the diptych may have been based on a similar cycle.

This diptych highlights the difficulty in differentiating between Early Christian and Carolingian works. With the refounding of the Holy Roman Empire under Charlemagne there was a revival of the imperial tradition; artists copied Late Antique models, often so closely that they were almost indistinguishable from the original, as in this instance.

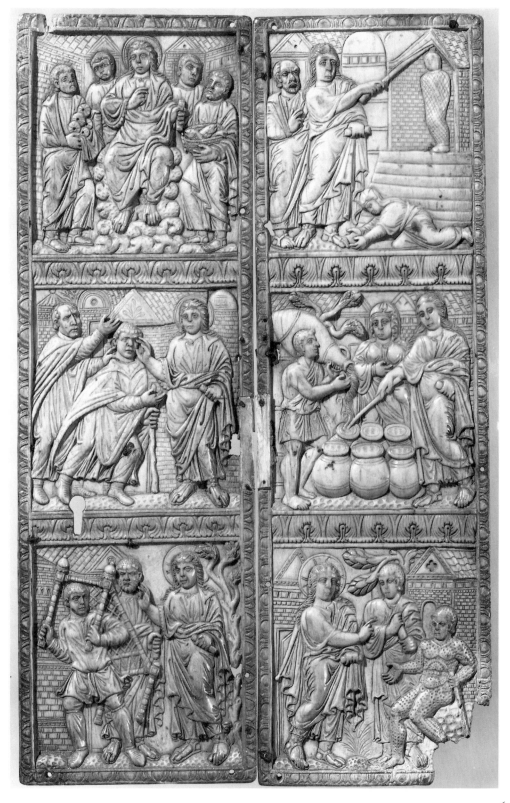

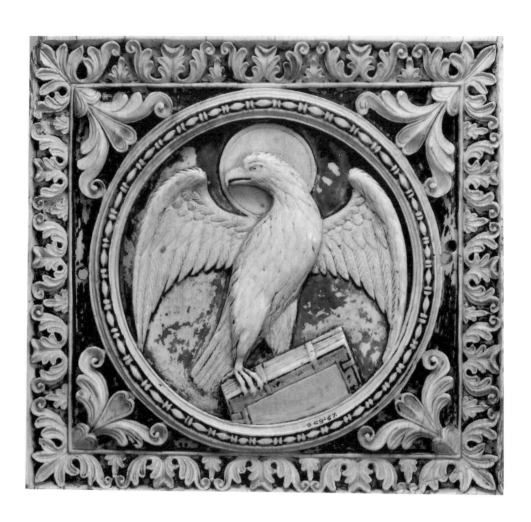

An Eagle, the Symbol of St John the Evangelist

Carolingian, 'Court School'; ninth century
Ivory; h 12 cm; w 13 cm
269-1867

An eagle, the symbol of St. John the Evangelist, a book held in its claws, in a roundel of bead and reel ornament set within a square border of acanthus. The colour is probably a later addition.

Two plaques of the same size and format, one with a bust of Christ, the other with a bust of an angel holding a book (the symbol of St. Matthew), both in the Museo Nazionale in Ravenna, belong with this piece. Together they must have formed part of a diptych, cut apart at some point in its history perhaps because of damage: lines of writing on the back of the V&A panel have been cut through. On the left side of the plaque holes for lacing the leaves of the diptych together can be seen. The complete diptych must have had the four symbols of the Evangelists, Christ, and possibly the Virgin, arranged in six roughly square panels, three to each leaf. The present panel would have been at the top of the right hand leaf. It seems that this ninth-century diptych was recut from a consular diptych, for on the back are the remains of the raised border to hold the wax, and the holes for hinges on the side are very like those seen on fifth- and sixth-century diptychs.

The representation of the Evangelists as beasts derives from Ezekiel, 1, 10., in which the prophet has a vision of a man with four faces – a lion, an ox, an eagle and a man. In art, the Evangelists could be represented seated at a lectern, accompanied by their respective symbols (as on the four eleventh-century examples in the V&A, p 100), by their symbols alone as here, or as anthropomorphs, having a human body but the head of their particular symbol.

This plaque can be dated and localised largely on the basis of the evidence of its companion plaques, whose figure style relates to the so-called Court School of Charlemagne. The closest comparison, however, seems to be a plaque of Christ blessing on a book cover in the Bibliothèque Nationale in Paris (Cod. lat 9387) which, with another plaque of an enthroned saint in Trento, shows an awareness of space and three-dimensional form closer to the antique than the more patterned Court School works.

Crucifixion Plaque

Metz; third quarter of the ninth century
Ivory; h 21 cm; w 12 cm
250-1867

Above Christ's head two busts in circles represent the sun and moon, with an angel on each side ready to receive Christ's soul. To the left of Christ stand the Virgin and Ecclesia (the Church), the latter holding a chalice to receive Christ's blood, and to the right are St. John the Evangelist and the figure of Synagogue, who holds a banner. Below them stand Longinus (with the lance) and Stephaton (with the sponge), with two figures on each side emerging from tombs in the shape of circular mausolea; at the bottom are large symbolic representations of Earth and Water. The surface of the relief is dotted with holes which originally held gold studs, some of which remain.

This is one of a series of ivory plaques of the Crucifixion produced in the second half of the ninth century, with certain unusual iconographic elements in common, all similarly disposed across three main registers, with the crucified Christ filling the centre and cutting across these horizontal divisions. These Crucifixion panels all seem to present an elaborate symbolic image.

The serpent wound around the base of the Cross symbolises sin overcome by Christ; Ecclesia catching the blood of Christ refers to the Eucharist, while the resurrection of the dead symbolises the conquest of death and the material world through the Crucifixion. The iconography of these plaques is perhaps derived from the cover of the Pericopes of Henry II in Munich, produced c.830–40, a work of the so-called 'Liuthard' ivory group, which takes its name from the scribe who worked on the manuscripts on which some of these ivories are attached.

The style of the Crucifixion group – thick set figures swathed in heavy rounded loops of drapery, with square jaws and straight blunt noses – is that of ivories produced at Metz in the second half of the ninth century and the early tenth century.

This plaque was formerly attached to an Evangeliary in Verdun Cathedral.

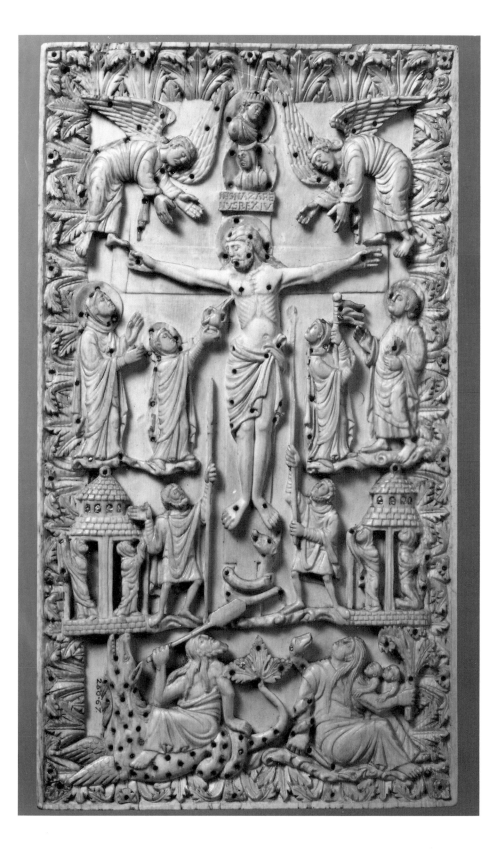

Liturgical Comb

Metz; third quarter of the ninth century
Ivory; h 21.5 cm; w 10 cm
A.544-1910

On the front a sunk relief with Sagittarius shooting at Capricorn, in symmetrically arranged loops of stylised acanthus. The border of a pattern of inlaid coloured glass and gold. On the back a symmetrical pattern of incised snakes wound around stems, this and the border also with coloured glass and gold.

Liturgical combs were sometimes used during the Mass and in the ceremony for the anointing of bishops. There is extensive literary support for this, unfortunately none of it earlier than the thirteenth century. Durandus, writing c.1280, devotes the fourth chapter of his book on the symbolism of churches to the liturgical use of combs, and indicates that the combing of the hair before the Mass was symbolic of the ordering and tidying of the mind. What probably started as a practical matter had by the thirteenth century become an established ritual. Even today the use of an ivory comb after the anointing ceremony is prescribed in the Pontifical of the Roman Curia.

There are several different kinds of combs, but from the Carolingian to the Romanesque period this form, with teeth on both short sides, seems to be most common. The semi-circular shape of the body of the comb is not a purely aesthetic choice, since it also gives extra strength to the fine teeth in the middle of the comb, at the point where there is most strain.

Two ivory reliquary caskets, one in Quedlinburg, the other divided between Munich and East Berlin (this panel is now greatly damaged), can be related to the comb. Both caskets have the same pattern of entwined incised snakes (although this is covered by later metalwork on the Quedlinburg casket) and a complete set of calendar symbols, including Sagittarius and Capricorn, which are very close to the figures on the comb. Here the comb is closer to the Munich casket in that Sagittarius is represented not in the usual form of a centaur but as a man.

Formerly in the Cathedral Treasury at Pavia.

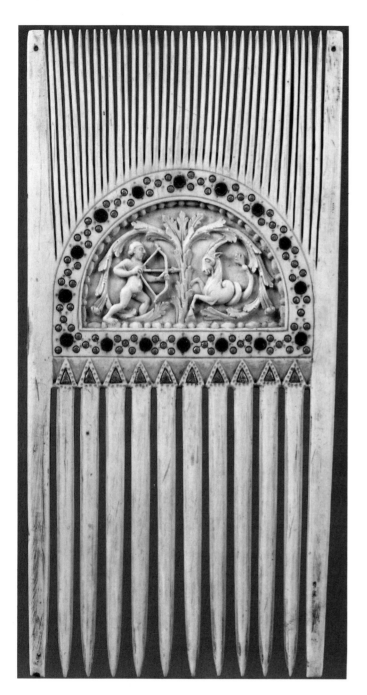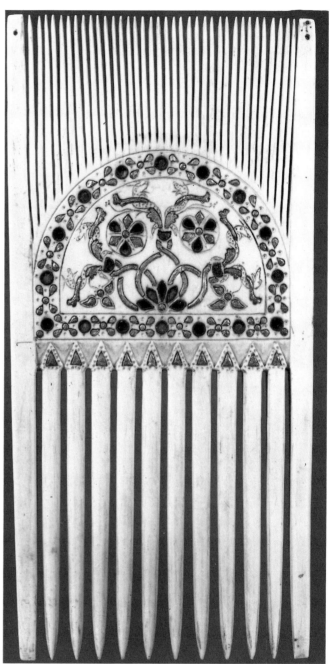

The Adoration of the Magi and the Presentation of Christ in the Temple

Metz; c.900
Ivory; h 18.5 cm; w 11.5 cm
150-1866

This plaque probably once formed part of a bookcover. At the top is the Adoration of the Magi: the star can be seen in the border above the head of the first Magus. Below is the Presentation in the Temple: Simeon stands to the right of an altar, arms outstretched to receive the Child who is carried by the Virgin, followed by Joseph and St. Anne.

In the Presentation Simeon is inspired by the Holy Ghost to recognise the Christ Child as the Saviour sent by God. In fact, the Presentation and the meeting with Simeon are two separate events, but from the eighth and ninth century onwards the Priest of the Presentation is merged with Simeon, and the Virgin is shown, as here, handing the child to Simeon across the altar. The rest of the scene is derived from Luke, 2: the two doves or young pigeons held by Joseph are for the ceremony of the purification of the Mother (after the birth of a child), which Luke combines with the Presentation, and the presence of the aged prophetess Anna is explained by the inclusion of her testimony in Luke's Gospel.

The importance of the star has its origins in classical art, as the rising of a star at the birth of a ruler was a familiar image in antiquity, and in Roman art a star over the head of an Emperor indicates his divinity. Although the Magi are now thought of as kings, they were not represented as such in the visual arts until the tenth century, so here they wear Phrygian caps rather than crowns.

This bookcover is a good example of the best work of the Metz school: the relief is deeply cut, the figures seem to stand almost free of the ground, their solid bodies clad in soft drapery which helps to reveal the form below. There is a real sense of movement, particularly in the figure of Simeon stepping forward to receive the Christ Child. This ivory can be compared with another slightly earlier, very high quality Metz work of c.870, a relief in Berlin showing Christ in the Temple, the Marriage at Cana and the Healing of the Leper.

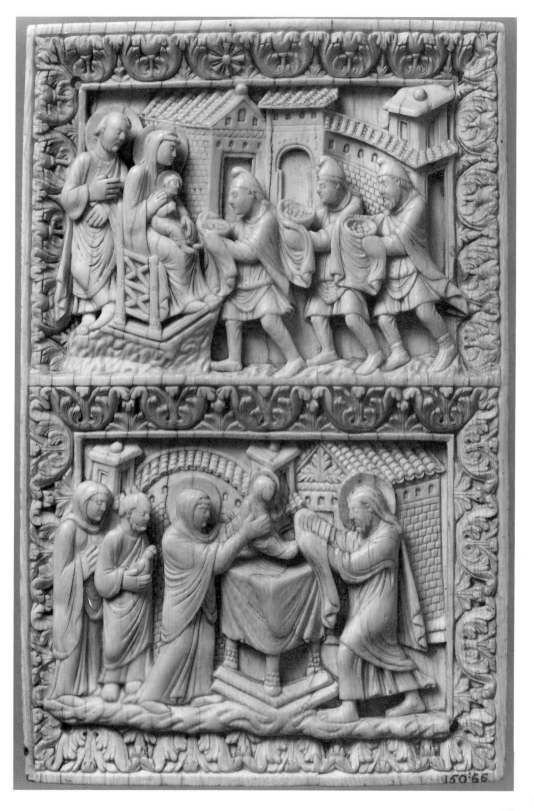

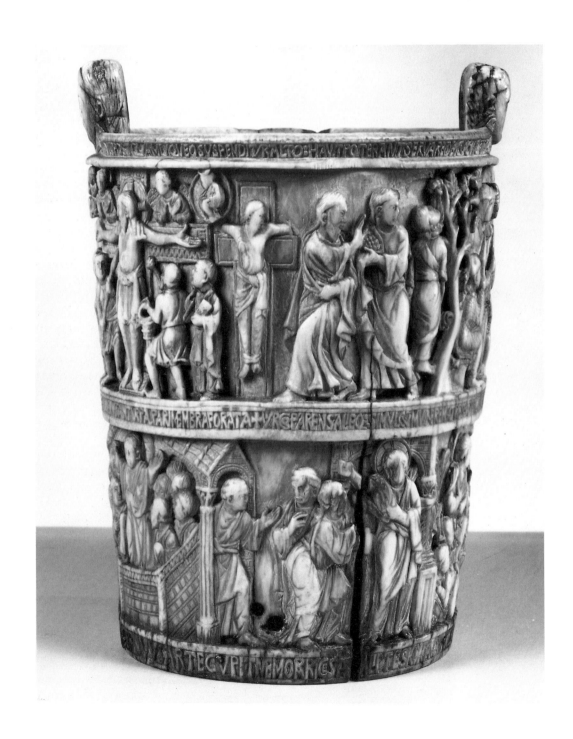

The Basilewsky Situla
Colour plate 3

Ottonian; c.980
Ivory; h 16 cm
A.18-1933

This 'situla' or holy water bucket, bears twelve scenes from the Passion, arranged in two superimposed rows. These are: Christ washing the feet of the disciples; Christ betrayed by Judas; the Bargain of Judas and the High Priest; the Crucifixion; Judas returning the thirty pieces of silver to the High Priest; Judas hanging himself; the soldiers guarding Christ's tomb; the Maries at the Sepulchre; the Harrowing of Hell; Christ's appearance to the two Maries; Christ's appearance to the Disciples; the Incredulity of St. Thomas. Two human mask-heads stand up from the top rim, pierced to take the ends of a metal handle. The situla would originally have had a separate metal bucket inside it.

There are three bands of inscriptions. The two upper bands contain lines from the fifth-century book of the Hexameter rendering of the New Testament story by Coelius Sedulius. The lower band runs 'May the Father, who added thrice five to the years of Hezekiah, grant many lustres to the august Otto. Reverently, Caesar, the annointing-vessel wishes to be remembered for its art.' The situla was produced in around 980 for the visit of Otto II to Milan. The reference to Hezekiah would have had special relevance in 980, as he came to the throne at 25, precisely Otto's age in that year.

Ivory situlae are very rare, and were apparently made only for special ceremonial occasions, such as an imperial visit; only four are known, all of them of the late tenth to early eleventh century. One of these, and a relief of Christ enthroned with the Emperor Otto II, his wife and child, both in Milan, relate stylistically to the Basilewsky situla, although the treatment of the scenes is somewhat coarser and broader. The Milan situla was given to the church of Sant' Ambrogio by Archbishop Gotfredus in 980 for use in ceremonies in connection with the Emperor's visit, while the relief may represent Otto and his family on his visit to Italy in 983. The relationship of the two situlae and the relief suggests that they were all made in the same place (although not necessarily in the same workshop) and Milan is the most likely centre of origin. This is supported by the relationship of several scenes on the London situla with scenes on a ninth-century ivory diptych in Milan Cathedral, which is known to have been there at least as early as the twelfth century. Scenes not related to the diptych can usually be traced to Carolingian models, the only exception being the Harrowing of Hell, where the unusual representation of an angel gripping the arms of Satan is a direct reference to a passage in the Apocryphal Gospel of Nicodemus.

The Basilewsky situla stands out from the group of related ivories in the unusually high quality of its workmanship, and the great beauty of its compositions. The style is more fluid, especially in the scenes relating to the ninth-century diptych, and despite the solidity of the figures there is still a great feeling of movement.

The Sion Gospels Book Cover

German (Trier?); tenth, twelfth and nineteenth centuries
Beechwood overlaid with gold sheets, stones and cloisonné enamel
plaques on gold, covering a tenth-century Evangeliary
h 25.4 cm; w 22 cm
567-1893

Although the manuscript of the Sion Gospels is itself beautifully written and dates from about the year 1000, the importance of the book lies chiefly in its cover. The enamels and the outer border are probably contemporary with the manuscript, but the seated figure of Christ and the surrounding strips of stamped work can hardly be earlier than the twelfth century. Few of the larger stones can be original as they differ considerably from those described in a fourteenth-century hand on the first page of the book. The enamels were considerably restored in the nineteenth century.

Precious bindings such as this one were reserved for the liturgical manuscripts used in services. Their decoration usually included the figure of Christ or the Crucifixion and the Evangelists, the whole often lavishly encrusted with gems.

An attempt has been made to identify this book with the Gospels of Charlemagne, a volume recorded as having belonged, until the fourteenth century, to the rich abbey of St. Maurice d'Agaune, in the canton of Valais, Switzerland. There is however, very good reason to suppose that it was originally made for the ancient church of Notre Dame de Valère, in the same canton, to which, according to a further inscription, it belonged in the seventeenth century; afterwards it came to the cathedral of Sion, in the valley below. In 1851 the cathedral authorities disposed of the book to a dealer at Geneva, by whom it was sold to the Marquis de Ganay. Towards the end of last century it passed into the Spitzer Collection, when the restorations were made; it was acquired for the Museum at the Spitzer sale in 1893.

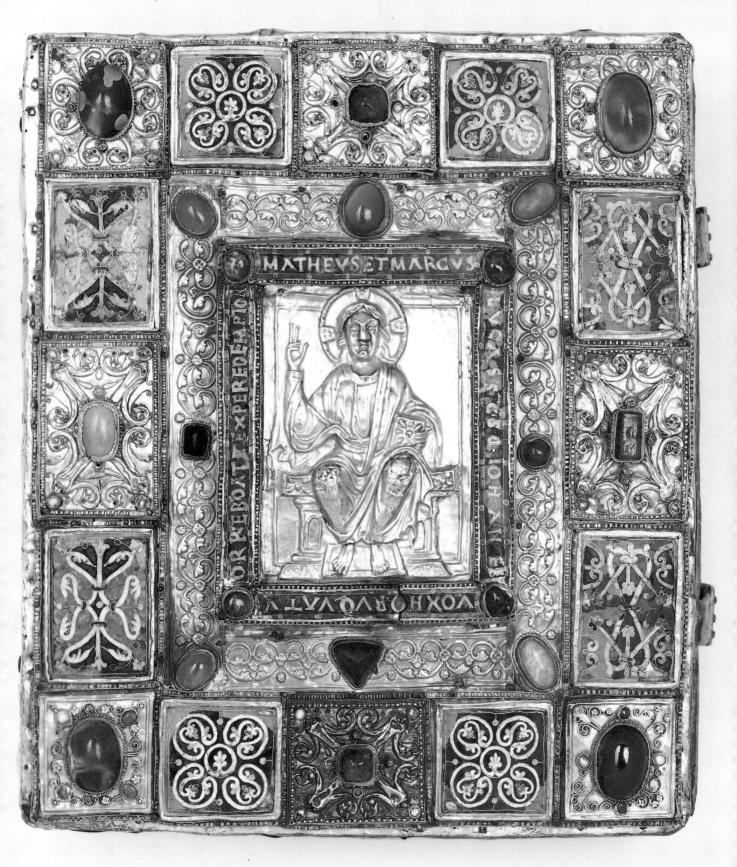

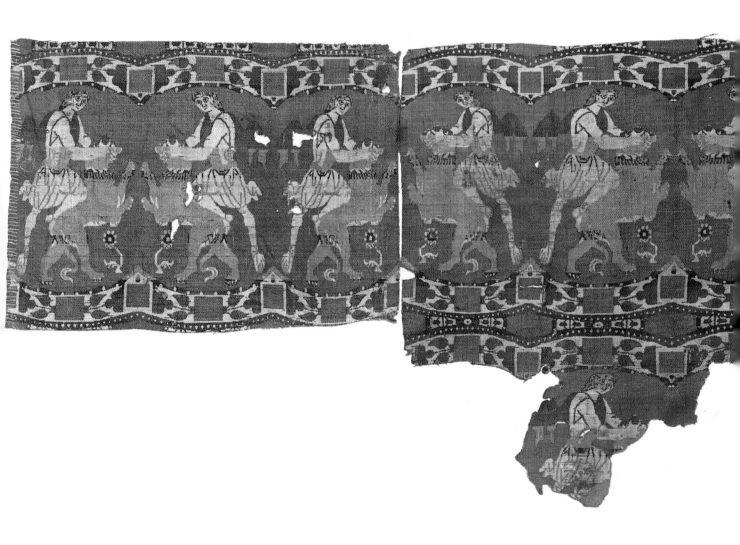

'Lion Strangler' Silk

Probably from the East Mediterranean; late eighth or ninth century
40 cm × 32 cm and 34 cm × 25.5 cm
7036-1860 and 8588-1863; From the Bock Collection; found in
the Cathedral of Chur in Switzerland.

These two fragments from the same complete textile are of silk compound twill. The scene on them represents the symbolic theme of man's victory over animals. A hero or gladiator wrestles with a lion. The group is reproduced, facing alternately to left and right, in horizontal rows. A number of so-called 'lion strangler' silks have been found in Western Europe, some of which can be firmly dated. A piece from Ottobeuren, West Germany, associated with the relics of St. Alexander, was brought from Rome in the time of Charlemagne and a silk from the Treasury at Trento in Italy is fixed inside the binding of a ninth-century manuscript: both these fragments can be attributed to the late eighth or the ninth century. Originally assigned to Alexandria and the sixth century, it is now evident that such silks are later, and were probably produced in several centres around the East Mediterranean; recently they have been attributed to Syria.

The survival of at least seven silks with similar patterns suggests that they must have been in considerable demand by the rich and powerful. The figure portrayed may be that of Samson or David, or the classical hero Hercules, who is depicted in Hellenistic-Byzantine style and wears the classical short tunic and *chlamys* or cloak over his shoulder. It is reasonable to assume that wherever this kind of silk was produced, the designers were either trained in the Byzantine tradition or strongly influenced by it. The broken circles above and below the figures suggest that the design was adapted into a freize from a series of roundels, a more familiar method of composition used in both Byzantine and Near Eastern textiles. The border pattern has been arbitrarily broken by the scalloped arrangement, so that it is incompletely shown: it represents a rose-stem with blossom and two buds. This design, which is frequently found on early medieval silks, was a stylised development of the naturalistic floral forms used in the late classical period.

As with the representation of mythological animals on silks (see the Senmurv, p 59), this type of scene also probably influenced Romanesque art, as may be seen, for instance, on a series of episodes from the life of Samson carved on a tympanum on the Collegiate Church of Nivelles in Belgium (a cast of which may be seen in the Cast Court of the V&A): the scene of Samson wrestling with the lion is very similar to the composition on the silks.

Canon Bock (1823–1899) was one of the most ubiquitous collectors of the second half of the nineteenth century. He bought or was presented with fragments of medieval silk from many of the ancient cathedrals and religious foundations, which he sold to the major public collections in Europe – the South Kensington Museum, Paris, Lyon, Vienna and Berlin: hence there are often pieces from the same silk in widely separated places.

Silk Fragment

Byzantine; eighth-ninth century
About 25 cm × 10 cm
762-1893; found in a shrine at Verdun

This fragment is from a compound twill silk which depicts a triumphant Byzantine Emperor in a *quadriga*, or four-horsed chariot, surrounded by a circle. It is one of a group of 'charioteer' silks of this period which survives. One notable piece, which is divided between the Cluny Museum in Paris and the Cathedral at Aachen is associated with the tomb of Charlemagne, who died in 814. That silk is related to another now in the Musées royaux d'Art et d'Histoire in Brussels, which was found in the Church at Musterbilsen (Limsburg) in West Germany; it is associated with the relics of St. Amour, who lived in the ninth century. Originally these silks were attributed to Constantinople and to the sixth century, but unless they were already of some age when they were placed in Western tombs an eighth or ninth-century date is more likely.

By referring to the more complete textiles of the same design, and to similar representations in other media, it is possible to reconstruct the pattern of the V&A fragment. A medallion from the late sixth or early seventh century in the Metropolitan Museum in New York has the head of the Emperor Tiberius on one side and the figure of an emperor in a *quadriga* on the other. Byzantine coins also show the same configuration. On the V&A fragment can be seen the figure of the Emperor, who has a diadem with a cross and a halo, together with parts of the horses, the reins and the chariot. The disposition of the figure is very similar to that of the charioteer in the Brussels silk, with arms raised in a victorious gesture.

A reconstruction can be seen opposite. The whole group is repeated within adjacent circles, with rosettes which can be seen at the top and bottom of the fragment, at the junction of the roundels. These suggest a diameter of approximately 41 cm.

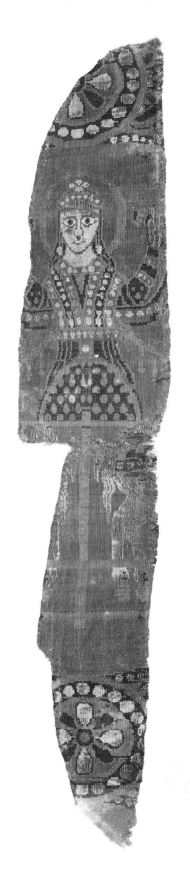

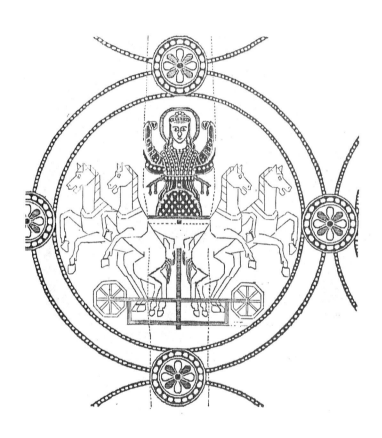

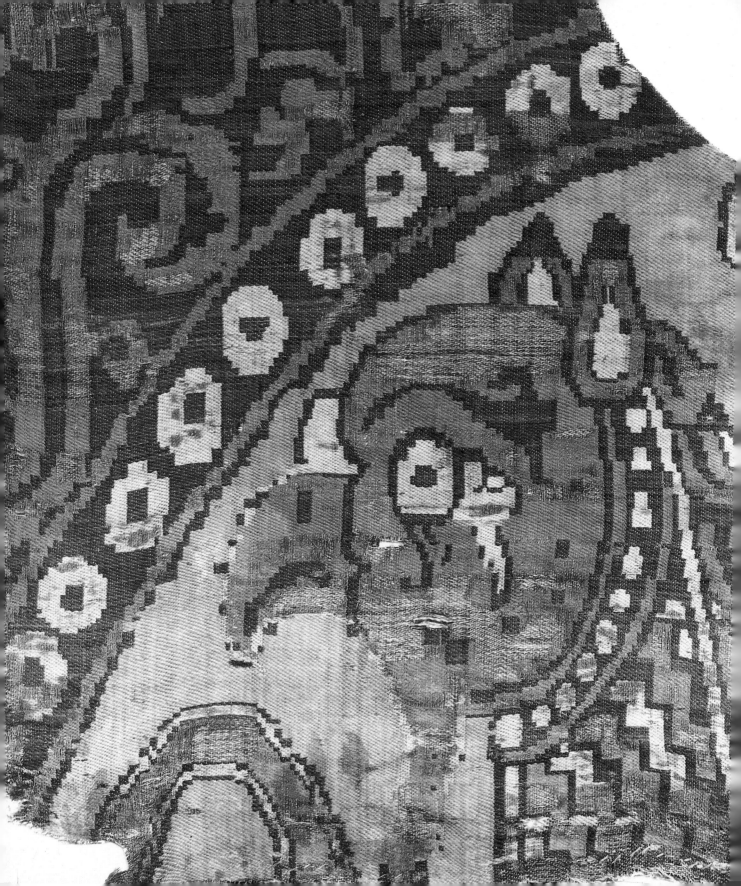

Silk Fragment
Colour plate 4

Byzantine; tenth–eleventh century
h 28 cm; w 23 cm
764-1893

On this small fragment of silk compound twill is represented part of a scene of a griffin or senmurv attacking an elephant. Unfortunately, only a small part of the elephant's trunk can be seen below and to the left of the griffin's head. Animal combat scenes, usually contained in roundels, were often used by Byzantine artists to decorate textiles and sculptures. Fierce beasts and fantastic monsters, including the griffin and senmurv, inherited from Sassanian art and earlier traditions, travelled on silks such as these to Western Europe where they had an influence on the development of the Romanesque style.

The subject represents a version of the ancient legend of Oriental origin, imported in the Book of Marco Polo, about a fabulous beast of prodigious strength which was capable of lifting an elephant: 'Tis said that in those other islands to the South . . . is found the Bird Gryphon . . . And it is so strong that it will seize an elephant in its talons and carry him high into the air'. He also told of the Indian 'garuda' that could fly away with an elephant. The griffin here has a goat's beard and a mane covering the neck and the curved tip of one wing is visible behind the head. The original design of the image may be gleaned from a brocaded silk in the Abbey of St. Waldburg at Eichstadt, West Germany (from the tomb of Count von Graisbach, who died in 1074) which also shows a griffin pouncing on an elephant, in more complete form.

A marble relief on a parapet of the gallery over one of the interior arches of St. Mark's, Venice, probably dating from the tenth or eleventh century, has a comparable scene and may have been copied from a textile. A more recent find also confirms the probable arrangement of the original design on the silk. During the restoration of Bremen Cathedral in 1973, parts of a cope were found which showed a large griffin with a beak poised above an elephant's trunk. The position of the beak in relation to the trunk is the same as on the Museum's piece; from this evidence it can be established that it must originally have consisted of a series of large repeating roundels (each containing the two animals) with each repeat being at least 61 cm across. Woven on a loom of unusual width, it may have been the work of one of the Imperial workshops, possibly even in Constantinople itself.

Detail is shown actual size

Four Byzantine Cameos
Colour plate 5

a) Virgin *Blachernitissa*
 Late twelfth century
 Bloodstone; h 4.5 cm
 A.4-1982

b) Christ blessing
 Late ninth or early tenth century
 Jasper; h 4.7 cm
 A.21-1932

c) Christ Pantocrator
 Late tenth or early eleventh century
 Bloodstone; h (including rim) 3.7 cm, w 2.7 cm
 A.160-1978

d) The Crucifixion with the Virgin and Saint John
 Late ninth or early tenth century
 Jasper; h 6.5 cm, w 6 cm
 A.77-1937

A good number of Byzantine cameos survive, made of semi-precious stones such as bloodstone, jasper and sardonyx, or occasionally lapis-lazuli or sapphire; they were probably used to adorn bookcovers, and as pendants, and rarely bear narrative scenes. A few pieces, such as (b) and the Serpentine roundel (p 90), can be dated because of inscriptions carved on them (the former referring to the Emperor Leo VI, 886–912), and most of the surviving Byzantine pieces seem to date from the tenth to twelfth century. They usually show single images of Christ or the Virgin, either full-length or in bust form, or representations of the most popular Byzantine saints or prophets – John the Baptist, St. George, St. Michael, Theodore, Demetrius, Daniel, and others.

Cameos and related portable sculptures were instrumental in carrying Byzantine style and iconography to the West; in Venice, for example, Byzantine gems were copied in glass paste as early as the twelfth century and many of the most popular Byzantine religious images were transmitted on to objects and larger monuments made in Italy and elsewhere in the West. There were many different ways of showing Christ and the Virgin in the Byzantine East, but these different types usually adhered to conventions laid down in their original model: thus the Virgin is most often shown as a *Theotokos Hodegetria* (see the ivory statuette on p 167), in the *orans* (praying) pose, or as a Virgin *Blachernitissa* (a), so-called because the original image of this type was housed in the Blachernae monastery in Constantinople.

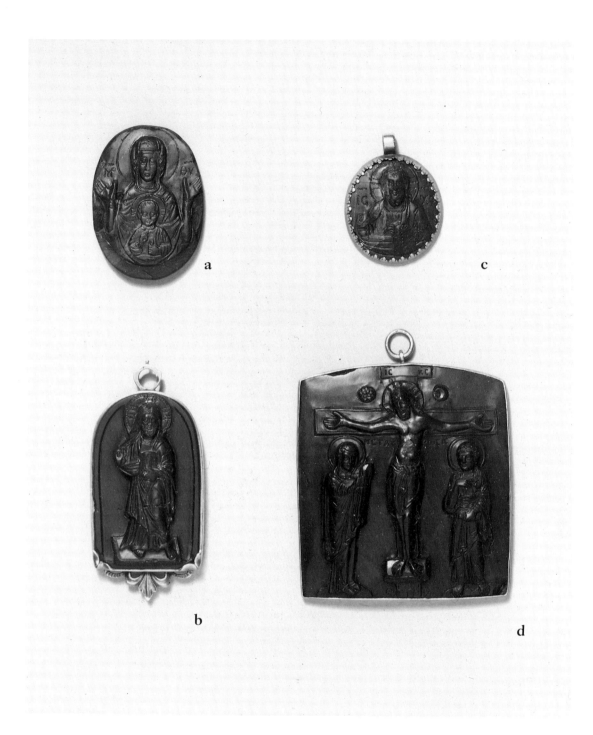

a

c

b

d

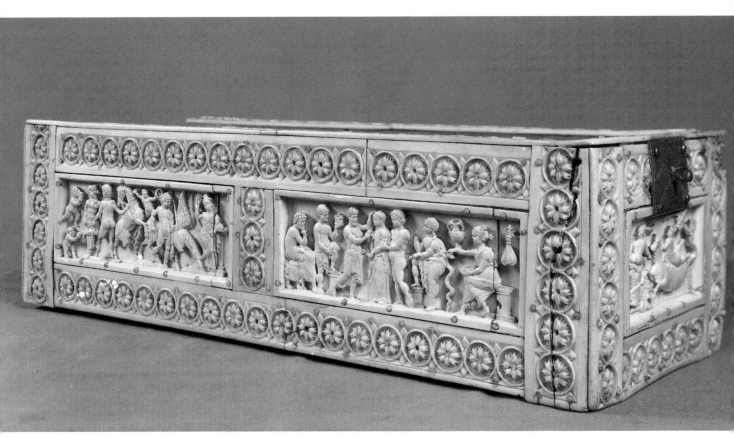

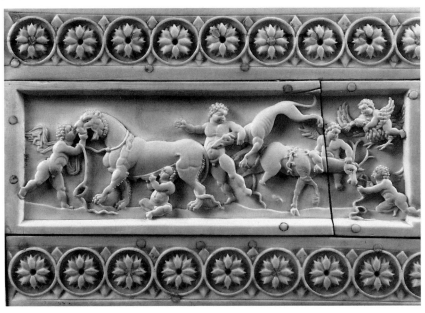

The Veroli Casket

Constantinople; tenth-eleventh century
Ivory and bone on wood; h 11.5 cm; l 40.5 cm; w 15.5 cm
216-1865

This casket, formerly in the Cathedral Treasury at Veroli (south-east of Rome), shows scenes from classical mythology. It is made of wood overlaid with ivory and bone, with traces of gilding, and has a gilded lock and handle. On the lid is the Rape of Europa with centaurs and Maenads playing and dancing to the music of Herakles who plays a lyre. On the front are scenes from the stories of Bellerophon and Iphigenia, and on the back is part of a Dionysiac procession, with two figures identified as Mars and Venus or Ares and Aphrodite. The ends bear scenes of Dionysus in a chariot drawn by panthers, and a nymph riding a seahorse. The borders on the sides are formed of rosettes in circles; on the lid the rosettes alternate with heads, and there is an inner border of acanthus ornament.

This is one of a group of works identifiable by their distinctive borders, known as 'Rosette caskets', about forty-three complete examples of which survive, and as many separate panels. Most of the caskets bear classical subjects, and the sources of the scenes may lie in illuminated manuscripts, such as copies of the plays of Euripides. A group of figures present at the Rape of Europa on the lid of the Veroli casket are copied from the stoning of Achau on the tenth-century Joshua Roll in the Vatican, or its fifth–sixth-century model. Many of the scenes on this casket reappear, with only slight variations, on other caskets in the group; a very similar representation of the Rape of Europa, for instance, can be seen on another ivory panel in the V&A collection.

It is generally agreed that these Rosette caskets were produced in Constantinople, at the end of the tenth and the beginning of the eleventh century. After the end of Iconoclasm (726–843) the classical heritage of the Empire continued to be cherished in the East, and under the Emperor Constantine VII Porphyrogenitus (913–59) there was renewed study of classical texts, continued by scholars and members of the court such as Michael Psellus in the eleventh century and Anna Comnena in the twelfth.

The casket may have belonged to a person close to the Imperial court, and was perhaps used to hold scent bottles or jewellery.

The Virgin Orans

Byzantine, between 1078 and 1081
Serpentine; 17.5 diam
A.1-1927

A bust of the Virgin in prayer (*orans*), her hands raised, palms facing outwards, in front of her breast. On the back is the rough outline of a head and the letter M. Around the edge runs an inscription in Greek invoking the help of the Virgin for the Emperor Nicephoras Botaniates (1078–81), making this one of the very few dated Byzantine works in hardstone.

The Virgin *Orans* is found more frequently with her arms raised and she often appears in this way on coins and seals; the form appears at an early date and is probably of pagan Egyptian origin.

The broad heavy style of this piece can be seen in several monumental sculptures: see for instance two marble reliefs in Berlin, showing the full-length Virgin *Orans* and the Archangel Michael, originally from the Church of the Theotokos Peribleptos in Psamatia, and a relief of the Virgin and Child found near the mosque of Sokollu Mehmet Pasha, now in the Archaeological Museum in Istanbul; the V&A roundel is very useful in helping to date such works.

The original function of the roundel is unknown: its bulk and weight make it unsuitable for use as an object of personal adornment. Formerly in the abbey of Heiligenkreuz in Austria.

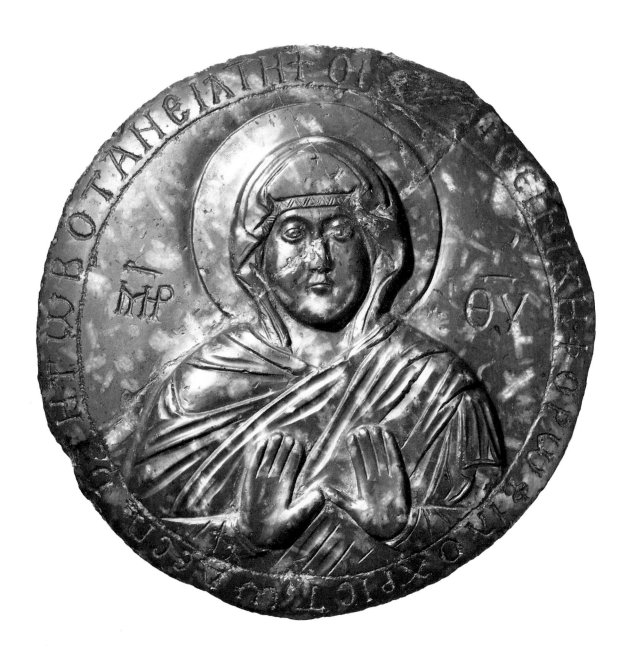

Christ Seated on a Cushioned Throne

Byzantine; second half of the eleventh century?
Ivory; h 12 cm; w 6.5 cm
273-1867

Christ's right hand is raised in benediction from within the folds of His cloak, as is seen on the Jasper cameo of the same subject (p 86). This is a standard iconographic motif seen in most representations of the Pantocrator (Christ the creator of all). The background has been cut away, probably prior to acquisition in the nineteenth century.

There are other Byzantine ivory plaques of the seated Christ, all very close to this example; one in the Bodleian Library in Oxford has also been cut away and now has a gilded background but others still have their ivory surround. The Christ was probably originally the centre of a triptych.

Byzantine ivories have been divided into several stylistic groups. These 'groups' are not so clear-cut as it once seemed and their dating is a problematic issue since few pieces give any indication as to when they were produced and it is possible that the style of the carvings remained static for long periods of time, undergoing only minimal changes even over a century. The group to which this ivory belongs is known as the 'Romanos' group, from a plaque representing the Emperor Romanos and his bride Eudokia crowned by Christ, in the Cabinet des Médailles in Paris. That plaque can be dated to either 945–9 or 1068–71 depending on whether the two figures are seen as the Emperor Romanos II and his wife Eudokia or as the later Emperor Romanos IV and Eudokia Makrembolitissa.

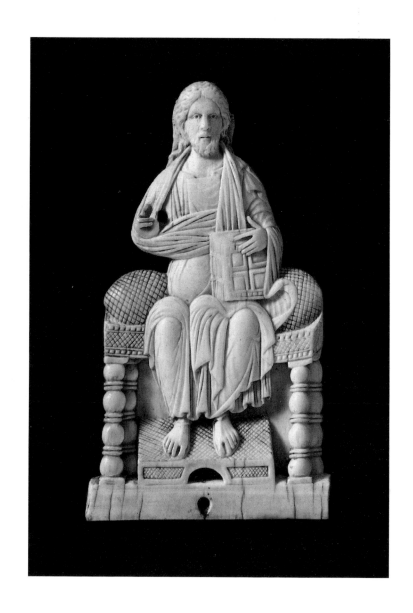

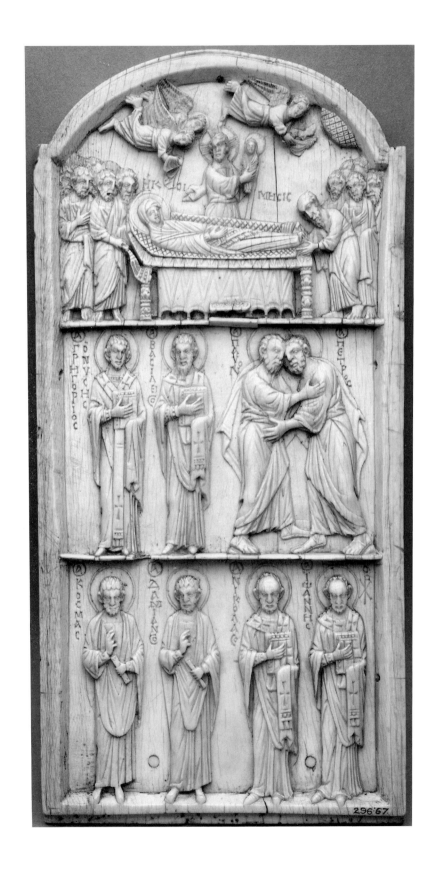

The Dormition of the Virgin, and Saints

Byzantine; late eleventh century?
Ivory; h 27 cm; w 13.5 cm
296-1867

At the top the 'Koimesis' or Death of the Virgin; the apostles stand at each end of the Virgin's bed; Christ stands behind the bed taking up her soul to Heaven. Below are eight saints: Gregory, Basil, Paul and Peter (embracing); Cosmas, Damian, Nicholas and John Chrysostom. On the back is a cross with rosettes at the ends of the arms (a cross is frequently carved on the back of Byzantine ivory panels). This plaque once formed the centre of a triptych.

Strictly speaking this scene does not show the moment of the Virgin's death but the moment at which Christ comes to take away her soul after her death. The story of the Death of the Virgin comes from the Apocryphal New Testament and appears very often in Byzantine art; its importance is reflected in the dominant place it often occupies in church decoration, on the West wall of the building. The basic format of the scene varies little over several centuries, the main differences being details such as the placing of a footstool in front of the bed, or the pose of the Virgin – she sometimes has her arms crossed on her chest. In earlier examples the Virgin's soul is borne away by an angel rather than by Christ himself.

Standing saints appear very frequently in all forms of Byzantine art; here they are arranged not according to the Calendar but according to their hierarchical order as found in the liturgy. This can be compared with two painted panels on Mount Sinai: both have three registers, the top occupied by a scene from the Life of the Virgin (her Birth and Presentation in the Temple), with two rows of saints below arranged in the liturgical order in which they are placed in church decorative schemes.

The panel belongs to the so-called 'Nicephorus' group of ivories, probably roughly contemporary with the 'Romanos' group (see Seated Christ, p 92). The iconography of the group is very similar to that of the 'Romanos' group but facial features tend to be broader and blunter, and the lines are less straight and sharp.

Reliquary Cross

Anglo-Saxon; c.1000 (except for the back and sides:
German(?), tenth century). Gold plaques on a cedar base, the figure
of Christ in walrus ivory, the titulus and medallions depicting the
symbols of the Evangelists in cloisonné enamel
h 18.5 cm; w 13.4 cm
7943-1862

A fragmentary inscription around the edge of the cross appears to list the saints' relics once contained in the cavity beneath the figure of Christ, and the cross may itself be a relic of the True Cross. All that now remains in the cavity is part of a human finger, possibly female.

The cross is a somewhat puzzling composite piece. The badly damaged back plaque depicts in *repoussé* the symbols of the Evangelists, and these must have served as models for the enamels on the front, to which they are extremely close in style and iconography. There can be no doubt that the elements of the front of the cross – ivory, enamels and gold – were made at the same time, just as there can be none that the figure of Christ is distinctively Anglo-Saxon. It bears a close resemblance to late tenth-century Anglo-Saxon manuscripts such as the Ramsey Psalter and the Sherborne Pontifical. The enamels are unique in Anglo-Saxon art of this period.

The cross is one of the rare surviving pieces which give substance to descriptions of the sumptuous church furnishings in contemporary documentary sources. It is most unlikely, because of its size and weight that it was made to be worn as a pectoral cross, and more probable that the suspension loop allowed it to hang above an altar or shrine. King Athelstan (925–39) gave a cross of gold and ivory to the shrine of St. Cuthbert at Chester-le-Street, and King Cnut (1016–35) gave the New Minster at Winchester a great gold cross containing relics.

The cross was acquired from the Soltikoff collection.

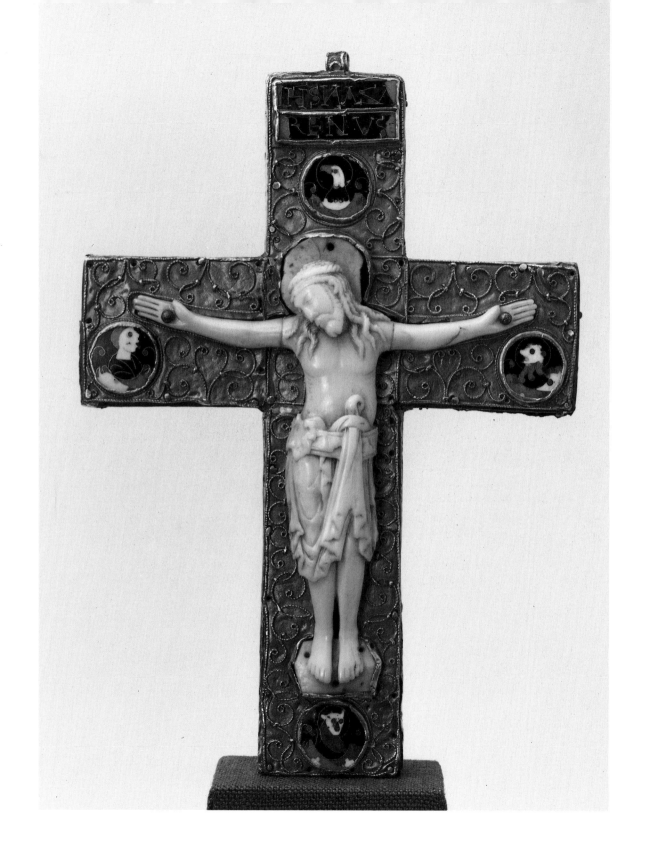

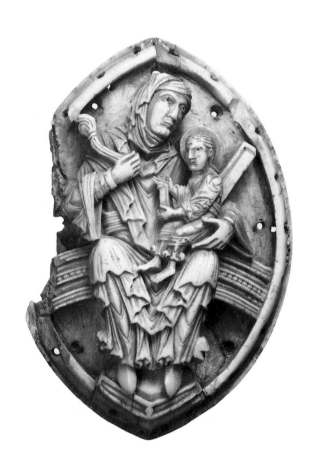

Virgin and Child

English (Anglo-Saxon); first half of the eleventh century
Walrus ivory; h 10 cm; w 6.7 cm
A.5-1935

The Virgin is shown seated on a rainbow-like arc within a mandorla. In her right hand she holds a sceptre in the form of a branch, in her left a book, and she supports the Christ Child on her lap. The many pin holes and the grooved border suggest that not only did a gold band run around the edge, but also that the background may have been gold-plated.

Another walrus ivory carving in the V&A, similarly shaped and stylistically very close, showing Christ in Majesty, has sometimes been cited as a companion piece to the Virgin and Child. The former has no provision, however, for the attachment of a gold band and ground suggesting that it was intended for a different object, although both pieces were probably produced in the same workshop. It seems unlikely that they were intended for a book cover, as the relief-carving is very deep; it is possible that they were originally attached to a portable altar or reliquary shrine.

Parallels for the lively zig-zagging draperies of both pieces can be found in English manuscripts of the first half of the eleventh century. This 'Winchester style', ultimately derived from the Carolingian Utrecht Psalter, is first seen in England in the Benedictional of St Aethelwold, produced c.980 at Winchester, and had spread to other major centres by the early eleventh century. The drapery of these pieces, however, especially the figure of Christ, is somewhat calmer than in earlier manifestations of the style.

The Four Evangelists

German (lower Rhine), middle–second half of the eleventh century
Ivory; h 9 cm, w 5.5 cm (each)
220-220c-1865

The four evangelists are each shown seated writing at a lectern, flanked by pinnacle towers. Above, their respective emblems emerge from the clouds: Matthew has an angel, Mark a lion, Luke an ox, and John has an eagle. There are traces of paint and gilding, which may however be of later date.

These four plaques probably decorated a bookcover. Very similar examples exist with the same disposition of the basic elements, and a set in the Walters Art Gallery, Baltimore, is still attached to a silver and filigree bookcover on a copy of the Gospels dating from before 1062.

The head of St. Matthew's angel is a type seen on an eleventh-century portable altar in Melk. This is one of a group of related portable altars, and it may be dated by an inscription on it to the third quarter of the eleventh century, which seems to be the most likely date for the evangelist plaques.

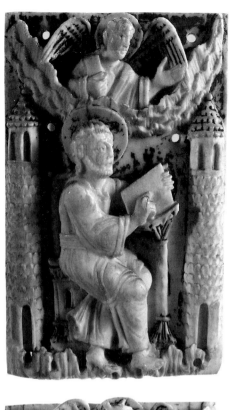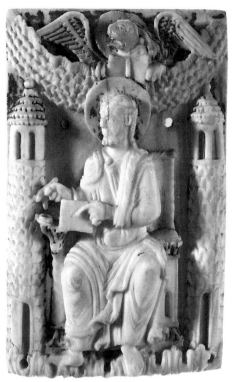
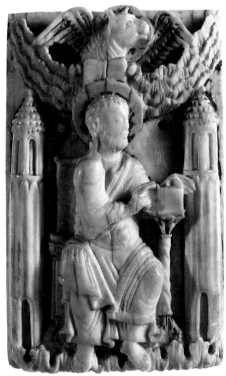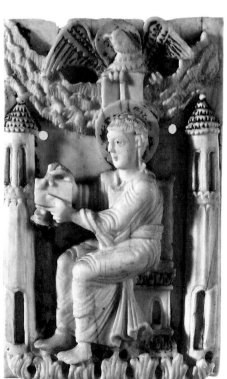

Panel with Scenes from the Life of Christ

Lower Rhine (Cologne?); second half of the eleventh century
Ivory; h 22 cm; w 13.5 cm
379-1871

The scenes are, from the top left: Joseph's Dream, the Flight into Egypt, the Massacre of the Innocents, Rachel(?) weeping for her dead child, Christ brought into the Temple by his parents, Christ among the Doctors, the Miracle at Cana, and an extension of the last scene, the wine brought to the Master of the Feast. This plaque is unique in its rich borders, which relate more to illuminated manuscripts than to contemporary sculpture, in its detailed architectural settings, and in the depth and intricacy of the carving. The virtuosity of the artist's work is a tour-de-force unmatched in any other surviving medieval ivory.

The selection of scenes forms no logical programme in itself, and might have formed part of a large cycle, perhaps for an antependium. The detail is so fine that it could not be seen at any great distance, yet the depth of carving and lack of major damage to the plaque suggest that it was not used as a bookcover.

The ivory shows certain iconographic peculiarities, such as the two scenes for the Marriage at Cana, and a scene which has been interpreted as Rachel mourning for her dead child. In the Bible, Matthew follows the Adoration of the Magi with the Flight into Egypt, after Herod's threat to massacre all the children of up to two years of age, and recalls the prophet Jeremiah's words describing Rachel weeping for her dead children, which to him represents a prophecy fulfilled in the Massacre of the Innocents.

The Massacre of the Innocents itself has been compared to mid ninth-century Metz works in its iconography, but a Cologne origin seems most likely not only because of a parallel for Rachel weeping on the mid eleventh-century wooden doors of Sta Maria im Kapitol in Cologne, and the use of scalloped haloes which becomes widespread in Cologne by the twelfth century, but also because of stylistic similarities with ivories known to have been produced in the Cologne area. These similarities tend to be limited to head types and a general resemblance in the drapery, as none of the other ivories can compare with the technical brilliance of this work.

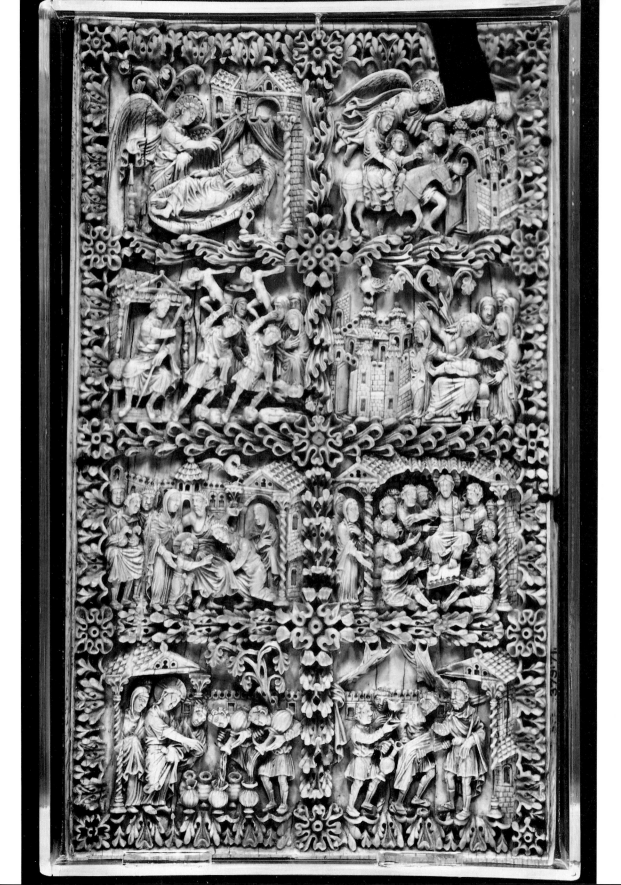

St. Peter Dictating the Gospel to St. Mark

South Italian?; late eleventh century
Ivory; h 13.5 cm; w 10 cm
270-1867

The Greek inscription reads 'POLIS ROMA', the lost upper part of the plaque probably once bearing a representation of the city of Rome. The angel behind the two saints has been interpreted as a personification of the genius of Rome.

This and another piece in the V&A showing part of the Marriage at Cana come from a series of fourteen plaques with scenes from the New Testament and the Life of St. Mark which have been grouped together and connected with the so-called 'Grado chair', an episcopal throne associated with St. Mark and given to the Cathedral at Grado by the Emperor Heraclius (610–41); thus they were believed to have been produced in Alexandria, c.600. The evidence for the existence of this ivory throne is, however, ambiguous and even contradictory, and the plaques do not resemble other works known to have been produced in the sixth century.

Thus, although the ivories are still known as the 'Grado' group they have also been attributed to late eleventh-century Southern Italy, on the grounds of their relationship with the Salerno ivories (see Joseph's Dream, p 107), probably made just before the consecration of Salerno Cathedral in 1084. Despite the clear connection between such scenes as the Marriage of Cana and the Raising of Lazarus in both groups of ivories, there are also differences between them, and it is more likely that a common iconographic source was available to both sets of artists, than the 'Grado' ivories served as a model for the Salerno group.

However, one of the drawbacks to an eleventh-century Italian provenance for the ivories is their high quality, far above any works known to have been produced in Southern Italy then. It is possible that they may have been produced in Venice (especially in view of that city's connection with St. Mark and its links with the East), but there is little evidence of ivory production there at this time.

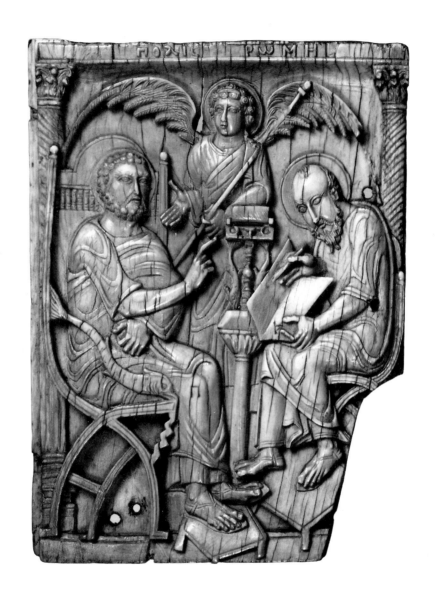

Joseph's Dream

South Italian (Salerno/Amalfi); second half of the eleventh century
Ivory; h 16.5 cm; w 12 cm
701-1884

This plaque probably shows Joseph's second dream, in which the angel warns him to flee from Bethlehem and the wrath of Herod (in the first dream an angel reassures Joseph as to the cause of Mary's pregnancy).

Ten other plaques, in a closely related style, with New Testament scenes may be grouped with this plaque; a panel showing the Presentation in the temple is also in the V&A collection. This series relates in style and iconography to the so-called Salerno ivories although the compositions are much simplified. The Salerno ivories are a group of plaques with both Old and New Testament scenes, previously thought to have come from a paliotto or altar frontal, but which may once have decorated the doors on a chancel screen in the Cathedral at Salerno, consecrated in 1084. Such complex cycles are usually seen only in church mural decoration of the sort seen in the late eleventh-century frescoes in Sant' Angelo in Formis, near Capua.

The second half of the eleventh century in Southern Italy was dominated by Abbot Desiderius, who was instrumental in the establishment of peace within the Church, in encouraging trade with the East, and who was responsible for a considerable artistic revival. We know from Leo of Ostia's chronicle that Byzantine artists were called to Montecassino in the years before the dedication of the new church in 1071, and that they instructed Desiderius's craftsmen – carving in ivory is specifically mentioned: the Salerno ivories and the later related group of which this plaque is a member show close links with Byzantine works.

The Gloucester Candlestick
Colour plate 6

English; early twelfth century
Gilt, base metal; h 51 cm
7649-1861

First modelled in wax, then cast in three sections by the *cire-perdue* process, this candlestick is an eloquent witness to the technical skill of the craftsman in the early years of the twelfth century. Its composition is unique: it contains copper, zinc, tin, lead, nickel, iron, antimony, arsenic and silver (between 6% and 24%).

Of the three inscriptions on the candlestick the most important is the one on the stem, above and below the central knop, referring to its donation:

+ ABBATIS.PETRI.GREGIS/ET :DEVOTIO.MITIS/
+ ME :DEDIT :ECCLESIE :/SCI :PETRI :GLOECESTRE :

(The devotion of abbot Peter and his gentle flock gave me to the church of St. Peter at Gloucester).

Peter became Abbot of the Benedictine monastery of St. Peter, Gloucester, in 1104 and died in 1113.

There is no piece of metalwork of this date with which the candlestick can be compared. Fantastic compositions of men, monsters and foliage were characteristic of the period all over northern Europe, but it has been suggested, on stylistic grounds, that the candlestick might have been made in Canterbury. It is possible that the candlestick was subsequently looted from the church when it was destroyed by fire in 1122; a medieval inscription inside the grease-pan states that it was presented by one Thomas de Poché (perhaps not long after that date) to the Cathedral of Le Mans, where it remained until the French Revolution. It reappears in the possession of an antiquary at Le Mans, who sold it to Prince Soltikoff, on the dispersal of whose collection in 1861 it was acquired by the Museum.

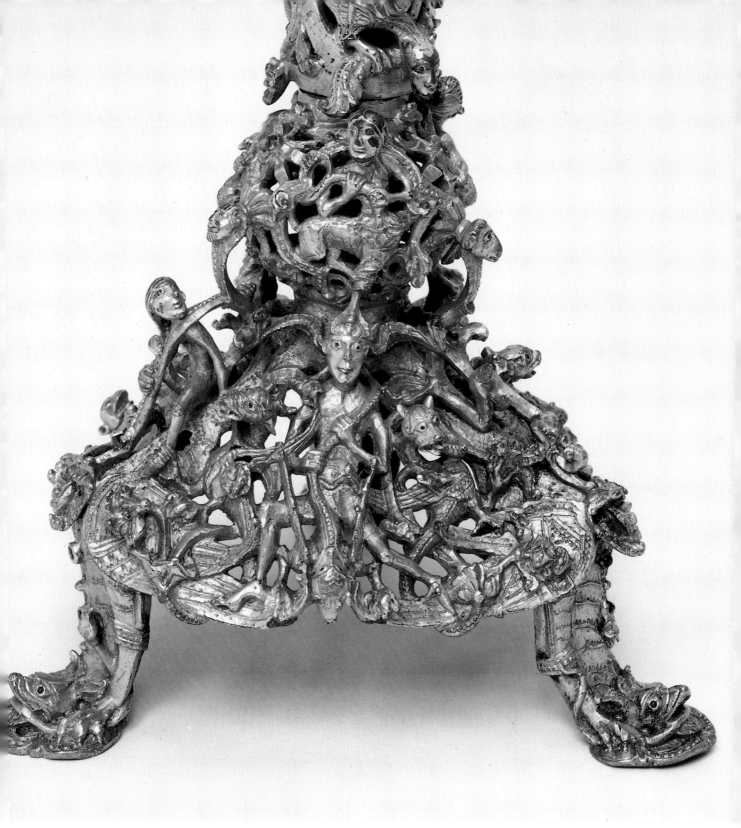

Detail

Liturgical Comb

St. Albans?; c.1120
Ivory; h 8.5 cm; w 11.5 cm
A.27-1977

On one side of the comb are the Nativity, the Flight into Egypt, the Washing of the Feet of the Disciples, the Crucifixion and the Entombment. On the other side are the Massacre of the Innocents, the Adoration of the Magi, the Dream of the Magi (the Magi sleeping in an upright position as a result of the shape of the comb), and the Annunciation to the Shepherds. The eye-shaped ends of the comb show a continuation of the Annunciation to the Shepherds, and the soldiers on watch at Christ's tomb.

This comb, unlike the ninth-century example (p 72), has its teeth on the long sides, a form which became more common in the twelfth century. The decoration is unusually extensive, not being confined to the central area, but filling all the available space. The crowded compositions with rather stiff figures, mainly seen in profile, are related to the illustrations of the St. Albans Psalter, executed c.1120–30 at St. Albans Abbey, although the figures are less elongated than those in the manuscript, and they stand more firmly on the ground.

Comparable in size, style, iconography, and even in composition, although clearly the work of another hand, is an ivory comb in the Musée de la Princerie, Verdun. The figures on the London comb are more rounded, with a greater sense of depth, and greater variety in the treatment of draperies, and while the Verdun comb has only Passion scenes the London example also shows Christ's Infancy. Certain elements of the scenes common to both, however, are the same, or simply reversed on the Verdun comb. The scenes on both works may ultimately, although not necessarily directly, derive from the same cycle, but it has been suggested that the drier, more regular carving of the Verdun comb could indicate a continental origin.

An oval ivory box in the V&A, showing a pair of centaurs and two men mounted on lions, and dated c.1130, also relates to St. Albans work as do several other ivories. The stylistic and iconographic relationship of the ivories and manuscripts illustrates well the close connection between works produced in different media during the medieval period. As an example of this it may be noted that the Bury St. Edmunds chronicle records the existence of one Magister Hugo, who not only worked on the great Bury Bible, now in the library of Corpus Christi College in Cambridge, but who was also skilled as a sculptor and metalworker.

Four Backgammon Pieces or Tablemen

a) Samson and Delilah
 St. Albans?; second quarter of the twelth century
 Walrus ivory; diameter 7 cm
 A.3-1931

b) Hercules grasping a snake
 Cologne; second half of the twelfth century
 Walrus ivory; diameter 7.5 cm
 A.3-1933

c) Man and woman playing backgammon
 Northern France; second quarter of the twelfth century
 Walrus ivory; diameter 6 cm
 375-1871

d) Hercules and the Hydra?
 Cologne; c.1140–50
 Elephant ivory; diameter 6.6 cm
 374-1871

These pieces are usually referred to as draughtsmen, but it now seems that they may in fact be backgammon pieces or 'tablemen'. The only medieval gamesboard to survive is for backgammon, and was found recently during excavations in Gloucester with a complete set of thirty pieces. Backgammon appears to have been a favourite game amongst the nobility and game sets were taken on the Crusades. Interest in the game may even have been stimulated at this period because of the contact with the East where it was very popular.

Pre-Romanesque game pieces are often decorated with simple incised patterns of circles, but over 200 figurative Romanesque ivory tablemen survive, showing a range of images from zodiac signs to biblical scenes, even with representations of people playing backgammon itself (see c). All of these date from c.1050–1200, the most elaborate being produced from the second quarter of the twelfth century on. The figurative pieces are nearly all carved in deep sunk relief with a high border so that they can be stacked without damage.

a) Samson lies horizontally, while a Philistine hands a pair of shears to Delilah for her to cut off his hair. This is one of the few ivories which shows evidence of red staining. There are three pieces executed in a very similar style, also with scenes from the history of Samson, in New York, Florence and Paris; this piece is slightly larger and may come from a similar set produced in the same workshop. The figure style relates to St. Albans/Bury St. Edmunds ivories of the second quarter of the twelfth century.

b) is unusually large with a bold motif in high relief. The subject may be Hercules fighting a snake; certainly the man is of Herculean proportions.

c) is by the Master of the St. Martin's group, so-called after three related pieces which show scenes from the Life of St. Martin (two are in the Ashmolean Museum in Oxford). The figure style can be paralleled in northern French works of the second quarter of the twelfth century.

d) is unusual in that it is made of elephant ivory. The subject cannot be identified with any certainty but mythological subjects do appear on game pieces and it is possible that the scene represents Hercules and the Hydra.

Portable Altar

German (Hildesheim): c.1130
Porphyry, mounted in wood, covered with copper,
engraved and partly gilt, embellished with *vernis
brun*; l 38.5 cm; w 22.9 cm
10-1873

The top shows scenes from the life of Christ: the Nativity, the Crucifixion, the three Maries at the Sepulchre, the Ascension and Christ in Majesty. Amongst the saints represented the most notable is Bishop Godehard of Hildesheim, who appears without a halo, which must indicate that the altar was made before his canonisation in 1132, and for a church closely connected with him – perhaps the Cathedral in Hildesheim.

The base of the altar shows the Trinity, with saints: St. Boniface with crozier, St. Pancras with martyr's palm, St. Peter with key, St. Paul and, at the bottom, St. Simplicius and St. Faustinus. The inscriptions allude to the numerous saints' relics within the altar.

The Mass is always celebrated on a consecrated altar, whether fixed or portable, which very often, in the medieval period, enclosed a relic or relics.

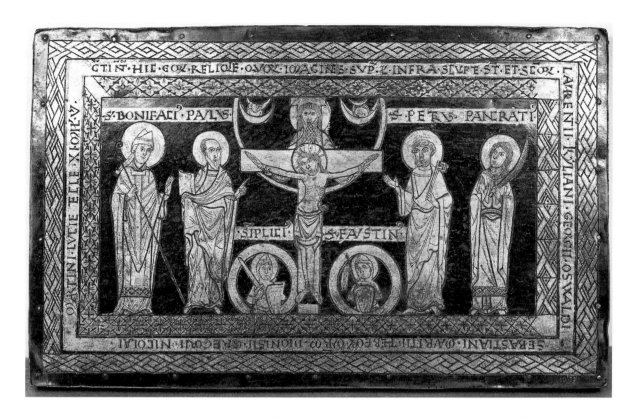

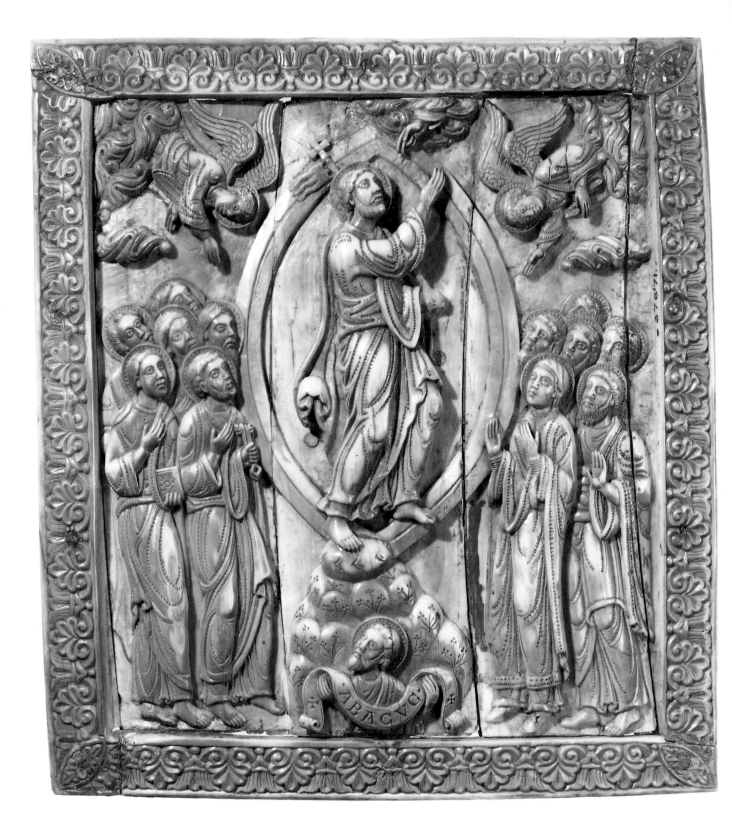

ABACVC

116

The Ascension

German (Cologne); second quarter of the twelfth century
Walrus ivory; h 21.5 cm; w 19.5 cm
378-1871

Christ ascends in a mandorla towards the hand of God held out to him from the clouds. In His left hand He holds the Banner of the Resurrection, and He is attended by the Virgin and eleven apostles. Below the rock, representing the Mount of Olives, on which Christ stands, is a half length figure of the prophet Habakkuk, who holds a scroll with his name inscribed upon it. The plaque is made up of seven pieces of walrus ivory, joined together to form an approximate square. The carved surface shows signs that it was once stained purple.

The Ascension represents Christ's final leave-taking after His many appearances to his followers. Little is made of it in the Gospels but Luke, in the Acts of the Apostles, tells us that it took place on Mount Olivet and that Christ was taken up into a cloud while two men in white robes (angels) appeared to explain the event to the disciples, as can be seen here. The Ascension is of importance not just as part of the Passion and Resurrection cycle of events, but also because the departure of Christ's physical presence marks the inauguration of a new, spiritual, more profound and rewarding presence. Habakkuk's appearance can be explained by his prophecy of the descent of God into the world to destroy sin and redeem the faithful through his mercy.

Two other plaques in the V&A, showing the Nativity and the Adoration of the Magi, as well as two in the Metropolitan Museum in New York, showing the three Maries at the Sepulchre and Doubting Thomas, all belong with this panel.

One of the main features of the style is the use of rows of dots to emphasize curved lines, which has given the group its name: 'gestichelte' or 'pricked'. Another series of plaques, slightly smaller, less well preserved, and with a slightly less imaginative expression of form, but stylistically and iconographically almost exactly the same as the larger series, is now divided between Cologne, Berlin and the V&A (a second Ascension). The main differences between the two Ascension plaques are in the reversed pose of Habakkuk and the scroll he holds, which says 'ELEVATUS EST SOL' in the smaller example. The size and number of plaques in each series suggests that they probably once formed a large altar frontal or decorated a pulpit.

Other works showing the same 'gestichelte' style confirm the Cologne provenance suggested by the expressionless oval faces shown in three-quarter profile and the softly rounded forms, which can be seen in romanesque sculpture in the Cologne area.

Panel of Stained and Painted Glass
Colour plate 7

French (Abbey of St. Denis); c.1140–44
78.8 cm × 17.5 cm
c.2-1983; Given by Mrs Charles S. Bird

The consecration of the new choir of the great Abbey of St. Denis near Paris took place on 11th June, 1144. It was built under the direction of Abbot Suger and both its architecture and its lavish use of stained glass were to have a considerable influence on the subsequent development of the Gothic style. This panel of glass originally formed a part of the elaborate border surrounding a series of narrative panels devoted to the Infancy of Christ. The window remained *in situ* at St. Denis, more or less in its original condition, until the late eighteenth century when it was recorded in Charles Percier's drawings. At the Revolution the cathedral churches passed into the jurisdiction of the State. Most of the St. Denis glass was taken out under the direction of Alexandre Lenoir and some was put on display in the Musée des Monuments Français. During the 1840s much of the St. Denis glass was returned to the Abbey and restorations were carried on by Henri and Alfred Gérente, supervised by the architect Viollet-le Duc. With each change of location parts of the St. Denis glass found their way into private hands. The detailed history of this border fragment is not known but it seems to have reached America, in company with a group of other quite unrelated pieces of medieval French glass, in the late nineteenth of early twentieth century. These were made up into a window and inserted into an out-house of a mansion in New England, whose owner gave the glass to the Museum.

Detail

Leaf from a Psalter
Colour plate 8

Canterbury, Christ Church(?); c.1140
Watercolour with egg or gum binding medium on vellum; 40 × 30 cm
816-1894 (MS.661)

Recto (colour plate):

1 Christ before Annas; Peter's first denial
2 The officer strikes Christ; Peter's second denial
3 Christ led before Caiaphas; Peter's third denial
4 Christ in the Hall of Judgement
5 The Mocking; the Flagellation
6 The Crown of Thorns
7 Christ carrying the Cross; Simon of Cyrene takes the Cross from Him
8 The crosses erected; Christ and the thieves on the crosses
9 Longinus pierces Christ's side while two men break the thieves' legs; the Earthquake
10 Crucifixion with Mary and John
11 Joseph begs Pilate for the body
12 The Deposition

Verso:

13 Three Jews ask Pilate for a guard; soldiers cast dice for the tunic
14 The swathing of the Body; the Entombment
15 Three Maries at the tomb; Peter and John at the tomb
16 Mary Magdalen at the tomb; Noli me tangere
17 Journey to Emmaus (two scenes)
18 Supper at Emmaus; Christ rises to leave
19 Christ appears to the Disciples
20 Incredulity of Thomas; Thomas prostrate
21 Christ appearing to the Disciples on the shore of Tiberias; Christ eats bread and fish with the Disciples (John 21, 1–14)
22 The Disciples touch Christ's arm; they give Him the fish and the honeycomb (Luke 24, 36–44)
23 The Ascension
24 Pentecost

This is one of the four surviving leaves, painted on both sides (the others are in the British Library and in the Pierpont Morgan Library, New York) which, between them, contain by far the largest series of New Testament illustration in England or anywhere else in the twelfth century. Only a few of the Old Testament scenes survive, but the Gospels are illustrated with about 150 scenes, each very small and simplified but clearly related to the miniatures in two other manuscripts, the St. Albans Psalter and the New Testament in Pembroke College, Cambridge. All three were probably derived from a common model similar to the eleventh-century German cycles from Echternach, which also contain several of the rare illustrations to the Parables and the Miracles. However, the four leaves contain a greater proportion of scenes than any of the Echternach manuscripts – and it is conceivable that they echo early Christian cycles of the kind contained in the sixth-seventh-century Gospels in Corpus Christi College, Cambridge. In any case, on the evidence available it is highly improbable that these scenes were invented for this particular manuscript.

The same series of illustrations, also arranged in small compartments, appears in a late twelfth-century Psalter from Canterbury, and hence it may be assumed that these leaves also originally prefaced a Canterbury Psalter. Containing a calendar and prayers as well as the Psalms, the Psalter was the central prayer book of the period for monks, clergy and laity alike. It was in England that the practice grew up of prefacing the Psalter text with Bible illustrations. What is unique about these leaves at this period is the profusion of tiny scenes giving the effect of a twelfth-century comic strip. A close look reveals that the two halves of the recto (colour plate) are by different artists. The upper half is cruder, characterised by profiles of the St. Albans Psalter type; the lower half is in a more sophisticated style linked in details, such as the treatment of curly hair and beards, with the great Bible at Lambeth Palace.

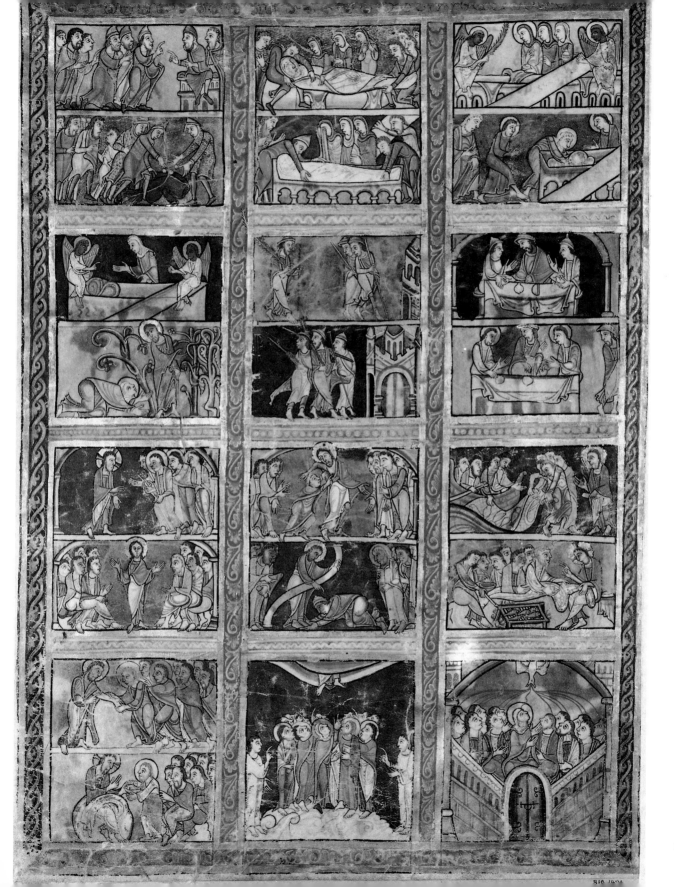

Virgin and Child

English (Shaftesbury/Dorchester?); second quarter
of the twelfth century
Walrus ivory; h 13.5 cm; w 6.4 cm
A.25-1933

The Virgin holds the Christ Child on her lap. In His left hand Christ holds a scroll, while His right is raised in blessing. An ivory figure of a magus in the Dorset County Museum clearly belongs with this piece, being very close in size and style: they are also rare survivals with the feature of staining (a handbook by the monk Theophilus, probably produced at the beginning of the twelfth century, describes how ivory is immersed in a solution of madder in order to stain it red, but few other examples survive of ivories that have been so treated). The holes pierced in the eyes would have been filled with jet or glass beads.

The figures once formed part of an Adoration of the Magi group, and Christ would thus have been blessing the approaching magi. The ivories were probably attached to a separate background, possibly of a contrasting material such as gilt copper, and the whole was possibly intended for a shrine or small reredos.

The unusual position of the Child, his knees across the Virgin's right wrist, is known in only one other Western example, the mid twelfth-century stone relief in York Minster, while the Virgin's throne with its twisted columns and pineapple knobs is paralleled in a late twelfth-century lead font at Walton-on-the-Hill in Surrey. However, the poses and proportions of the figures are also matched in the Shaftesbury Psalter of c.1130–40, and a Shaftesbury provenance seems likely, especially as the Dorchester magus was found at Milborne St. Andrew, only twenty miles from Shaftesbury.

The manuscript and the carvings show very similar long faces and especially close is the mouth, with the accentuated roundness of the lower lip and chin, and the large eyes. But the fine parallel folds of the ivory are not seen in the manuscript and the images in the latter are stiffer and more hieratic.

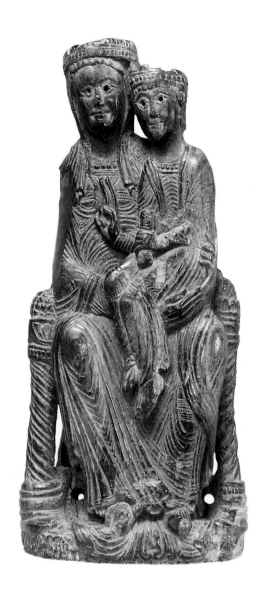

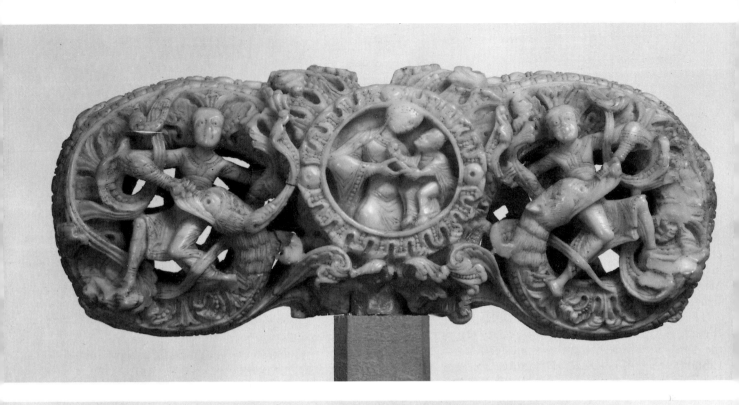

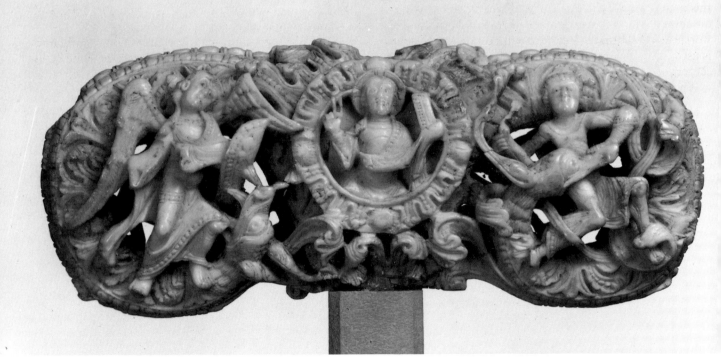

Head of a Tau-Cross

English (Winchester); c.1140–50
Walrus ivory; h 5.5 cm; w 16.5 cm
371-1871

This piece originally formed the upper terminal of an ecclesiastical staff. On one side is the Virgin and Child in a central medallion between two men struggling with serpents, whose bodies form the volutes of the cross. On the other side the central medallion is occupied by Christ blessing, holding a book in His left hand. To the left St. Michael subdues the dragon, and to the right another man struggles with a serpent.

The fleshy, luxuriant foliage is very close to that found in Winchester manuscripts of the mid-twelfth century, as on the Tree of Jesse leaf in the Winchester Psalter (British Library). The figure style relates to earlier work in the Winchester Bible (Winchester Cathedral) and the biting beasts also find parallels in the work of one of the artists of this manuscript. Classical bead and reel ornament is seen on several other ivories attributed to Southern English workshops of the first half of the twelfth century, and here it is used, in a very unclassical manner, along the spine of the serpents. This reinforces the attribution to Winchester.

The tau-cross form was used for pastoral staffs in England both before and after the Norman conquest. In the Old Testament (Ezekiel 9, 4) the mark of the tau is a symbol of righteousness, and thus it is particularly suitable for marking high ecclesiastical office. A French twelfth-century tau-cross head in the V&A shows, on its underside, two ecclesiastics, one holding a single volute pastoral staff (shaped like the St. Nicholas crozier, p 141), the other holding a tau-cross staff. Both of these forms existed together for some time, but around the beginning of the thirteenth century the single volute form becomes more usual. Two other tau-cross fragments, one in the British Museum and another found a few years ago during excavations at Battle Abbey, very close to each other in design and execution, show foliage that is related to that on the present example, but are of less complex form and would seem to be of the early twelfth century.

The skilful carving and intricacy of this ivory indicates, with the St. Nicholas crozier, how high was the standard of English carving in the mid-twelfth century, although sadly only a small proportion of works has survived.

The Adoration of the Magi

Spanish; first half of the twelfth century
Whalebone; h 36.5 cm; w (at base) 16 cm
142-1866

The three magi approach from the left bearing egg-cup shaped vessels containing their gifts of gold, frankincense and myrrh, with the star which guided them above their heads. The relief is dominated by the Virgin and Child who are represented on a disproportionately large scale. The Virgin holds a lily in her right hand, and Christ, holding a book in His left hand, blesses the approaching magi. The scene is set into an architectural framework distorted to follow the tapering of the whalebone, with an owl and a small figure (once blowing a horn) on top of the roof.

The artist's love of decoration can be seen in the elaborately pleated drapery edged with geometric designs; even the area around the Virgin's feet is filled by foliate scrolls and a small tree (according to Rabanus Maurus, both the palm tree and the vine are symbols of the Church, as is the Virgin). Altogether this is one of the strangest surviving representations of the Adoration of the Magi.

Despite suggestions of an English or Flemish provenance for this ivory, it is now clear that it must be of Spanish origin, as parallels can be drawn with Spanish works both in ivory and in monumental sculpture. The narrow pleated linen cap worn by the Virgin, for example, is seen only in Spanish art. A whalebone plaque of the Virgin and Child in the Louvre, while of inferior workmanship, would seem to have been produced by a related workshop, and can be related to Spanish works such as ivory reliefs on an eleventh-century casket in the Monastery of San Isidoro in Leon. The cloister reliefs of Santo Domingo de Silos also include a parallel for the figure blowing a horn on top of the building and closest of all iconographically is a tympanum on the twelfth-century church of Sta. Maria at Uncastillo: there is a similar disposition of elements, and the details are the same, even down to the capitals of the arch.

The precise function of the plaque has not been ascertained. It is too bulky for a bookcover, and its irregular shape would make it unsuitable for most purposes; it was perhaps a portable votive image.

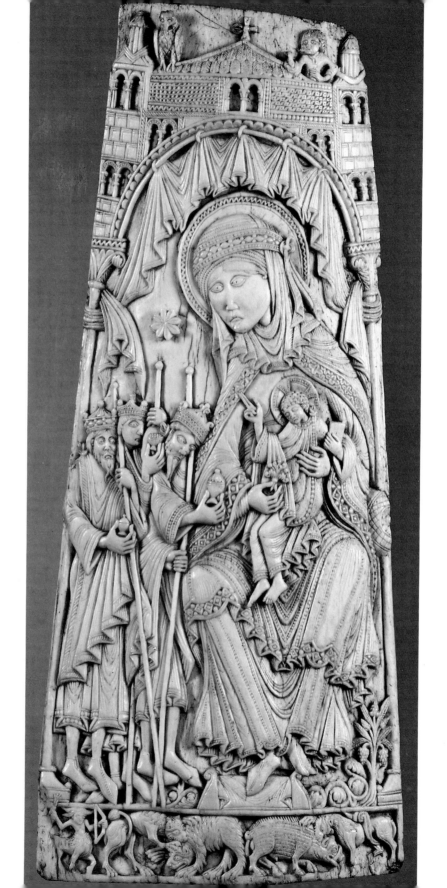

127

The Masters Plaque

English; c.1150–60
Copper-gilt with champlevé enamel; h 13.8 cm; w 8.9 cm
M.209-1925

The scene depicts the Last Judgement. Christ hovers with two angels above a scene showing the torments of Hell. In the folds of Christ's mantle four human heads probably represent the souls of the Blessed. Below, the Damned are driven by devils into the cauldron of Hell, with the mouth of Hell represented as a flaming head (bottom left).

The iconography is unique for a Last Judgement, and appears to conflate representations of the Ascension with those of the Harrowing of Hell. The marvellous animation of the drawing style compares closely with the miniatures in the Winchester Psalter of c.1150. The use of enamel is, however, unsophisticated and suggests a craftsman new to the possibilities of the technique.

The plaque probably formed part of a series, but its original function and setting are unknown. It is inscribed on the back: 'Given to Thomas Kerrich by Robert Masters, DD, Aug, 23rd 1796'. It was inherited by its last owner from Albert Hartshone, FSA, grandson of Kerrich.

The Balfour and Warwick Ciboria

English; 1150–75
Champlevé enamel and copper gilt;
A(M.1-1981): h 18.3 cm; d 16.5 cm B(M.159-1919): h 12 cm; d 20 cm

A ciborium is larger than a pyx and holds the consecrated wafers for distribution to those taking communion.

A The Balfour ciborium is in a remarkably good state of preservation. It depicts complementary scenes from the Old Testament (the bowl) and the New (the cover) on the theme of the Redemption, a subject appropriate for a eucharistic container. The scenes are as follows:

BOWL	COVER
1 The Circumcision of Isaac	1a The Baptism of Christ
2 Isaac carrying the logs	2a Christ carrying the Cross
3 The Sacrifice of Isaac by Abraham	3a Crucifixion
4 Samson and the harlot of Gaza	4a Holy Women at the Sepulchre
5 David slaying the bear	5a The Harrowing of Hell
6 Elijah's Ascension	6a Christ's Ascension

Formerly owned by Lord Balfour of Burleigh, whose ancestor, Sir James Balfour of Pittendreich, is supposed to have been given the ciborium by Mary Queen of Scots.

Detail: The Sacrifice
of Isaac by Abraham

B The Warwick Ciborium. Only fragments of enamel remain as a result of damage caused by the fire of 1871 at Warwick Castle. The ciborium's present appearance, however, demonstrates the surface preparation, normally invisible, necessary before the enamel was applied. The cover has long been missing, but the scenes on the bowl suggest what the cover might have depicted, as follows:

BOWL	COVER
1 Moses and the Burning Bush	1b The Nativity?
2 Sacrifice of Cain and Abel	2b The Presentation?
3 The Circumcision of Isaac	3b The Baptism of Christ?
4 Isaac carrying the logs	4b Christ carrying the Cross?
5 The Sacrifice of Isaac by Abraham	5b The Crucifixion?
6 Jonah and the whale	6b Holy Women at the Sepulchre?

Despite the difference in their condition, the similarities between the two ciboria are striking. In fact, three scenes are shared by both (Isaac's circumcision, Isaac and the logs, Isaac's Sacrifice). The first two of these are iconographically very rare, but appeared in twelfth-century wall-paintings in the Worcester cathedral chapter-house, and in the choir of Peterborough cathedral. Further evidence for an English origin for the ciboria lies in the similarity of their unusually elaborate floral scrolls to those on certain English sculptures, and in English manuscripts. Another ciborium, the central member of the group, is preserved in the Pierpont Morgan Library, New York. It shares scenes with both the other ciboria, but is stylistically closest to the Balfour ciborium. Without doubt both of these were made by the same craftsman, while the Warwick craftsman, whose style is sparer, may have been another member of the workshop.

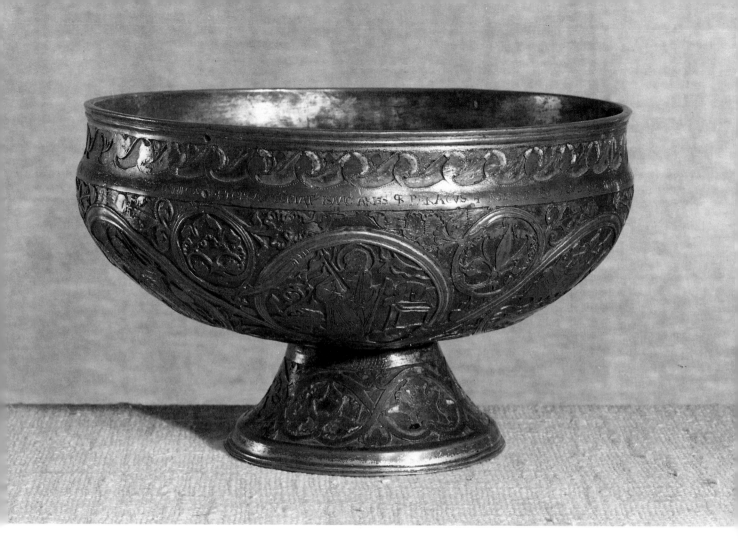

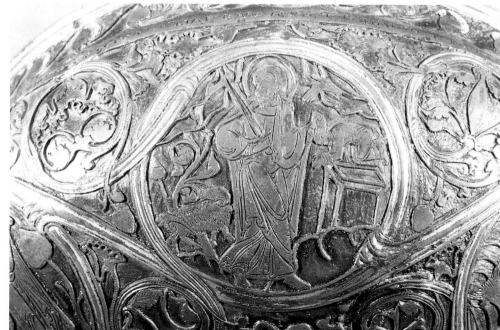

Detail: The Sacrifice
of Isaac by Abraham

133

The Alton Towers Triptych

Rhenish (Cologne); c.1150, the wooden base and many of the metal
mounts on it probably nineteenth-century. Copper gilt with
champlevé enamel, bordered by strips of copper gilt, partly decorated
with *vernis brun* (brown varnish), set on a wooden base
h 36.2 cm; w 47.6 cm
4757-1858.

The theme of the Redemption is here illustrated by scenes from the New
Testament on the central panel, which are paralleled on the wings by scenes
from the Old Testament considered to prefigure them. The Crucifixion is
thus placed between the Sacrifice of Isaac by Abraham (Genesis 22, 9), and
Moses and the brazen serpent (Numbers 21, 9); the Holy Women at the
Sepulchre between Jonah and the whale (Jonah 1, 17) and Elisha raising a
dead man (II Kings 12, 21); the Harrowing of Hell between the catching of
Leviathan (Job 41, 1) and Samson carrying the gates of Gaza (Judges 16, 3).

The origin of the triptych is disputed. The style of the enamel, with
figures entirely engraved and gilt against an enamelled background, and the
cool range of colours used have some resemblance to the work of goldsmiths
working in and around Cologne in the Rhineland (hence the term Rhenish),
in particular in the style of Eilbertus of Cologne, the maker of a portable altar
now in the Kunstgewerbemuseum, Berlin. However, the typological icon-
ography and the division of the composition into complex geometrical areas
is more characteristic of Mosan illumination. As an altarpiece the triptych
is an oddity also. It is remarkably small – far smaller than contemporary
altarpieces such as those in the National Museum in Copenhagen, or that
in the Musée de Cluny, originally from the abbey of Stavelot.

It is far closer in size as well as shape to a number of reliquary-triptychs of
the period, notably that from Ste. Croix in Liège and the Stavelot triptych
now in the Pierpont Morgan Library, New York. It has been suggested that
the present frame, and many of its metal fittings, may date from the
nineteenth century, and it seems not unlikely that the original frame may
have incorporated a relic or relics, so that the triptych functioned originally
as a reliquary.

Acquired from the collection of the Earl of Shrewsbury of Alton Towers,
Staffordshire, in 1858.

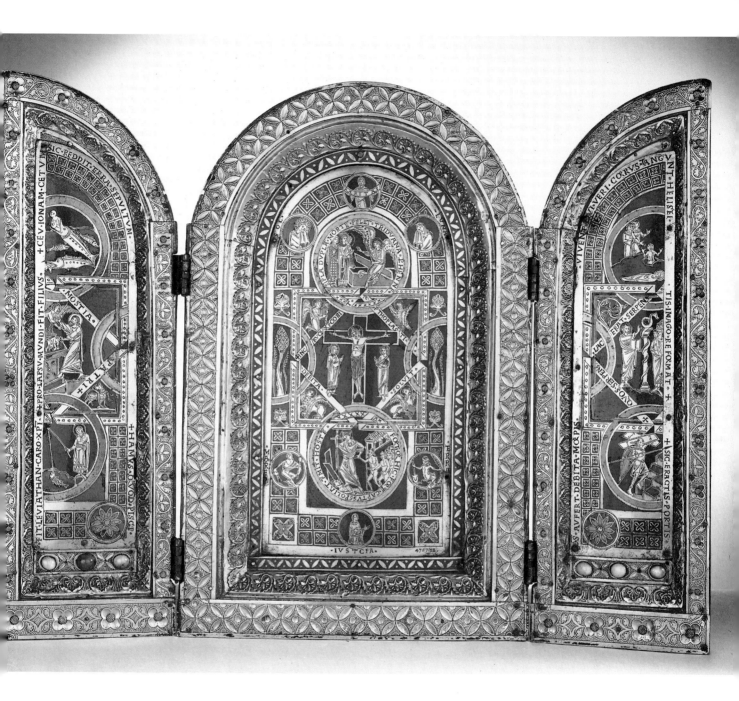

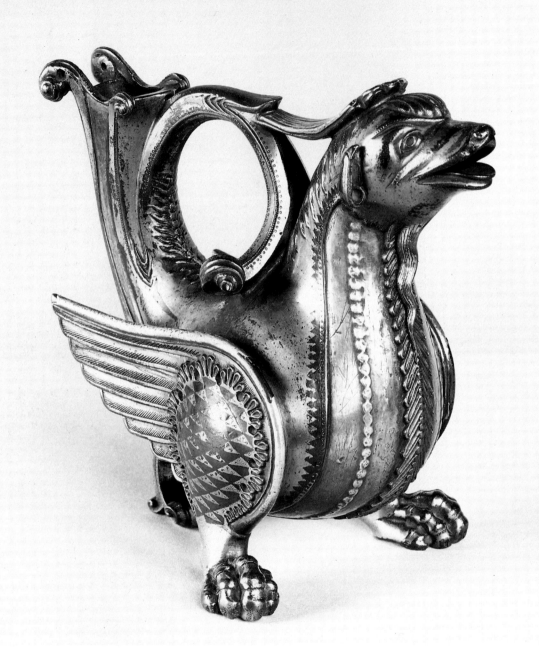

Griffin Ewer
Colour plate 9

Mosan (or German); c.1150
Gilt bronze, cast and chased, decorated with silver and niello
h 18.3 cm
1471-1870

The fabulous beast known as a griffin – which the ewer most resembles –
combined the attributes of an eagle and a lion. Ewers, often known as
aquamanilia (from the latin *aqua* – water – and *manus* – hand) were used both
in the home and in church, during the Mass, for the ceremony of the ritual
washing of the celebrant's hands. Ewers often took the shape of real or
fantastic creatures – horses and unicorns were popular – and were frequently
made of gold or silver, as well as of ceramic or base metal. They were filled
through the opening at the top, the mouth acting as the spout. A companion
to this ewer, in the shape of a dragon, is in the Kunsthistorisches Museum,
Vienna.

Both these ewers clearly owe their form to eastern representations of
'senmurvs', very similar creatures to griffins: images of these beasts are seen
on many Sassanian and Byzantine silks which were imported into the North-
West of Europe (see pp 59 and 85).

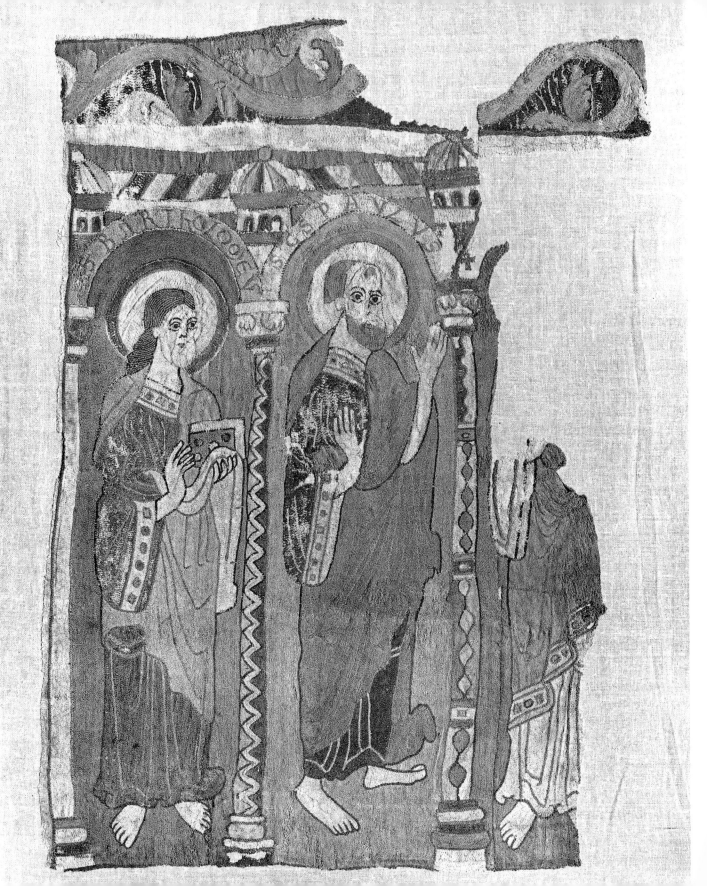

Fragment from a Wall Hanging or Altar Dossal

Lower Saxony; 1150–60
Linen ground entirely covered with silk embroidery
in chain stitch; 82.5 × 59 cm
8713-1863; From the collection of Dr Franz Bock

St. Bartholomew, St. Paul and the incomplete figure of a third apostle stand within a Romanesque arcade bearing their names and topped with small turreted buildings. Above is a border containing foliate scrolls.

The figure of St. John from the same panel is in the Cluny Museum, Paris, and a fifth, incomplete figure is in the Österreichisches Museum für angewandte Kunst, Vienna. Two further fragments in the Museum's collection and two in Vienna may also be from the same hanging. They include part of the figure of Christ in Majesty (1252-1864, Room 101), and the original composition of the panel may have been similar to that of a complete German painted altar dossal of c.1170–80 (now in the Westfalisches Landesmuseum, Münster), in which the figure of Christ in Majesty is flanked by two male and two female saints within Romanesque arches topped by buildings. The figures of the apostles are also related stylistically and technically to a much larger fragment of another wall hanging decorated with scenes from the New Testament, which is now in the Kunstgewerbemuseum, Berlin: this has been dated to 1160–70 by comparison with illuminated manuscripts and architectural features of the Halberstadt region and, by the same comparison, the Museum's fragments have been dated slightly earlier. The Museum's pieces, and those in Paris and Vienna, were acquired by Dr Bock from the Convent of Huysburg, near Halberstadt.

The St. Nicholas Crozier
Colour plate 10

English (Winchester?); c.1150–70
Elephant ivory; h 12 cm; w 11 cm
218-1865

The crozier shows three scenes relating to Christ: at the end of the volute are, on one side, the Nativity with Christ cradled in a tendril which springs from the stem of the crozier, and on the other side an angel supporting the Lamb of God (the *Agnus Dei*), now lacking its head. The Annunciation to the Shepherds fills one side of the shaft of the crozier, with the angel, marked by the inscription 'ANGELUS', flying down above the star to the three shepherds and their numerous animals. The remaining scenes are from the Life of St. Nicholas: beside the Annunciation to the Shepherds is the Birth of St. Nicholas, and above that is the infant Saint's abstinence from his mother's milk on fast days. The outer curve of the crozier head is filled by the representation of the Saint giving money to the impoverished nobleman of Myra for his three dowerless daughters, to prevent their being sold into prostitution. St. Nicholas was a popular saint in the West after the translation of his body to Bari in 1087, and this piece was probably made for the head of an institution dedicated to him, or for an abbot or bishop of the same name. The closest stylistic comparisons can be drawn with the unfinished illuminations by the so-called 'Master of the Apocrypha Drawings' in the Winchester Bible (Winchester Cathedral Library), dating from around the 1150s.

The crozier is unusual in having little solely decorative ornament, filling almost the entire area with narrative scenes. The skilful and original way in which they are arranged on the somewhat awkwardly shaped object, with the Virgin and the angel of the Agnus Dei sliding from the top of the volute or St. Nicholas's father pushing his way out of the body of the crozier, also makes this piece stand out from most other surviving works as the product of an outstandingly inventive creative genius.

Leaf from a Bible, Psalter or Model Book
Colour plate 11

Liège; c.1160
Watercolour, with egg or gum binding medium and
gold leaf on vellum; 22.9 × 15.9 cm
8982 (MS 413)

The front (colour plate) shows the Sacrifice of Cain and Abel and the Killing of Abel (Genesis, 4); on the reverse is Melchisedek blessing Abraham and the capture of Lot. Another fragment from the same manuscript is in Liège University (Wittert Coll.) and there are ten further leaves from a very similar manuscript in the Berlin-Dahlem Print Room.

These two leaves embody the medieval custom of interpreting the Old Testament as a prefiguration of the New. Each major New Testament subject was seen as having several forerunners or 'types' in the Old Testament, and in the twelfth century these were illustrated in often elaborate picture cycles. Both of these scenes are important for their typological significance, and it is probably because of it that they were chosen for illustration. Cain and Abel sacrificing are symbols of Synagogue and Church, while Melchisedek giving Abraham bread and wine was universally accepted as prefiguring the Eucharist. Both scenes appear in identical form and typological context on contemporary enamelled crosses produced in the region of Liège, and it may be that these leaves once formed part of a model book used by Mosan goldsmiths.

In style, also, these miniatures, with their characteristic square-jawed figures, are close to manuscripts from that area, such as the Floreffe Bible in the British Library (MS Add. 17737-8), as well as to the region's enamels.

The Eltenberg Reliquary

Rhenish (Cologne); about 1180 AD
Copper and bronze gilt, with champlevé enamel and
walrus ivory carvings, on a wooden foundation
h 54.5 cm; l 51 cm; w 51 cm
7650-1861

Around the dome are seated Christ and eleven apostles, with, below, sixteen figures of prophets who hold inscribed scrolls. Four ivory plaques depict the Virgin and Child with St. Joseph, the Journey of the Magi, the Crucifixion and the Holy Women at the Sepulchre; the first two of these are nineteenth-century replacements, copied from the reliquary now in the Kunstgewerbe-museum, Berlin (originally in Brunswick Cathedral). The latter reliquary once enclosed the head of St. Gregory Nazianzus, and it is probable that the Eltenberg reliquary likewise contained a substantial relic.

This reliquary illustrates how astoundingly proficient the Rhenish goldsmiths of the twelfth century were in achieving rich effects without the lavish use of costly materials. The enamel-work is remarkable for its splendour of colour and the richness and beauty of its ornament. The designs include a variety of floral, geometrical, imbricated and twisted patterns but the dominant motif is a superb floral scroll. Some details are carried out in cloisonné enamel.

Reliquaries could take a multitude of forms, their shape very often indicating the nature of the saint's relic within. Head reliquaries were most often an attempt at a life-like model of a head, frequently in gold or silver and enamel.

At the time of the French Revolution, this reliquary was in the Benedictine nunnery at Eltenberg (Hoch Elten) on the German/Dutch border. On the suppression of the nunnery in the early nineteenth century, the last canoness hid the reliquary in the chimney of her house. Thereafter it passed to several owners, including the dealer Jacob Cohen of Anhalt and Prince Florentin of Salm-Salm, whose restorer, F. Schultz of Anhalt, repaired it; it was probably again repaired on behalf of the dealer Schmitz of Cologne. It belonged finally to Prince Soltikoff, from whom the Museum bought it in 1861.

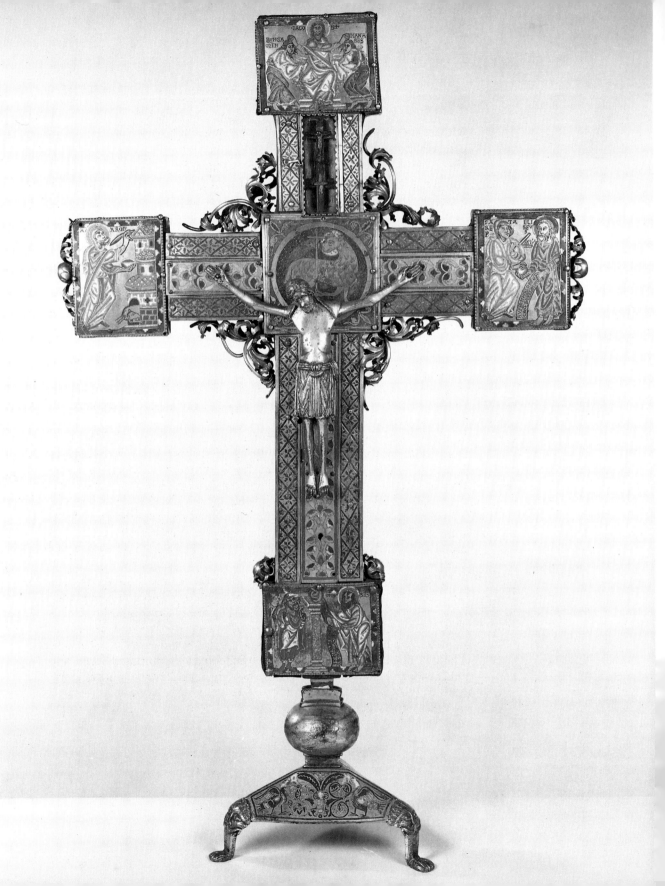

Altar Cross

Mosan and North German; twelfth century, with
fifteenth-century additions.
Champlevé enamel with details in cloisonné on
copper-gilt, mounted on a wooden base
h 66.1 cm; w 41.9 cm
7234-1860

At the extremities are four Old Testament types of the Redemption of
Christ: Aaron marking a house with the blood of the Passover (Exodus 12, 7),
Jacob blessing the sons of Joseph (Genesis 48), Elijah and the widow Sarepta
(I Kings 17, 8–16) and Moses and the Brazen Serpent (Numbers 21, 9 and
St. John 3, 14): these are typical examples of Mosan work of the second half
of the twelfth century.

The central plaques back and front, showing Christ in Majesty and the
Lamb of God, the figure of Christ and the cross-foot are in a very different
style, probably North German (Lower Saxony), but similar in date to the
Mosan plaques. The copper gilt leaves and flowers on the arms of the cross
are of the fifteenth century.

The cross was possibly assembled in the fifteenth century. The
iconography of the Mosan plaques is close to that of a cross in the British
Museum, which shows in addition the Return of the Spies from the
Promised Land (Numbers 13, 25). This scene may originally have taken the
place of the present Lamb of God plaque on this cross. Rubrics in early
missals indicate that a cross should be placed on the altar at the time of the
Mass to remind the participants of the sacrifice being celebrated, and during
much of the Middle Ages it was not the custom to leave the cross on the altar
at other times.

Mosan enamels were produced in the area Abbot Suger called Lorraine –
this included the ecclesiastical and metalworking centres of Liège and
Maastricht on the Meuse (Mosan – from the Meuse valley). Mosan
enamellers seem to have flourished over the comparatively short period
1140–80, producing work for such great abbeys of the region as Stavelot.
The style of enamelling is one ultimately indebted to Byzantine cloisonné on
gold, copper being used instead, perhaps because it was cheaper, more
readily available, and more robust. The copper was engraved and the
background gilt, while the figures were enamelled in a wide and subtle range
of colours.

Figure Personifying the Sea

Mosan; c.1175–90
Gilt bronze, cast and chased; h 9 cm
630-1864

This allegorical figure is inscribed MARE (Sea) and originally held either an urn or a fish as a symbolic attribute. It almost certainly formed part of a set of the Four Elements (Earth, Air, Fire and Water) probably designed to support the base of a shrine, candlestick or reliquary. Four figures of approximately the same date, also personifying the elements, survive in the Bayerisches Nationalmuseum in Munich. The renowned St. Omer cross-base – thought to be a miniature version of the great cross designed by Suger for St. Denis – though resting on a base supported by figures of the four Evangelists, is decorated at the top with busts representing the four elements. The finely executed vigorous naturalism of the figure here compares closely with the modelling of the figures on the St. Omer candlestick.

Mitre

English; 1160–1220
Silk twill woven with a lozenge pattern, lined with coarse linen and embroidered with silver-gilt thread (membrane on a silk core) in underside couching and feather stitch. Decorative bands of red silk compound twill; 22.9 × 27.9 cm plus lappets

Lent by gracious permission of His Eminence the Cardinal Archbishop of Westminster.

The foliate scrolls form roundels which originally enclosed jewels or metal ornaments and stitch marks on the plain red bands indicate the similar use there of applied decorations. There are also stitch marks indicating that the gold scroll work was once outlined with coloured silk embroidery. The woven silk between the back and front panels is powdered with embroidered gold spots, a common decorative device of the period. One lappet, with matching gold scroll work is original. It was trimmed with tassels of red silk and silver-gilt thread, of which only fragments remain. The second lappet, of silk damask embroidered with a human figure, probably an apostle, comes from a near-contemporary mitre in Sens Cathedral. Five other thirteenth-century mitres have been recorded.

The Westminster mitre is the earliest example of *Opus Anglicanum* in the Museum and one of the earliest to have survived, although it is clear from records and from the superb tenth-century stole and maniple of St. Cuthbert preserved at Durham Cathedral that English embroidery was fully developed and internationally renowned before the Norman conquest. Unlike the Durham pieces, in which the gold thread is surface couched, that on the mitre is underside couched. This technique, by which tiny loops of the surface gold thread were pulled through to the back of the ground fabric and held there by a linen thread, was to be a hall-mark of *Opus Anglicanum* during its greatest period. Not only did it produce a gold surface uninterrupted by less lustrous threads but it left the textile completely flexible, an important quality for the full and flowing vestments of the medieval period. The combination of woven silks and metal threads from Italy with English embroidery, in a mitre which belonged originally to a French bishop, is indicative of the complex international trade that produced the rich vestments worn throughout Europe by the princes of the Church.

The Westminster mitre was presented to Monsignor (later Cardinal) Wiseman by Monsignor de Cosnac, Archbishop of Sens, in 1842. It was then said to have belonged to St. Thomas of Canterbury and to have been preserved at Sens with other relics of the saint. However, it did not figure in the 1446 and 1464 inventories of the relics, although it would seem to be one of the three mitres recorded in the cathedral in 1536 ('Troys petites myttres ou il n'y a nulle pierre') and described in recognisable detail in the seventeenth century.

The Temptation of Christ by the Devil
Colour plate 12

French (Cathedral of Saint-Pierre of Troyes); c.1170–80
Two panels of stained and painted glass; 47 cm × 43.8 cm and
46.3 cm × 42.5 cm
C.107 and C.108-1919; Given by J. P. Morgan

In 1188 a fire destroyed the eleventh-century church of Bishop Milon and the present Cathedral of Troyes was built in about 1200. These two panels are in a style showing that they were probably originally in the earlier building and were reused in the new Cathedral. They must have come from a small window in one of the ambulatory chapels devoted solely to the Temptations to which Christ was submitted by the Devil. After the Baptism Christ went into the wilderness where he fasted: one of the panels shows the first temptation when the Devil came to Christ and said 'If thou be the Son of God command that these stones be made bread'. The other panel shows the second temptation when the Devil carried Christ up on to a high pinnacle of the Temple in Jerusalem and said 'If thou be the Son of God, cast thyself down: for it is written He shall give his angels charge concerning thee: and in their hands they shall bear thee up, lest at any time thou dash thy foot against a stone' (Matthew, Chapter 4, Verses 1 to 6).

There are two other surviving panels in the same temptation series: one, now in a private collection in Montreal, showing Christ seated upon the Temple with the Devil tempting him to throw himself down; the other, in the Musée de Cluny in Paris, shows Christ ministered unto by angels after the third temptation. The V&A also possesses two other stained glass panels of the same date from Troyes Cathedral, a scene from the legend of St. Nicholas, which formed part of a window illustrating that Saint's Life (C.106-1919), and another with Christ feeding the Five Thousand (C.105-1919). These are illustrated opposite.

All the twelfth-century glass at Troyes which survived the renovation work of 1849 and 1866 was subsequently dispersed. The two panels in the Museum were given by the American J. P. Morgan in 1919 after the First World War as a demonstration of his belief in Anglo-American friendship.

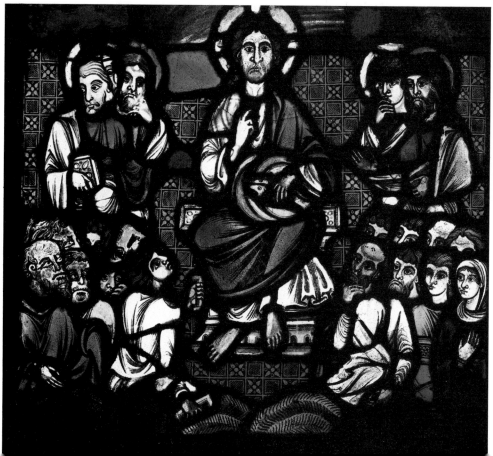

153

Panel of Stained and Painted Glass
Colour plate 13

English (Canterbury Cathedral); c.1180–1200
80.5 cm × 45 cm
C.2-1958; Given by Mr John Hunt

This irregular-shaped panel of glass filled with *rinceau* ornament of a winding stem encircling a palmette once formed part of the background in a window otherwise fitted with large roundels painted with narrative scenes. The unusual outline exactly fits an armature of iron bars still in position in the Trinity Chapel ambulatory of Canterbury Cathedral. Other fragments from this window still in the Cathedral are in the south choir aisle at triforium level, in the Trinity chapel clerestory and in the south-west transept. The only intact roundel is in the Fogg Museum, Cambridge, Massachusetts, and shows an unidentified scene from the life of Thomas Becket. 'The Fogg Medallion Master', as he has been called, appears to have been at work in the late twelfth and early years of the thirteenth century. It is not known how this window came to be dispersed but it seems to have happened before 1800. The donor acquired it from the collection of Mr Philip Nelson.

Detail

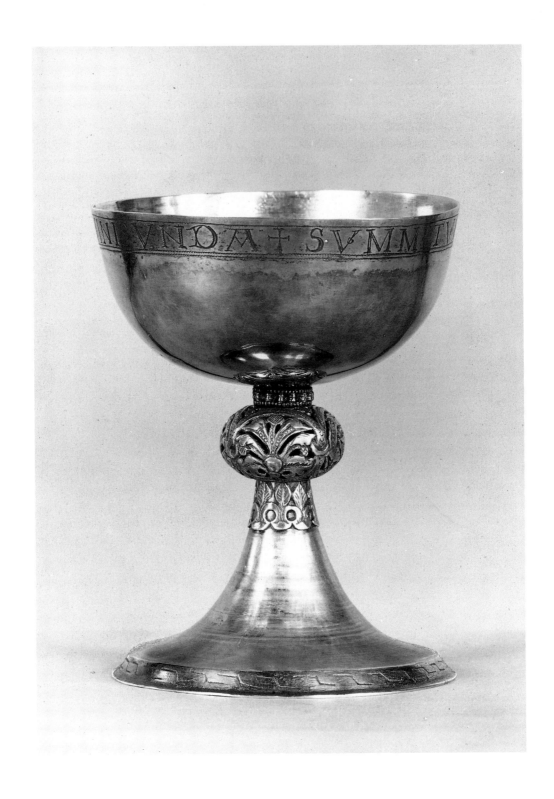

Icelandic Chalice

Icelandic; thirteenth century
Silver parcel-gilt; h 12.4 cm
639-1902

The Holy Communion or Eucharist is that part of the Mass at which the people participate in the sacrifice of Christ by partaking of His body and blood in the consecrated bread and wine. The custom of communicating in two kinds, that is, receiving both bread and wine, was followed in the Roman Catholic Church until the wine was gradually withdrawn from the laity in the thirteenth century. This chalice illustrates the basic elements of the vessel which developed over the centuries: the bowl, stem, knop and base. The companion piece to the chalice is the paten (which has not survived), a round, concave plate on which the eucharistic bread is offered and consecrated.

From the earliest times the Scandinavians were noted for their metal-working skills, so that it was only natural that a vigorous school of ecclesiastical goldsmiths' work should spring up after their belated conversion to Christianity. The chalice shows to what good purpose Scandinavian goldsmiths could put their knowledge of Romanesque forms and decoration by the beginning of the thirteenth century. Around its lip a Latin verse, in well-proportioned letters, but not quite correctly transcribed, tells that 'From hence is drunk the pure flow of the Divine Blood', (SUMMITVR HINC NVNDA DIVINI SANGVINIS VNDA). The knop, which is cast hollow, is skilfully chased and pierced with foliage.

The chalice is said to have come from Grund, a village in northern Iceland only a few miles from Holar, once the seat of the cathedral for that region of Iceland, and it is possible that it once belonged to the cathedral. It is difficult to decide whether it was actually made in Iceland, but it is worth noting that the National Museum in Copenhagen possesses a similar but slightly smaller chalice from Svalbard, also in northern Iceland. The chalice belongs to the finest period of Icelandic culture, the age of Snorri Sturluson (1178–1241) – the great scholar, poet and historian – a time when Icelanders were in frequent touch with the rest of Europe, especially Scandinavia and England. The chalice was bought in Copenhagen in 1902.

Detail

Leaf from a Gospel Book: St. Mark
Colour plate 14

Constantinople; second half of the twelfth century
Watercolour with egg or gum binding medium, and
gold leaf on vellum; 31 × 21 cm
8980 E (MS 1420)

Following Byzantine custom, St. Mark is shown as a young man and is identified by an inscription in Greek above his head. He is writing on a scroll and a book is lying on a lectern fixed to his desk with an adjustable screw.

Classical Roman texts had often been prefaced by a portrait of the author and following in this tradition portraits of the Evangelists were placed at the beginning of their Gospels from Early Christian times. Indeed, the Evangelist portrait is by far the most prevalent type of figure illustration in Byzantine manuscripts. The scroll on which St. Mark is writing recalls that this was the common way of transmitting the written word before the invention of the codex in the second century AD.

This particular example has recently been identified by a Russian scholar as probably having formed part of a Gospel Book now in the State Historical Museum, Moscow (MS Sin. Gr. 41), which contains very similar miniatures. The dark shading and careful modelling of the face and the voluminous draperies show Byzantine art as a repository of what remained of classical naturalism in the Middle Ages. It was much admired in the West for this reason, and paintings of this kind greatly influenced Western artists in the twelfth century.

Casket with Apostles and Saints

South Italian; first half of the twelfth century
Wood covered with bone; l 48 cm; w 20.5 cm; h 13.5 cm
A.543-1910

The casket is made of walnut wood covered with bone plaques, carved with half-length figures of saints within elaborate foliate borders. Each saint has his or her name incised on the background, originally filled with coloured paste, traces of which can still be seen. On the lid are saints Julia and Darias, the Virgin, Christ and saints John the Baptist, Alexander and Chrysanthus; on the front saints Philip, Thomas, John the Evangelist, Peter, Paul, Andrew, Bartholomew and James the Greater; on the back saints Stephen, Mark, Jude, Matthew, James the Less, Simon, Matthias and Luke; on one end saints Nereus, Gregory and Achilleus, and on the other saints Justus and Pancratius (one plaque is missing).

A Roman provenance has been suggested on the basis of the iconography; all the martyrs except Justus are Roman martyrs. However, in both iconography and style the casket relates to work in Apulia. Saints Chrysanthus and Darias were especially honoured at Oria in Apulia, and here they are seen in a prominent position on the lid of the box flanking the Virgin and Christ. The borders relate to the foliate scroll decoration on the doorway of the church of S. Nicola e Cataldo in Lecce and the figures themselves are very close to those seen on the tympanum of the north doorway of the Cathedral of Troia, dated to the first quarter of the twelfth century.

The casket can be compared with Byzantine examples such as the Veroli casket (p 89) especially in its rich borders, and the rigid, staring half-length saints are clearly provincial versions of Byzantine types. The vertical arrangement of the inscriptions, although they are in Latin, also indicates Byzantine influence, and this casket was probably produced in imitation of an imported Byzantine example.

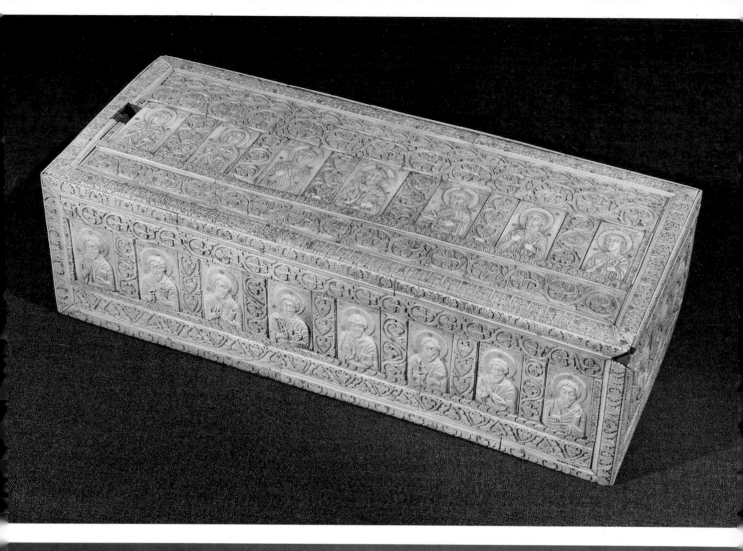

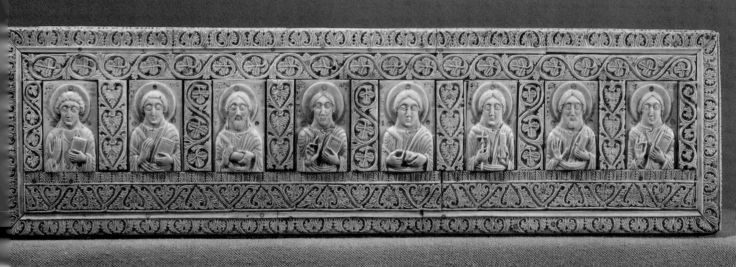

The Last Judgement

Italo-Byzantine (Venice?); twelfth century
Ivory; h 15.5 cm; w 21.5 cm
A.24-1926

This is a very full representation of the Last Judgement. At the top the Deesis: Christ seated on the globe between the Virgin and St. John the Baptist; they take their place as intercessors, at the Last Judgement, interceding to save the repentant sinners, while the twelve apostles beside them are assessors, helping the Judge to decide the fate of the souls of the dead. At the bottom, to the right of the centre, an angel blows a horn, the signal for the resurrection of the dead. The left of the central zone shows two groups of the Blessed, and below various saints are led into Paradise, already occupied by the penitent thief (with his cross), the Virgin, and Abraham with Lazarus in his bosom. A river of fire descending from below Christ's feet, between two cherubim, leads to Hell on the right, where an angel ushers the Damned towards Satan on his throne of serpents. The figure in Satan's lap may be the rich man (as a pendant to Lazarus in Paradise). The figures at the bottom right have been identified as the sinners gnawing their lips and tongues mentioned in the apocryphal Apocalypse, or 'the violent who walk naked in darkness', and the skulls represent those who sinned with their eyes and by touch. The empty throne with the open book and the instruments of the Passion is the Byzantine 'Etimasia', symbolising Our Lord as Judge.

This representation is an abbreviated version of the subject seen in the mosaics in Torcello Cathedral near Venice, of c.1100. One unusual iconographic detail shared by both representations is the presence of the repentant thief in Paradise itself rather than proceeding towards it with the other Blessed. Most elements of the scene are already mentioned in the fourth-century description of the subject by Ephrain Syrus, but the typical Byzantine scheme, of which this is an example, does not seem to have developed until much later. The Etimasia, for instance, only forms part of the Last Judgement from the eleventh century onwards.

Although this plaque is from the same Italo-Byzantine group as the panel with the Christological scenes (p 165) the style is freer and more dynamic, as may be seen by a comparison of the Angel driving the Damned into Hell with the Angel of the Annunciation on the Christological plaque. Drapery relates far better to the body beneath, and the heads show more variety.

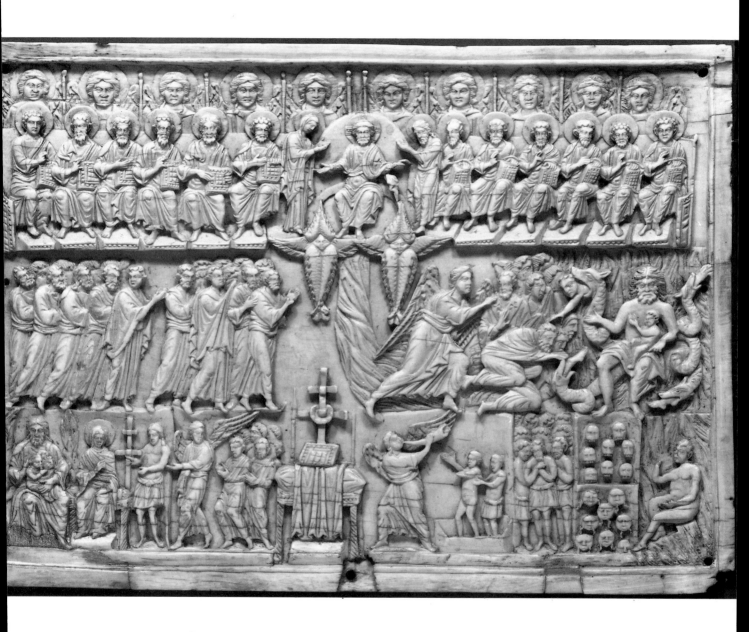

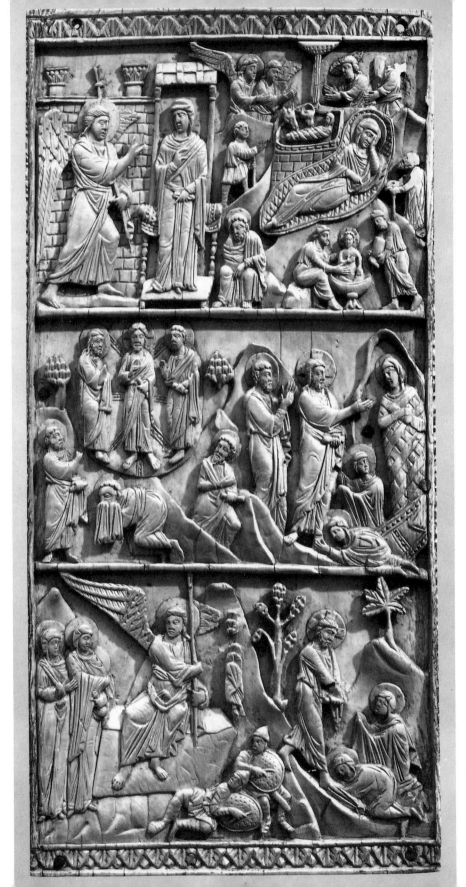

Christological Scenes

Italo-Byzantine (Venice?); twelfth century
Ivory; h 25 cm; w 1 cm
295-1867

The scenes on the plaque are the Annunciation, the Nativity, the Transfiguration, the Raising of Lazarus, the Maries at the Sepulchre and the Meeting in the Garden.

Various works in a related style – probably the products of the same school but not necessarily the same workshop – survive in various museums, including a plaque with the Entry into Jerusalem in the British Museum, a Nativity in Liverpool and panels showing the Raising of Lazarus and the Last Judgement (see p 162) in the V&A. In this group compositions tend to be crowded, with comparatively small-scale figures, their heads seen in almost full profile but with features carved on the steeply cut concealed side. Iconography, drapery and ornament are clearly based on Byzantine prototypes but for several reasons it is probable that these ivories were produced in Italy. The handling of various features is less accomplished than in Byzantine works, and the overall appearance of the pieces is one of a provincial reflection of Byzantine originals; although the same disposition of drapery can be seen as in Byzantine examples, there is a totally different effect, the figures being more rigid and linear. Also, one of the plaques of the group (now in Ravenna) shows Christ enthroned, in a very Byzantine manner, but within a rounded mandorla supported by four angels, close to Western representations of Christ in Majesty with the four Evangelist symbols. Venice has been suggested as the centre of production, largely on the grounds of its close connections with the East, and in the relationship of the Last Judgement plaque with twelfth-century mosaics in Torcello.

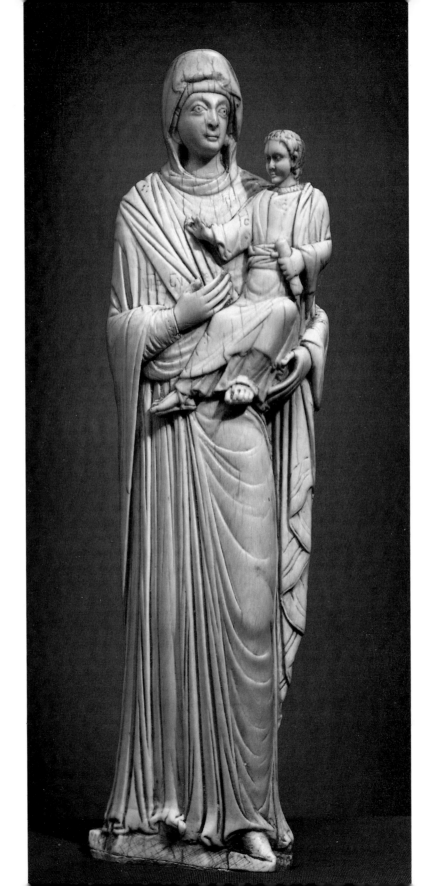

The 'Theotokos Hodegetria' (Virgin and Child)

Byzantine; eleventh–twelfth century
Ivory; h 32.5 cm
702-1884

This statuette represents the 'Theotokos Hodegetria' or 'the Mother of God showing the Way' (ie through the Christ Child). It is one of the most common iconographic types in Byzantine art, and was popular throughout the East from the early sixth century onwards. From the eleventh century the Child is occasionally represented on the Virgin's right arm. The head of the Child on this statuette is a later Western(?) restoration.

Statuary in the round is almost unknown in Byzantine art – this is the sole surviving example – although there is said to have been an ivory statue of St. Helena in Hagia Sophia in Constantinople; other similar surviving sculptural representations of the Hodegetria are all reliefs. There is a monumental marble version in the Istanbul Archaeological Museum which is very close, and several ivory plaques, which probably once formed the central panels of triptychs, survive in various museums. The basic format of the Hodegetria remains unchanged; even the drapery patterns hardly vary from one piece to another.

The head of the Virgin, with broad fleshy features and high arched eyebrows, can be compared with such works as the late eleventh-century serpentine Virgin *Orans* in the V&A (p 90) and other marble *orans* figures in Berlin, also of the late eleventh century, as well as other ivory representations of the Hodegetria. The statuette was probably produced at the end of the eleventh or early in the twelfth century.

John the Baptist and Four Saints

Byzantine; twelfth century
Ivory; h 23.5 cm; w 13.5 cm
215-1866

This pierced plaque shows St. John the Baptist in the central medallion (apparently based upon conventional representations of the Pantocrator), with running clockwise from top left, Saints Philip, Stephen, Thomas and Andrew. The area between has been cut away leaving a delicate foliate pattern. There are traces of gilding and the plaque may originally have been set against a gold ground.

The ivory has been associated with the so-called 'Romanos' group (see the ivory Seated Christ, p 92) but the carving is much finer and more detailed. The same artist was possibly responsible for a casket with half-length figures of saints now in the Museo Nazionale in Florence. It has been suggested that this plaque may also once have formed the lid of a casket but it seems more likely that it was attached to a bookcover or formed part of a triptych. But the iconography would be unusual for a bookcover and there are no signs of the attachment of wings for a triptych. However, there is a similarly designed panel with the Virgin and four saints in medallions, once the central panel of a triptych (now in Berlin) and the saints in medallions are also paralleled in several eleventh-century(?) ivory triptychs such as the Harbaville triptych in the Louvre and a Crucifixion triptych in the British Museum. Whatever the object from which the plaque came, it probably belonged to an establishment dedicated to St. John the Baptist; this would explain his dominant position, enhanced by the use of the Pantocrator image.

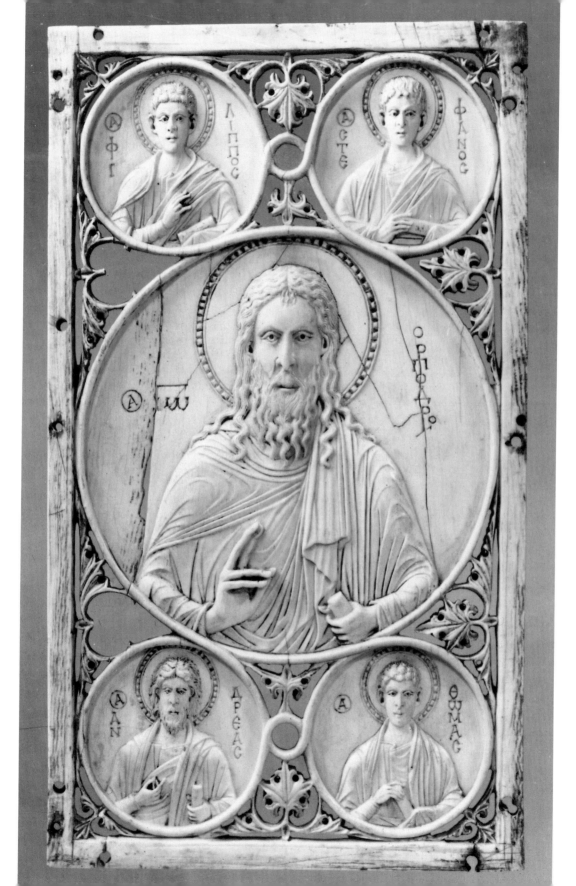

The Annunciation
Colour plate 15

Byzantine; about 1320
Mosaic; h 15.2 cm; w 10.2 cm
7231-1860

This representation of the Annunciation is formed of tiny tesserae of gold, silver, lapis lazuli and other semi-precious stones set into wax on a wood base. Few portable mosaics of this type survive, and this panel is one of the finest, being related to a mosaic diptych depicting the Twelve Feasts of the Church, in the Museo dell'Opera del Duomo in Florence. The Annunciation is a slightly larger and more elaborate version of the same scene on one of the Florence panels.

Most of the surviving portable mosaics were probably executed in the Palaeologan era, during the rule of the first two Palaeologan Emperors, Michael VII (1261–82) and Andronicus II (1282–1328). The major work of this time is the mosaic and fresco decoration of the Kariye Camii (Church of St. Saviour in Chora) in Istanbul, carried out at the orders of Theodore Metochites, c.1308–20/1, and executed in a style closely analogous to the present mosaic icon.

Constantinople had been taken by the Crusaders in 1204, and thus most Greek artists had been dispersed and trained in other areas such as Trebizond, Serbia and Nicaea. With the return of the Emperor to the capital in 1261, the artists and craftsmen also returned and merged their disparate styles during the second half of the thirteenth century. The tall, slender proportions of the figures are characteristic of their new style and specific details in the mosaic relate it closely to the Kariye Camii – for instance in the way that the lower edge of the angel's cloak is rolled up, and the use of architecture, with a building behind each figure connected by a low wall creating a limited space or 'stage' on which the figures 'perform'.

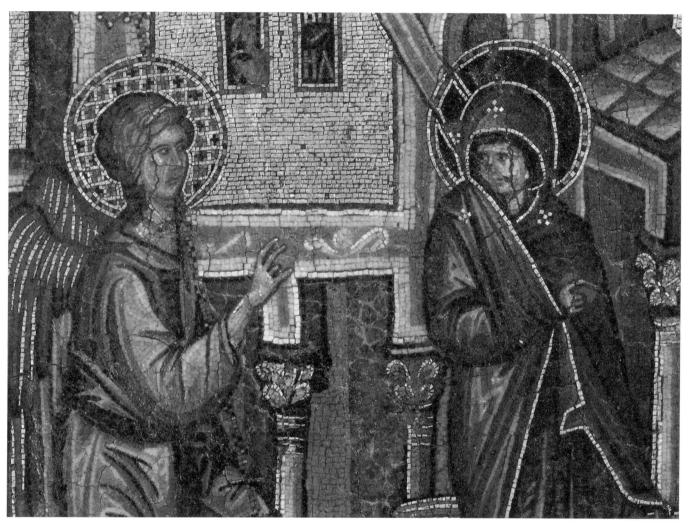

Detail approximately twice actual size

St Paul

South German (Bamberg?); early thirteenth century
Ivory; h 10.5 cm; w 6.5 cm
274-1867

St. Paul stands between two trees, holding a scroll in his left hand and with his right hand raised. The inscription around the border reads: PERNICIES. FIDEI.SAULUS. CEDENDO. FIDELES. INVIGILA(T FI)DEI.VERBA. SERENDO. DĪ – Saul, the destroyer of the faithful, after his conversion, watches over the faith, preaching the word of God.

Saul of Tarsus, a great persecutor of Christians, was converted after a vision and, taking the name Paul, set out to convert others. His many Epistles form a large part of the New Testament as evidence of his great evangelical activity. This image, with Paul seeming to burst forth from between the trees, standing out from the picture plane with his feet firmly planted on the lower border, well befits the subject of a tireless and powerful missionary, who had a great influence on the development of Christian thought. Paul's normal attributes are a sword and a book, but the scroll he carries here may bear particular reference to his Epistles, especially if, as is possible, the ivory was intended for the cover of a copy of the Epistles of St. Paul or the Acts of the Apostles.

The ivory can be related to German works produced around the end of the twelfth and the beginning of the thirteenth century. A small group of ivories, including a *Flight into Egypt* in the Museo Nazionale in Florence, and a *Tree of Jesse*, now shared by the Metropolitan Museum of Art in New York and the Louvre, possibly carved in Bamberg, provide some convincing parallels, especially in the interlaced borders, which are very close to the interlaced branches of the trees beside St. Paul. Large-scale sculpture of the early thirteenth century provides some comparable works. It is not so much specific details that relate works such as the Bamberg choir screen of c.1220–25 to this ivory, but the spirit underlying them: the preaching St. Paul and the disputing prophets of the choir screen show a similar external expression, in their vitality and dynamism and in their swirling draperies, of the vehemence of their words. Compared with the solidity and dignity of the figures on the other ivories, the figure of St. Paul is clearly looking forward into the thirteenth century, nearer to the beginnings of German Gothic sculpture, soon to emerge at Bamberg itself.

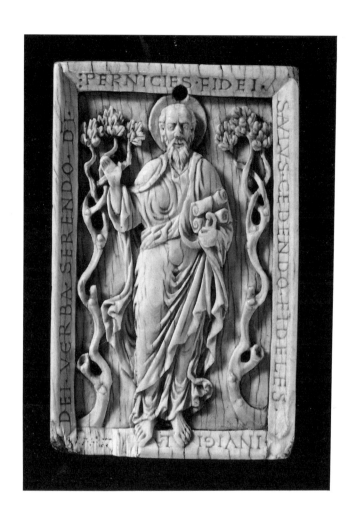

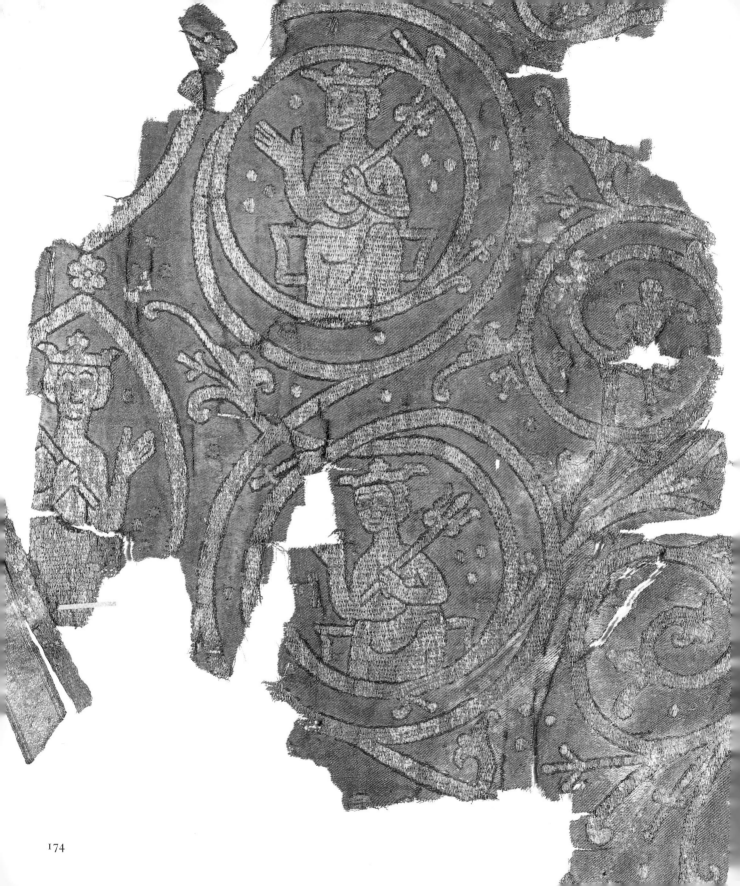

174

Fragment of a Pair of Buskins

English; 1220–50
Woven silk twill (originally red) embroidered with silver-gilt thread and coloured silks in underside couching and stem stitch; 29 × 22.5 cm
1380-1901

Foliate scrolls enclosing kings.

This embroidery demonstrates well the tenacity of the Romanesque style, showing clearly characteristic elements of twelfth-century art, such as the scroll work, which encloses stiffly drawn hieratic figures, arranged in a formal geometric pattern. This scroll work can be seen even more clearly in a larger fragment from the same pair of buskins (now in the British Museum) where the scrolls extend in mirror image on either side of a central, vertical row of kings, possibly in a formal representation of the Tree of Jesse. Records of the period contain references to similarly decorated vestments; the 1295 inventory of St. Paul's Cathedral lists 'Item, sandals and buskins of red samite embroidered with figures of kings in vine-scrolls'. For the use of foliate work in other textiles, see also the Westminster mitre (p 150) and the Clare chasuble (p 186).

The fine silver-gilt thread is laid in vertical lines regardless of the underlying design and it is underside couched in a regular brick pattern which is typical of *Opus Anglicanum* in the early medieval period. In later examples more complex couching patterns were to be used, although the vertical lines of thread remained a constant feature of English work. Coloured silk threads are used only to outline the pattern and to define certain details. It was for its fine gold work that English embroidery won international renown and Matthew Paris described how, in 1246, Pope Innocent IV 'having noticed that the ecclesiastical ornaments of certain English priests, such as choral copes and mitres, were embroidered in gold thread after a most desirable fashion, asked "whence came this work?". From England they told him. Then exclaimed the Pope, "England is for us surely a garden of delights, truly an inexhaustible well; and from there where so many things abound, many may be extorted." Thereupon the same Lord Pope, allured by the desire of the eye, sent letters, blessed and sealed, to well nigh all the Abbots of the Cistercian Order established in England, desiring that they should send him without delay these embroideries of gold which he preferred above all others . . . This command of my Lord Pope did not displease the London merchants who traded in these embroideries and sold them at their own price.' (Matthew Paris, *Historia major* . . . , ed Willielmo Wats, Paris, 1644, p 473).

This fragment of a buskin is part of a collection of embroidered textiles (now divided between the V&A, the British Museum and Worcester Cathedral), which were removed in 1861 from a stone tomb believed to be that of Walter de Cantelupe, Bishop of Worcester, 1236–66.

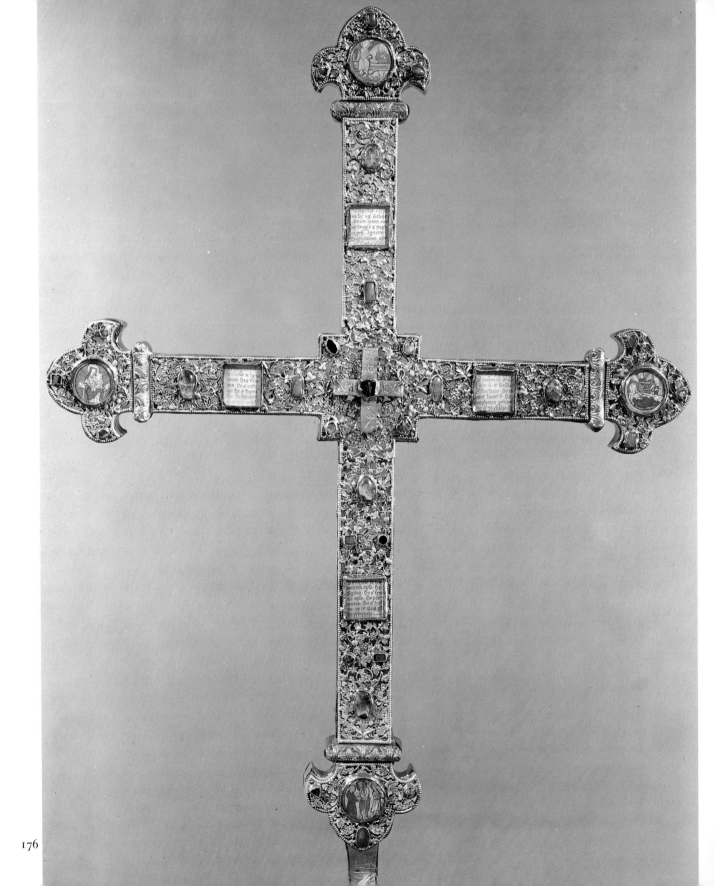

The Oignies Altar Cross

Mosan; c.1225–50
Silver-gilt set with precious stones and miniatures
painted on vellum; the back of copper-gilt; h 26.7 cm
244-1874

The front of the Cross is of silver-gilt stamped in openwork, set with amethysts and cornelians. Tablets of glass cover lists of the relics inside the Cross and miniatures which depict scenes from the Life of Christ: the Nativity, the Flagellation, the three Maries at the Sepulchre and the Virgin and Child.

This beautiful altar-cross is one of the finest expressions of High Gothic art in the Museum. Its style is one associated with the Treasury of the Priory of St. Nicholas at Oignies-sur-Sambre, near Namur in Belgium. The Priory had been founded in 1192 by three brothers belonging to a wealthy family in Walcourt. All three brothers became priests. A fourth, Hugo, devoted himself to enriching the church with goldsmith's work of his own making, until his death in about 1240. Three authenticated pieces by him may still be seen at the Convent of the Sisters of Our Lady of Namur.

If not by Hugo himself, the Cross was obviously made by someone familiar with his work, which it closely resembles; its maker was perhaps also responsible for a cross and reliquary at Walcourt, in the same style.

Crozier-Head (Pastoral Staff) with the Coronation of the Virgin

French (Limoges); thirteenth century
Gilt copper decorated with champlevé enamel;
h 33.1 cm; diam of volute 13.4 cm
288-1874

Becket Reliquary-Châsse

French (Limoges); about 1200
Copper, engraved and decorated with champlevé enamel;
h 19 cm; w 16.5 cm
Lent anonymously

Limoges in southern France became from the late twelfth century a centre for the production of champlevé enamels on a vast scale. They were widely exported and a large number of them survive. The earliest type, of which the Museum lacks an example, is characterised by figures which are enamelled on a gilt ground background. During the thirteenth century this type gave way to one in which figures were engraved and gilt, against an enamelled background. A distinctive feature of Limoges enamels is the brilliant blue commonly used as background, often decorated with polychrome rosettes.

a) Limoges enamellers often decorated the crook of a crozier with scenes from the life of the Virgin, as here, or with figures of saints such as St. Michael. Many croziers have been excavated from the graves of bishops, as it was the custom until at least the sixteenth century for bishops to be buried with a crozier at their side.

b) Reliquary-châsses took the form of small caskets with gabled roofs containing the relics of a saint, and were generally decorated with scenes from a saint's life or that of Christ, or figures of saints. This casket depicts the martyrdom of Thomas Becket, Archbishop of Canterbury until he was murdered in 1170. Becket was canonised in 1173 and became one of the most popular saints in Europe. Curiously, although his shrine was of course in Canterbury, it was the enamellers of Limoges who produced these distinctive Becket reliquaries in the late twelfth and thirteenth centuries. An unusual feature here is the depiction of two saints to the right of the altar; this appears on only one other, now lost, casket formerly in the collections of the antiquaries William Stukeley (1687–1765) and Thomas Astle (1735–1803).

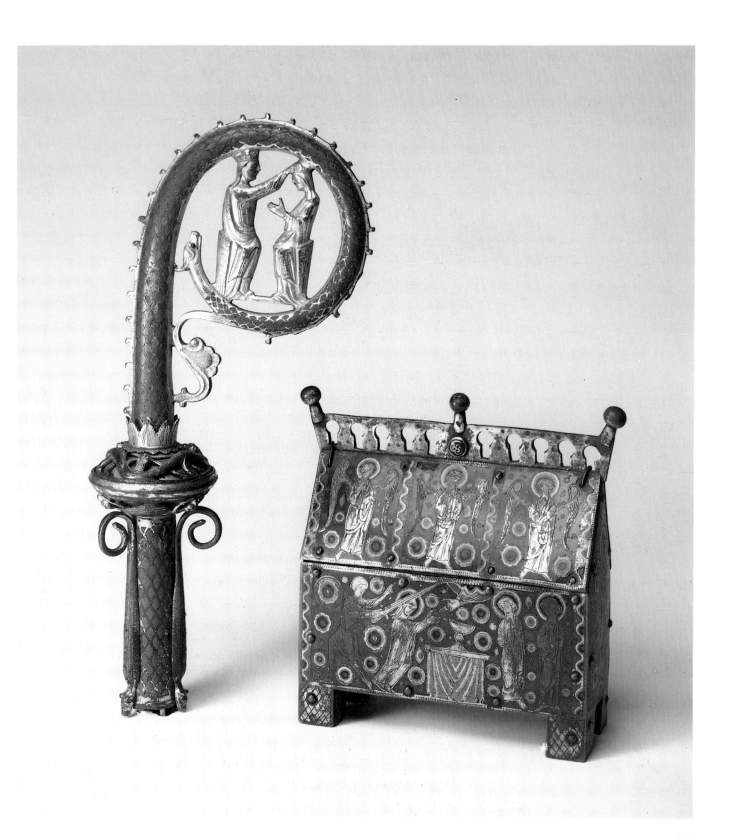

Hand Reliquary

Flemish; thirteenth century
Silver, parcel-gilt, set with a stone; h 22.8 cm; w 11.5 cm
M.353-1956; Given by Dr W.L. Hildburgh

The bones of venerated saints were often housed in reliquaries which took the appropriate shape: heads, hands, arms and feet were encased in silver and gold, frequently embellished with gems. It is in fact likely that this hand reliquary originally formed part of an arm reliquary, from which the hand has been detached at an uncertain date. The relics (now lost) would have been visible through the windows in the fingers. Note how the ring is worn at the very end of the finger, a common practice throughout the Middle Ages and well into the sixteenth century.

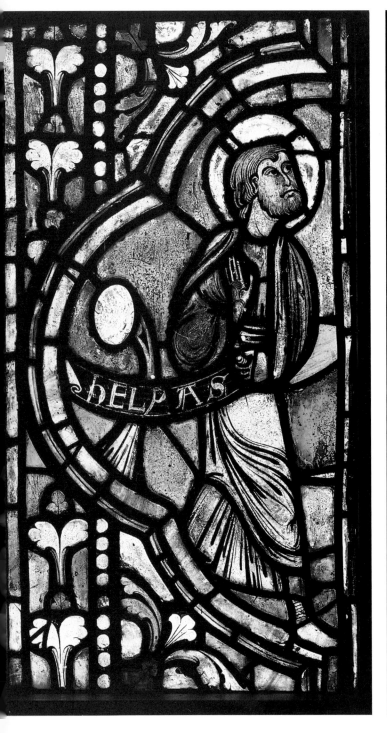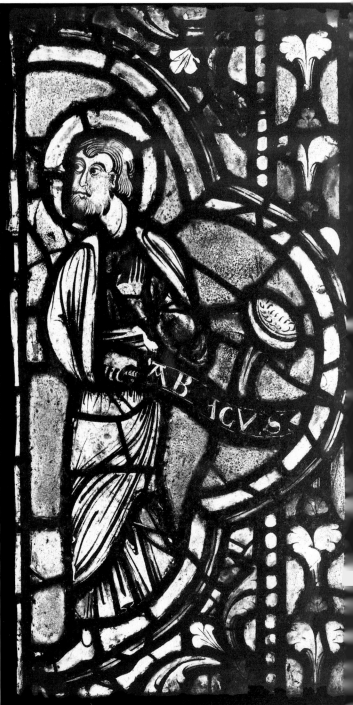

Figures of Prophets from a Tree of Jesse
Colour plate 16

French (possibly from the Cathedral of Saint-Pierre
of Troyes); first half of the thirteenth century
Two panels of stained and painted glass
64.2 cm × 34.9 cm and 64.8 cm × 35.3 cm
6A and 6B-1881; Given by Henry Vaughan

Each of these prophets carries a scroll inscribed with his name in Lombardic
lettering; 'HELPAS' and 'ABACVS' (for Habakkuk). They come from a 'Tree of
Jesse', a popular subject for windows throughout the Middle Ages. Jesse is
often shown lying across the bottom of the composition with a stem rising
from him, often shown as a vine, in the branches or tendrils of which are
placed rows of kings and prophets, culminating at the top with the Virgin
Mary and Christ. The stem is similar to a family tree in that it symbolises the
genealogy of Christ descended from Jesse. It is not known where exactly
these panels came from but it is highly likely to be from the Champagne or
Burgundy region of France and there is a strong possibility that they may
have been made for Troyes Cathedral. Views differ on the date, but they are
hardly likely to pre-date 1210–15 and must have been made before the
middle of the thirteenth century.

The Flagellation of Christ
Colour plate 17

French; early thirteenth century
Panel of stained and painted glass; 77.5 cm × 68.6 cm
5460-1858

This panel shows Christ being whipped by his gaolers before He was led out
to be crucified. This scene would have formed part of a Redemption window
showing the events at the end of Christ's life, culminating in a scene of the
Resurrection or of Christ in Majesty. It is not known where the panel
originally came from but the style suggests a church with glass associated
with the Sens-Canterbury school, probably in the area to the east of Paris,
somewhere between St. Quentin in the north and Troyes in the south.
Nothing is known of the history of the panel until it was bought in 1858.

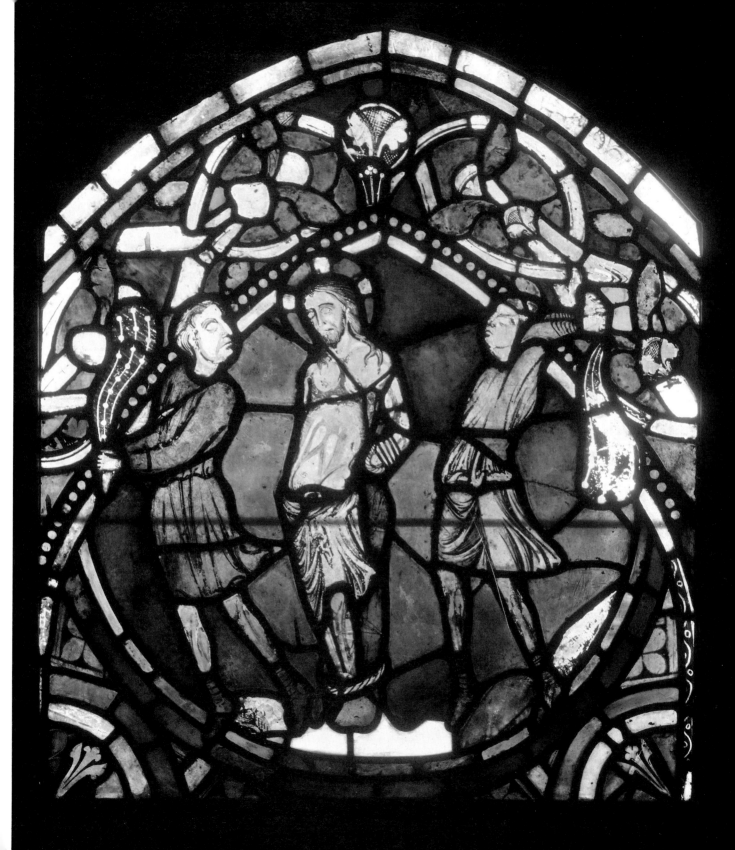

The Clare Chasuble

English; 1272–94
Blue silk, satin weave, embroidered with silver-gilt and silver thread and coloured silks in underside couching, split stitch and laid and couched work
120.5 × 81.5 cm
673-1864

On the back a wide vertical band is decorated with four barbed quatrefoils containing Christ Crucified, with the Virgin and St. John; the Virgin and Child; SS. Peter and Paul; and the Stoning of St. Stephen. Between the quatrefoils, stiff scroll work is reminiscent of the wrought iron hinge straps of medieval doors. The main ground of the vestment is decorated with vigorously drawn but delicate foliate scroll work enclosing lions and griffins. In its decoration the chasuble is a transitional piece. The scroll work looks back to an earlier style, while the quatrefoils enclosing pictorial motifs belong to a decorative scheme based on repeating geometric shapes which was standard in *Opus Anglicanum* from the mid-thirteenth to the early fourteenth century (see the Syon Cope, p 190). The Clare chasuble is the earliest recorded example in which the silk embroidery of the faces follows the contours of the features, with the cheeks being worked in indented spirals. Although here distorted by wear, other examples show the depth of feeling that could be conveyed by this technique.

The chasuble is sadly mutilated, having been reduced from a voluminous garment like that worn by St. Stephen in the lowest quatrefoil on the back, while the need to give rigid support to this now-frail textile further obscures its original qualities of softness and fluidity. The join down the centre front is covered by a band of sixteenth-century bobbin lace.

Part of the missing ground fabric appears to have been used to make a stole and maniple which were additionally decorated with four shields of arms. These were described in 1786 by the then owner of the chasuble, David Wells, FSA, of Burbach (Burbage), Leicestershire, in a letter to *The Gentleman's Magazine*: 'The four coats are embroidered on a piece of very rich silk, in which are interwoven flowers and griffins in gold, at the bottom and corners whereof the shields are finely wrought in needle-work, the gold and silver yet fresh, the other colours much faded, as is the stuff itself.' The arms were those of Clare, Cornwall, Lacy and England and they enable the chasuble to be dated very precisely. They stand for Margaret de Clare, who married Edmund Plantagenet, Earl of Cornwall, in 1272. The arms of Lacy relate to her mother and those of England are a reference to her husband's royal descent as nephew of Henry III. The marriage remained childless and ended in divorce in 1294.

Although the stole and maniple are now lost, the fact that the armorial shields were once part of the chasuble is supported by the remains of a tiny section of one shield (probably that of Lacy) at the upper, right hand edge of the back, and the presence of a strap (from which a shield once hung) draped over a scrolling stem by the neck edge of the left front.

The early history of the chasuble is not known. David Wells had acquired it from 'a gentleman in Wales' and it subsequently passed through the hands of his nephew, Ambrose Salisbury, John G. Nichols, FSA, and John Bowyer Nichols. It was bought by the Museum at the latter's sale, 28th June, 1864 (lot 160).

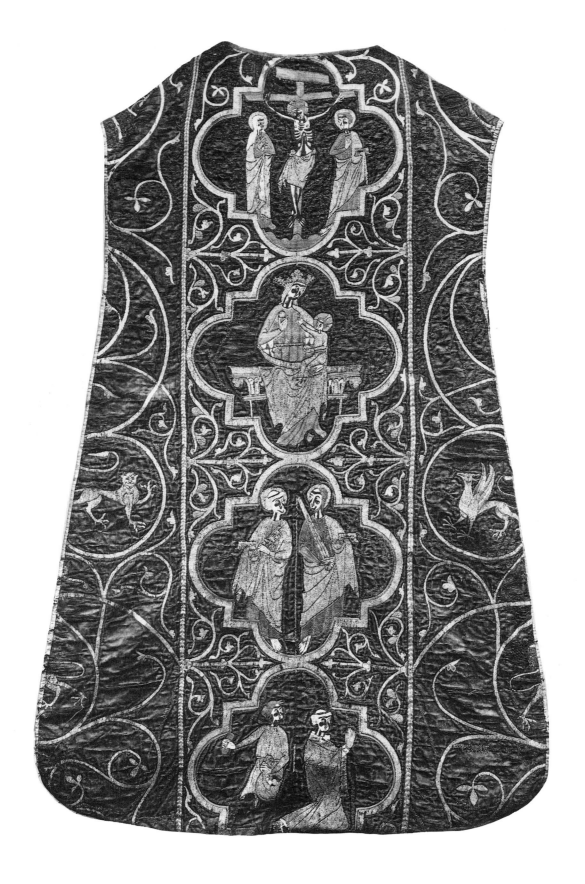

187

Diptych with Scenes from the Passion
(The Soissons Diptych)

French (Paris); end of the thirteenth century
Ivory; h 32.5 cm; w 11.5 cm (each leaf)
211-1865

The scenes read across the leaves from bottom left and back again. They are: Judas receiving the thirty pieces of silver from the High Priest; the Betrayal; the death of Judas; the Buffeting of Christ; Pilate washing his hands; the Flagellation; Christ carrying the Cross; the Crucifixion; the Deposition; the Entombment; the Resurrection; the Harrowing of Hell; the three Maries at the Sepulchre; Noli Me Tangere (Christ's appearance to Mary Magdalene); Christ's appearance to the three Maries; Doubting Thomas; the Ascension; and the Descent of the Holy Spirit (Pentecost).

The ivory is said to have come from the Abbey of St. Jean-des-Vignes at Soissons, and thereby gives its name to a group of related ivories, the so-called 'Soissons group'. The group consists mainly of comparatively large-scale diptychs, and slightly smaller triptychs, usually divided into three horizontal bands with a rich architectural framework of cusped arches and pierced High Gothic gables. The term 'Soissons group' is, however, something of a misnomer, for it is generally agreed that the ivories were produced in Paris, and the 'group' includes pieces in several different styles.

These works show a certain degree of iconographic consistency, even among different stylistic groups. The Passion is the main subject of most of the diptychs – although a few ivories do have Infancy scenes – and the representations are generally devoid of symbolism, concentrating on narrative.

The earliest, highest quality ivories of the group date from c. 1250–70; the V&A possesses one of the major early works, the so-called 'Salting Leaf' (A.546-1910). The later ivories, including this Passion diptych, show slightly stiffer, more simplified elements, with less elegantly proportioned figures and a broader, heavier treatment of drapery, but a more complex architectural setting. Little new is added to the basic format and the later works hardly ever match the originality of the early pieces.

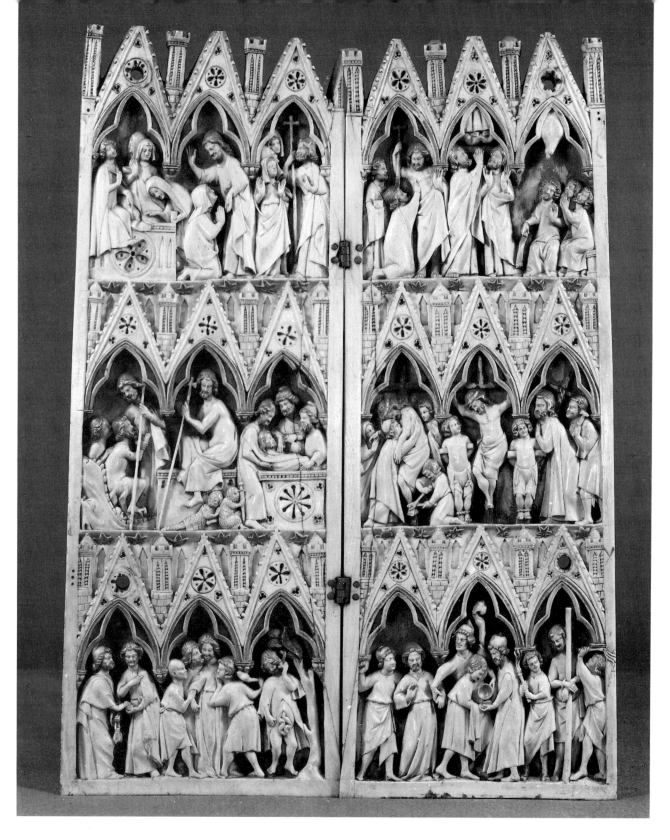

189

The Syon Cope

English; 1300–20
Linen embroidered with silk, silver-gilt and silver thread in underside couching,
split stitch and laid and couched work; 147.5 × 295 cm
83-1864

Scenes from the Life of Christ and the Virgin, and standing apostles.

Three (originally four) rows of interlaced barbed quatrefoils enclose, down the centre back, the Coronation of the Virgin; Christ Crucified, with the Virgin and St. John; the Archangel Michael with the dragon. To the left are the Burial of the Virgin, with St. Thomas receiving the Virgin's girdle; Christ appearing to St. Mary Magdalene; St. Peter with a key; St. Philip with three loaves; St. Bartholomew with a flaying knife and St. Andrew with a cross. To the right are the Death of the Virgin; St. Paul with a sword; the Incredulity of St. Thomas; St. James the Great with a pilgrim's staff and a purse embroidered with a scallop shell; St. Thomas with a lance and St. Simon with a club. The apostles in the fourth, dismembered row are not identifiable, nor is it possible to decipher the remains of an inscribed scroll. Between the quatrefoils are six-winged seraphs except along the upper edge, where there are the remains of angels holding crowns and the figures of two kneeling clerics, perhaps representations of the priest for whom the vestment was made. They hold scrolls inscribed 'DAVN : PERS : DE' with, on one, a further garbled inscription. (DAVN is an abbreviated clerical title and PERS a medieval version of Peter).

The iconography is related to that of a cope of 1280–1310 in the Vatican Museum, in which the figures are enclosed in touching star-shaped compartments, and the general design is similar to that of another cope of 1300–20 in Madrid in which the barbed quatrefoils touch but do not overlap. In both these examples, the larger interspaces leave room for the seraphs to spread wide one pair of their wings. The more closely folded wings of the seraphs on the Syon cope are reminiscent of those found in illuminated manuscripts. See, for example, the initial letter of Psalm 109 in the Ormesby Psalter (1285–1330) in the Bodleian Library, where the angels also stand on wheels. The pose of the figures and their softly waving hair also demonstrate the close links with the East Anglian School of illuminators.

The Vatican and Madrid copes are grounded respectively with rose-red silk and with linen entirely covered with underside-couched silver-gilt thread. In the Syon cope, however, the linen ground is covered with red (faded to brown) and green silk, underside couched in a chevron pattern. This use of silk thread, which is unique among surviving examples of *Opus Anglicanum* led Mrs Christie (see *Further Reading*) to conclude that the ground had been reworked at a later date, but this theory is not now accepted. However, the vestment is not in its original form. It was made as a chasuble. Pieces cut from the lower back have been used to complete the semi-circular edge and to fill in the original neck line at the centre top.

The orphrey bands and morse, which presumably were added when the chasuble was converted into a cope, are made from pieces of contemporary (possibly originally associated) vestments. The wide orphrey along the upper edge consists of three joined alb apparels, three narrow apparels make up the morse and the narrow orphrey along the curved edge is formed from a stole and a maniple. All are of linen embroidered with silver-gilt and silver thread and coloured silks in underside couching, cross and plait stitches. They are decorated with armorial lozenges set in squares which are grounded alternately in red and green. In colouring and general treatment the embroidery is close to that of two seal bags, holding the seals on charters dated 1319, which are in the Record Office of the Corporation of London. The use of armorial devices on stoles and maniples is recorded in the inventories of Canterbury and Exeter Cathedrals (1316 and 1327) and Westminster Abbey (1388).

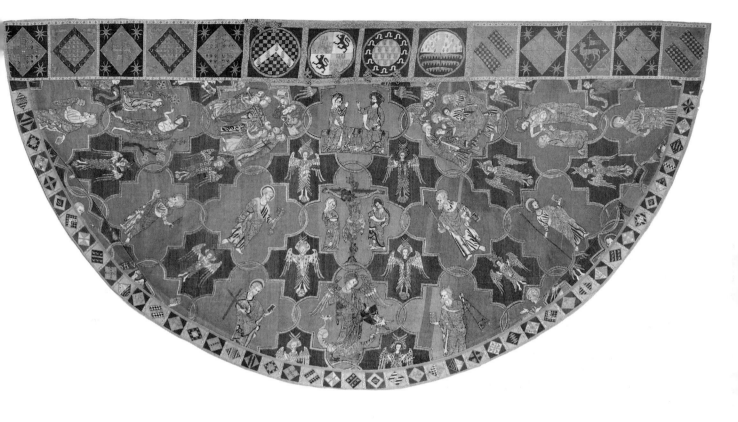

Their purpose may have been purely decorative since they refer neither to related families nor even to personages alive at the same time.

The Syon Cope takes its name from the Bridgettine Convent of Syon in Middlesex, which was founded by Henry V in 1414–15. The cope appears to have been in the possession of the nuns when they went into exile early in the reign of Queen Elizabeth and it was returned when the Order was re-established in England in about 1810. It subsequently passed through the hands of the 16th Earl of Shrewsbury, Dr Rock and Bishop James Browne. It was purchased by the Museum in 1864.

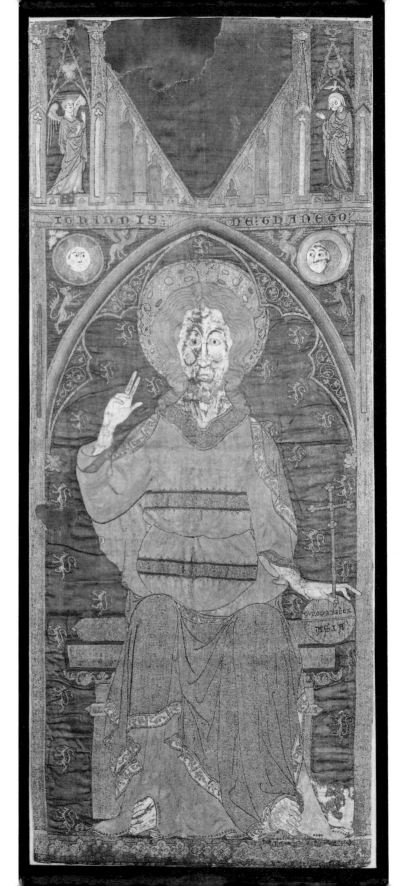

The John of Thanet Panel

English; 1300–20
Blue silk twill embroidered with silver-gilt and silver thread and coloured
silks and pearls in underside couching and split stitch; 100 × 24 cm
T.337-1921. Purchased with the aid of the National Art-Collections Fund

Christ in Majesty beneath a Gothic arch. His right hand is raised in blessing and He holds a cross in His left hand, which rests on an orb inscribed in Lombardic characters 'EVROPA AF$_F$CA ASIA'. Within the spandrels of the arch are the sun and the moon and, rising above the horizontal band, are two pinnacled turrets in which stand the figures of the Annunciation: on the left the Angel Gabriel and on the right the Virgin Mary with the Dove above her. The blue ground is powdered with small gold lions and (within the spandrels) wyverns. The horizontal band is inscribed 'JOHANNIS: DE: THANETO'.

This magnificent panel is perhaps the most impressive example of *Opus Anglicanum* to have survived. In scale, the figure of Christ is approached only by the (slightly smaller) figures of the Crucifixion on the Melk Chasuble (Kunsthistorisches Museum, Vienna), which is also sufficiently close stylistically to suggest that the two pieces were drawn by the same hand. The graceful pose of the figures, the undulating folds of the ample garments, the softly waving hair and other details show strong affinities with the illuminated manuscripts of the East Anglian School.

The fact that, despite its scale, the panel once formed part of a cope is indicated by the blank triangular panel at the top. This is the right shape and size to have been covered by the vestigial hood of the period. The Melk chasuble demonstrates the use on a vestment of a large-scale figure subject and further evidence is provided by records such as the inventory of the vestments of Pope Boniface VIII (1294–1303), which lists an English cope decorated with a large figure of a bishop, with below the twelve apostles arranged in a semi-circle.

The incomplete inscription 'JOHANNIS: DE: THANETO' refers to John of Thanet, a monk of Canterbury Cathedral. He has been described as 'a Monk and Chaunter of this Church, well vers'd in the Mathematicks; but especially skill'd in Musick. He set the Services and Offices for this Church to Musick, and wrote some Legends of Saints. He died in the Year 1330, on the 6th of the Ides of April, in Time of High Mass, being aged 92 Years, and was buried in this Church.' (J. Dart, *The History and Antiquities of the Cathedral Church of Canterbury*, 1726, p 184). He seems also to have commissioned vestments for the Cathedral; a chasuble and an alb are listed in the 1315 inventory of the vestry – 'Item Casula. J. de Taneto, de rubeo sindone de tuly. cum rosis brudato. Item. Alba Johannis de Taneto cum parusis de rubea sindone de tripe brudatis cum rosis.' The present panel is not mentioned but the last few pages of the inventory are missing.

The panel was purchased for the Museum from the Dominican Priory, Haverstock Hill, but it is not known when it came into the possession of the Dominican Order.

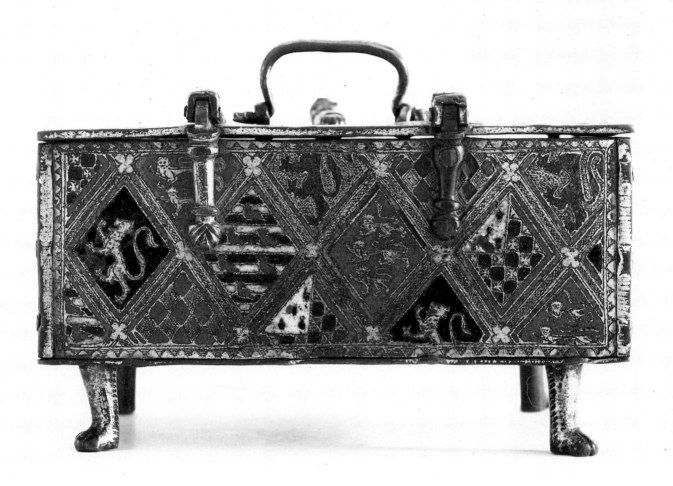

The Valence Casket
Colour plate 18

Limoges or England; about 1300
Copper-gilt and champlevé enamel
h 8.8 cm; w 17.6 cm; l 13.3 cm
4-1865

Decorated with the armorial bearings of the Valence family (Earls of Pembroke), the Royal house of England, the Dukes of Britanny (Dreux), the families of Angoulême, Brabant and Lacy (Earls of Lincoln).

The casket may have belonged either to Aymer de Valence (d 1324) or to his father, William, whose partly enamelled tomb in Westminster Abbey is closely comparable. Another enamelled tomb, made for Walter de Merton, Bishop of Rochester (d 1276), was commissioned from a Limoges craftsman named John, so the casket, which is unique, may have been made either in Limoges or England. A contemporary enamelled cup lid, also decorated with arms, survives in All Souls College, Oxford, and is associated with Aymer de Valence's wife, Beatrice de Nesle.

It cannot be chance that the increasing use of enamel on metalwork from the late thirteenth century coincides with a growth of interest in, and use of, heraldic ornament. Enamel was the only means by which metal could be permanently coloured and colour was a crucial element in heraldic language.

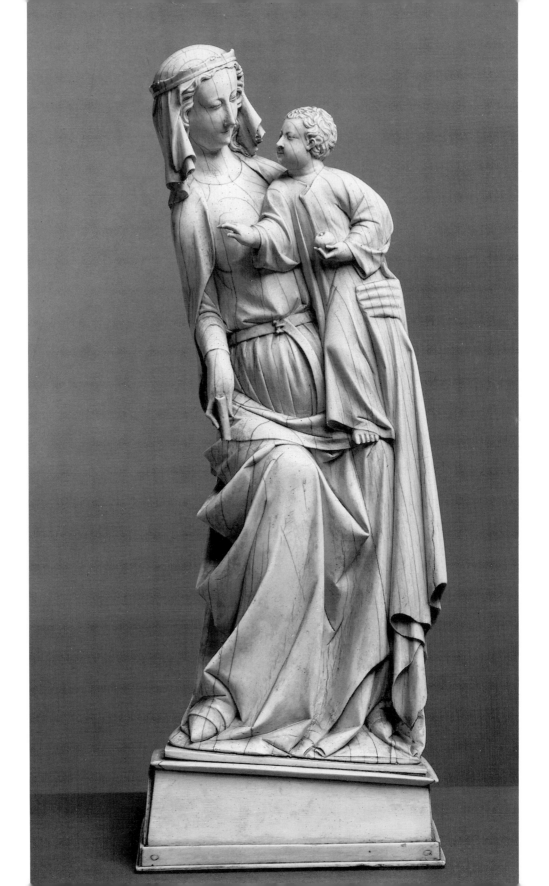

Seated Virgin and Child

French; early fourteenth century
Ivory; h 36 cm
4685-1858

The Virgin turns to look at her Child. She holds the stem of what was probably a lily. The Child holds an apple in His left hand, and His right is stretched out as if to touch the lily.

The thirteenth century saw the development of the cult of the Virgin which had grown up in the previous century. The Hours of the Virgin were now recited daily and many tracts were written upon her virtues and her symbolic status. The most frequently recurring theme is that of the Virgin as Queen of Heaven. While most Romanesque and Early Gothic portals were devoted to representations of the Last Judgement or Christ and the Apostles, in the second half of the twelfth and in the thirteenth century, Virgin portals appear more and more often, reflecting a move away from a concentration on the harsh God of the Old Testament to the more merciful God of the New, and a more humane and personal religion. The basic elements of later representations of the Virgin can be seen in the twelfth century – the crowned Virgin seated with the Child on her lap, holding a flowering sceptre – but these images are hieratic and solemn; in the thirteenth century the idea of the Virgin interceding to save the repentant sinner is more fully developed, and representations of her become more gentle and maternal, as, for example, in the *Vierge dorée* at Amiens of c.1259–69, who smiles lovingly at her Child.

In the second half of the thirteenth century, however, great church portals such as those at Bourges and Poitiers simply repeated formulae used in earlier monuments. The emphasis in production shifted towards private sculptural commissions, more particularly portable devotional objects, and numerous ivory Madonnas and diptychs survive from the thirteenth and fourteenth centuries. The models for such portable pieces are found in monumental sculpture, but small ivories allowed a refinement of detail which would usually have been out of place in larger works. The love of elegance for its own sake increasingly dominated art at the end of the thirteenth and into the fourteenth century, and although early ivory Madonnas such as that of the Ste. Chapelle of c.1265–79 (now in the Louvre), despite their preciosity, show rich heavy drapery falling in natural folds, later examples are often mannered and refined almost to the point of cold sharpness.

The Steeple Aston Cope (reused as an altar frontal and dossal)
Colour plate 19

English; 1310–40
Silk twill embroidered with silver-gilt and silver thread and coloured silks in underside couching and split stitch with a little raised work; in two pieces
141 × 157.5 cm and 80 × 219 cm
Lent by the Vicar and Churchwardens of Steeple Aston, Oxfordshire.

Scenes from the Life of Christ and the Virgin, and the martyrdoms of saints. Their names are inscribed in Lombardic characters above their heads.

The original decorative scheme of the cope (almost all of which is preserved in the two panels) is still clear. Entwined branches of oak and ivy form barbed quatrefoils with leaf masks at the intersections. Between the quatrefoils are lively heraldic lions. The dossal is made from the back of the cope with three central quatrefoils containing the Coronation of the Virgin, the Crucifixion with the Virgin and St. John, and Christ carrying the Cross. To the left are St. Andrew, St. Lawrence and St. Bartholomew. To the right are St. Peter, St. Stephen and St. Margaret. Most of the remaining saints from the left of the cope are now on the right of the frontal: St. James the Great, St. Thomas and St. James the Less. The scene of SS. John and Thaddeus, which belongs with this group, has been exchanged for that of two un-named saints. These were originally on the right of the cope together with St. Catherine, St. Paul and St. Barnabus (all now on the left side of the frontal). Two further quatrefoils, with figures of SS. Simon and Jude and two un-named saints are split between the two halves of the frontal.

Half the original wide orphrey is used to make the bands at the sides of the frontal. Musical angels on horseback alternate with quatrefoils containing representations of the universe: in the centre, a star within a lobed disc represents the firmament; around it, enclosed in a larger lobed disc, swim four fish in a wavy sea; in the outer section, representing earth, are the figures of a stag, a doe, a finch and a snipe. Much of the narrow orphrey band, worked entirely in gold with rabbits, goats, stags, hogs and other animals, has survived attached to the frontal. The hood is missing but the morse has been used to cover a damaged area above the scene of the Coronation of the Virgin. It is decorated with the *Agnus Dei* supporting the cross and banner of the Resurrection. On the banner is a Maltese cross and in the corners are the symbols of the four evangelists.

Worn and dismembered though it is, the cope still conveys something of its original great beauty. Worked almost entirely in gold on a pale ground, the more brightly coloured silk threads are used only to define and to highlight the design. The areas of goldwork are subtly patterned both by the arrangements of the couching stitches and by laying the gold threads in opposing directions. Unusually, the gold threads follow the outlines of the entwined branches and also of St. Margaret's dragon, which is equally unusually shaded by the use of silver-gilt thread wrapped with coloured silks. The grapes on the leaf masks are in raised satin stitch and the silver thread of the *Agnus Dei* on the morse is laid over padding, a technique found in only one other example of English embroidery of the period (the cope in the Basilica of St. John Lateran, Rome).

The folds of the garments are defined by the use of horizontally laid threads, a technique found also in the Butler-Bowdon cope (p 216) and a few other early fourteenth-century pieces. In other ways, however, the figures on the Steeple Aston Cope differ from those on other embroideries of the period. In general, their garments are more skimpy and lack the rich drapes and swirling folds around the feet, while in several instances the faces are presented in stark profile, as opposed to the more usual three-quarters view further softened by wavy hair. Parallels can be found, however, for other details, such as the naturalistically drawn birds, the musical angels and the leaf masks, both in embroideries of the period and in the margin decorations of illuminated manuscripts of the East Anglian School. The abundantly leafy interlace that forms the quatrefoils is not dissimilar to the leafy Tree of Jesse in the Ormesby Psalter (F.9b) in the Bodleian Library.

The cope has been in the Church of Steeple Aston, Oxfordshire from time immemorial. It is not known when it was reformed as a frontal and dossal (*since this entry was written the cope has been restored to its original form*).

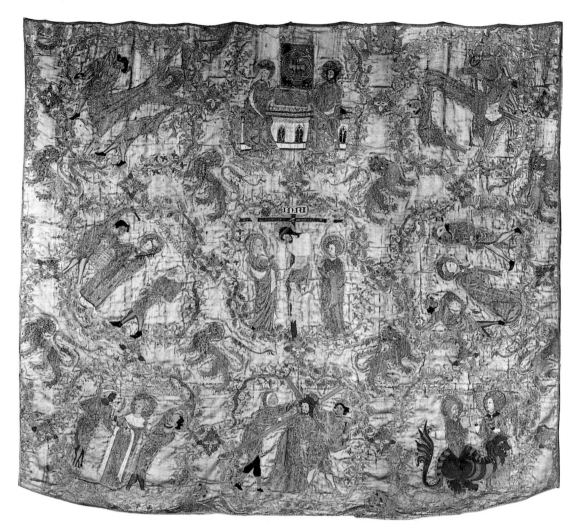

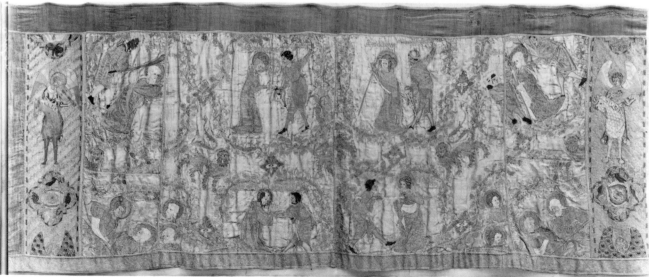

The pieces are shown in approximately relative sizes

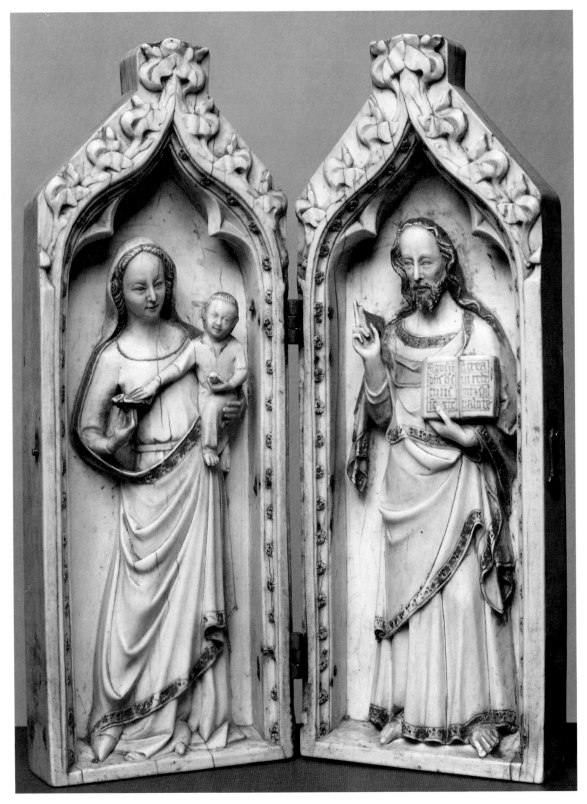

Diptych with the Virgin and Child and Christ Blessing (The Salting Diptych)

English (Westminster?); early fourteenth century
Ivory; h 21.6 cm; w 16.2 cm
A.545-1910

The Virgin and Child and Christ stand in deep niches below trefoiled ogee arches. The Christ Child holds an apple and rests His right hand on the bunch of flowers held by the Virgin. The adult Christ holds a book bearing the inscription: EGO SU(M) D(OMI)N(U)S D(EU)S TUUS I(HSOV)C XP(ISTO)C Q(UI) CREAVI REDEMI ET SALVABO TE. The soffit of the arch is decorated with rosettes, and the ogee bears rich foliated crockets.

The Virgin and Child are represented in a typical French manner, but there is no ivory precedent for the standing Christ from the early fourteenth century and this figure, with its broad treatment and monumental style, was possibly inspired by large-scale sculpture.

The gravity and majestic dignity of the figures may also in part be due to an English origin. This is suggested by the long faces with high rounded foreheads, which can be compared with works such as the bronze effigies of Eleanor of Castile and Henry III executed by William Torel in the 1290s for Westminster Abbey. A slightly more developed form of the drapery can also be seen in another Westminster work, the sedilia of c.1308. Even stronger evidence for an English origin is the use of the ogee arch, which first appeared in England on the Eleanor Crosses (built 1291–94 to mark the twelve resting places of the bier carrying Eleanor's body to Westminster after her death at Harby in Nottinghamshire), but which is not seen in France until nearly a century after this.

A somewhat later version of this style can be seen in the Grandisson triptych in the British Museum, made for Bishop John Grandisson of Exeter before 1369. Here is the same strong individuality, the same monumentality and very similar facial features.

The high quality of this work implies that, despite the lack of surviving examples, there seems to have been an established and continuing tradition of ivory carving in England in the early fourteenth century.

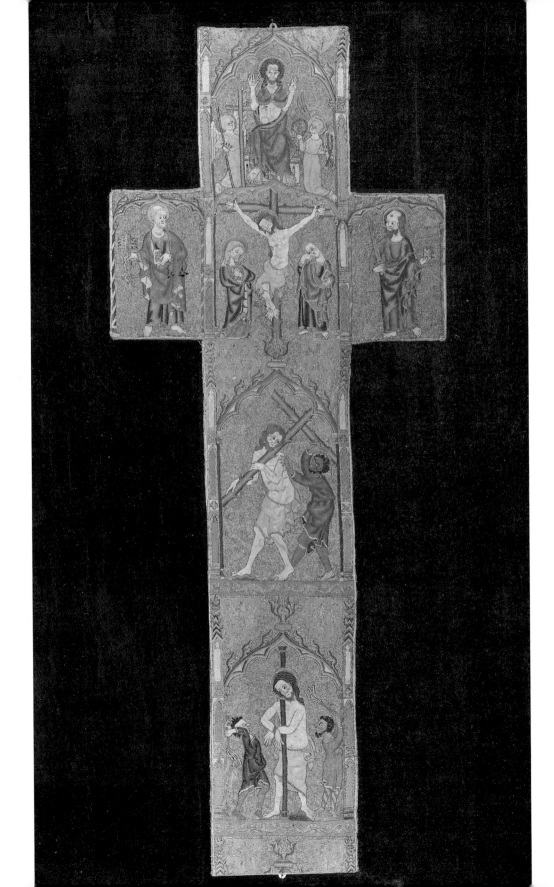

202

The Marnhull Orphrey

English; 1315–35
Linen embroidered with silver-gilt and silver thread and coloured
silks in underside couching, split stitch and laid and couched work
109 × 19 cm (44.5 cm across the arms)
T.31-1936. Purchased for the Museum by the National Art-Collections Fund

Scenes from the Life of Christ. In the cross-arms are SS. Peter and Paul. In
the central pillar, scenes of the Flagellation, Christ carrying the Cross, Christ
Crucified with the Virgin and St. John, and Christ in Judgement with
attendant angels holding the Instruments of the Passion. All the scenes are
enclosed in crocketted ogee arches supported by pinnacled turrets contain-
ing niches. Beneath the two lower scenes are horizontal bands decorated with
wyverns. In the spandrels of the arches are shields of arms.

The orphrey is missing most of one scene at the lower end and a small
piece has been cut from the top, but all other edges are original and the
embroidery is amazingly fresh and undamaged. It is worked in the classic
manner of *Opus Anglicanum* and is representative of the pieces in which the
linen ground is entirely covered with gold threads decoratively couched, in
this instance with quatrefoils, foliate crosses and lions. The effect of the gold
ground is similar to that achieved in illuminated manuscripts such as the
twenty-six full-page miniatures illustrating the Life of Christ in the Bodleian
Library (Ms. Gough, Liturg. 8). The figures in these East Anglian
miniatures, notably the Flagellation, are also similar to those of the Marnhull
orphrey.

The shields in the spandrels are blazoned *gules a lion rampant argent
crowned or* for Wokyndon. The Wokyndon family were patrons of St. Paul's
Cathedral and the cathedral archives contain the 1322 will of Joan, widow of
Sir Nicholas Wokyndon. She founded a chantry at the cathedral in 1321.

When the orphrey was acquired from the Roman Catholic Presbytery at
Marnhull in Dorset it was mounted on the back of a nineteenth-century
chasuble with an early fifteenth-century orphrey on the front (T.31A-1936).
The earlier history of the orphrey is not known.

The Life of the Virgin Apparels

English; 1320–40
Velvet embroidered with silver and silver-gilt thread and coloured silks in underside couching, split stitch and laid and couched work
53.5 × 84 cm (each apparel originally 27 × 84 cm)
8128-1863. Given by Ralph Oakden

Scenes from the Life of the Virgin and her Parents.

One complete and two incomplete apparels are joined to make a panel decorated with two rows of crocketted ogee arches enclosing figures. The first two scenes of the first apparel are missing; then come the Annunciation to St. Anne, with the inscription on the scroll 'OCCVRRE VIRO AD PORTAM' and, on the book, 'MISERERE MEI DEVS' (Psalm 51), the Meeting of Joachim and Anne at the Golden Gate and the Birth of the Virgin. In the second apparel are the Presentation of the Virgin at the Temple and the Education of the Virgin, her book inscribed 'DOMINE LABIA MEA'. The three following scenes are missing. The lower apparel is complete and shows the Annunciation, with the inscription 'AVE MARIA GRACIA', the Visitation, the Nativity, the Annunciation to the Shepherds, with the inscription 'GLORIA IN EXCELSIS DEO', and the Journey of the Magi. The fourth apparel, with the later life of the Virgin, is missing. In the spandrels are shields of arms.

Stylistically and technically the panel is close to a burse in the Museum's collection, one panel of which bears a near-identical representation of the Annunciation (T.2-1940). There are also affinities with the Butler-Bowdon (p 216) and Vich copes. Although incomplete, the apparels demonstrate beautifully the lively narrative style which was a notable feature of *Opus Anglicanum* in the late thirteenth and fourteenth centuries.

Velvet grounds were first used in *Opus Anglicanum* in the late thirteenth century; an early reference occurs in a 1295 inventory of St. Paul's Cathedral: 'Item Capa de dono domini Radulphi de Staneford de Indico velvetto, cum aurifrigio de rubeo velvetto, cum platis et perlis desuper positis'. (W. Dugdale, *The History of St. Paul's Cathedral*, London, 1818, p 318). The embroidery of the apparels is very fine, with detailed patterning within the gold work and laid silk threads couched with gold for the decorated pillow covers. As in other examples of *Opus Anglicanum* (and illuminated manuscripts), several of the garments are decorated with shield shapes, a formalised representation of minever adapted from heraldic devices. To achieve such delicate effects on the difficult pile surface of the velvet, the embroidery was worked through an overlaying piece of fine fabric on which the design had been drawn out.

The shields of arms within the spandrels are blazoned alternately *azure three cinquefoils or*, for Bardolf, and *barruly of ten argent and sable* for an unknown family

The early history of the apparels before they were acquired from Mr. Oakden is not known.

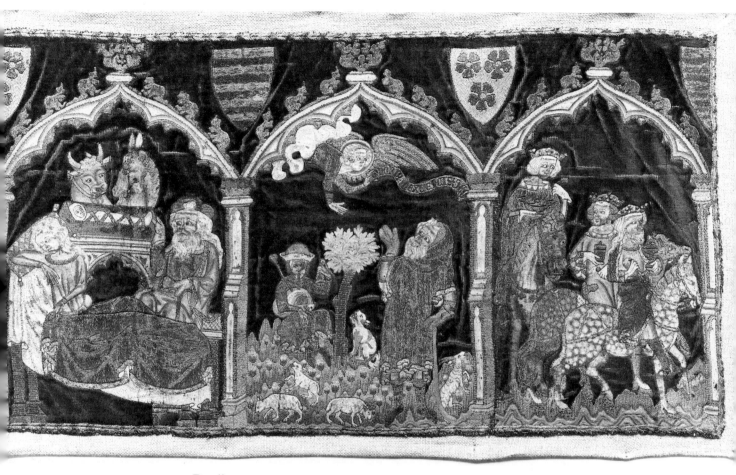

Detail

Diptych
Colour plate 20

English; c.1325
Silver gilt, enamelled with *basse taille*; h 4.1 cm; w 6.3 cm
M.544-1910

The left panel shows the Annunciation and the Nativity, the right the Crucifixion. On the back are scenes showing the Resurrection and Ascension, the Coronation of the Virgin, and Saints Christopher and George. The diptych was probably commissioned by someone with a particular devotion to St. Christopher, the patron saint of travellers, and St. George, patron saint of soldiers and several of England's medieval monarchs.

These tiny, portable enamels, like their ivory counterparts, were made for the wealthy and devout for use in their private devotions. They may be seen as miniature versions of the large altarpieces found in churches and cathedrals.

Formerly in the Spitzer and Salting collections.

Plaque Showing the Annunciation

Sienese; c.1320
Translucent enamel on silver, set into a frame of gilt copper; diam 7.9 cm
221-1874

The delicacy of the colouring and the style of the engraving bear some resemblance to the work of Ugolino di Vieri, whose great enamelled masterpiece – the Reliquary of the Sacro Corporale (dated 1338) – is preserved in Orvieto Cathedral, and is one of the supreme achievements of enamelling in the Gothic period. The plaque was once considered to be part of a morse but is more likely to have been designed for a reliquary or for a large processional cross. The Musée de Cluny in Paris possesses a companion plaque depicting Saint Galgano, patron saint of Siena. A reliquary of Saint Galgano made for the Abbey of San Galgano in Tuscany (now preserved in the parish church of Frosini) is decorated with enamels close in style to these plaques, and it seems not unlikely that they too were made for the Abbey.

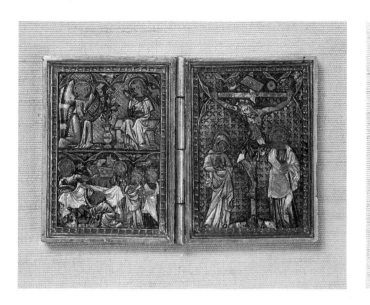

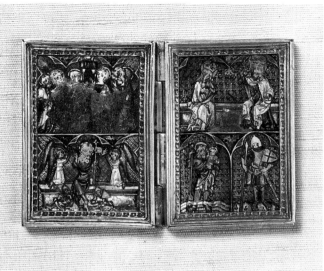

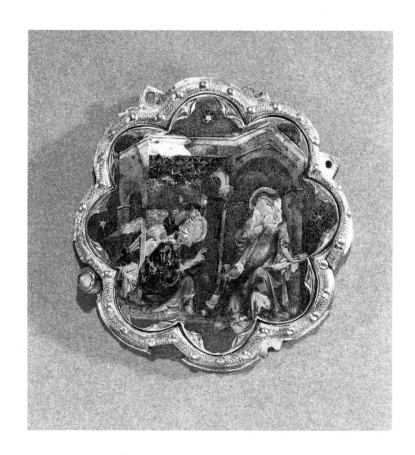

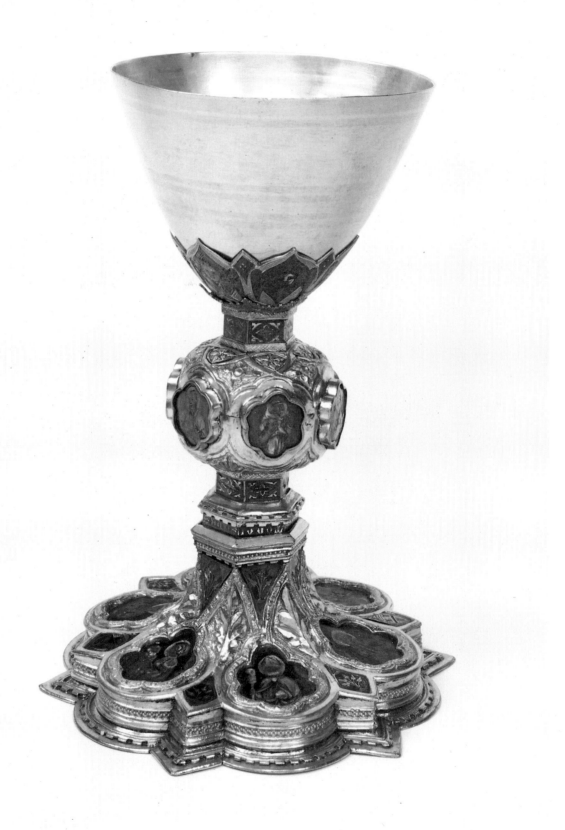

Chalice

Italian (Sienese); first half of the fourteenth century
Gilt copper, the bowl of silver, set with plaques of translucent
enamel on silver; h 21.6 cm; diam 15.2 cm
237-1874

On the foot are depicted the Crucifixion, the Virgin and St. John, St. Nicholas, St. Lawrence (?), and St. Martin. On the knop are: Christ, St. Peter, St. Paul, St. Francis of Assisi, St. Stephen and a bishop saint. The inscription reads '+FRATE IACHOMO MONDUSI+DE SENA+ME FECIT' (Brother Iachomo Mondusi of Siena made me) – this might actually mean not that Mondusi was the goldsmith, but that he commissioned and paid for the making of the chalice. The type of chalice, with its foot shaped as a cusped hexafoil, is first found in the example made by the Sienese goldsmith Guccio di Mannaia in c.1288 for Pope Nicholas IV, who presented it to the basilica of San Francesco in Assisi, where it is still preserved. This new gothic form of chalice continued to be made in Italy almost unchanged throughout the fourteenth and well into the fifteenth centuries. Large numbers of chalices of this type were produced, the majority, as here, not of the highest artistic quality. They were made with an eye to economy, since only the plaques holding the enamel, and sometimes the bowl, were of silver, the rest being of copper, which when gilt would have given an effect as splendid as silver.

Numerous examples survive in the British Museum, the Fitzwilliam Museum in Cambridge, many museums in the USA, Italy and France, as well as in the Italian churches for which they were originally made.

Bowl from the Rouen Treasure

French (Montpellier); fourteenth century
Silver, parcel-gilt, set with an enamelled medallion of a griffin in the centre and struck with the mark MOP; diam 18.4 cm; h 4 cm
106-1865

This bowl forms part of the so-called Rouen treasure, said to have been found in an iron box when pulling down a house in Rouen in 1864. Four silver spoons (two with the Paris mark and two with that of Rouen) – all of the fourteenth century – and a gold écu of Philip VI of Valois (1328–50) from the same hoard are also in the Museum. Other pieces from the hoard have been identified elsewhere: a bowl in the Louvre, four bowls in the Hermitage Museum in Leningrad and two bowls and a beaker in the Cluny Museum in Paris. The latter are traditionally known as the Gaillon treasure, said to have been discovered in 1851 during digging at the Château de Gaillon in Normandy, once the country palace of the archbishops of Rouen. The traditional stories of provenance have clearly become confused. There is no doubt, however, that the various pieces make up one hoard, for several of the bowls are engraved with the same (unidentified) mark of ownership, or are very similar in style.

 This piece bears the earliest known hall-mark for Montpellier and though called a bowl, was probably designed as a drinking vessel.

Devotional Booklet
Colour plate 21

German (Lower Rhine/Westphalia); c.1330–50
Ivory; h 10.5 cm; w 6 cm
11-1872

This ivory booklet has on its cover the Coronation of the Virgin attended by censing angels, and St. Lawrence and a Bishop. A monk kneels in the corner of both scenes. The carved surface is painted and gilded. Inside, the leaves have been painted with scenes from the Passion: the Last Supper, the Kiss of Judas, Christ before Pilate, Christ before Herod, the Flagellation, Pilate washing his hands, Christ carrying the cross, the Crucifixion, the Resurrection and the Veronica; the last two leaves bear emblems of the Passion. The three holes at the top of each inner leaf may have been for the attachment of small silk curtains to protect the miniatures as is seen in manuscripts occasionally.

The Coronation of the Virgin, first seen in the twelfth century on a capital from Reading Abbey, symbolises the concept of the Virgin as Queen of Heaven, an idea suggested in the psalms. The type seen here, with Christ himself placing the Crown upon the Virgin's head (rather than an angel) occurs first in the mid-thirteenth century at buildings such as Sens, Auxerre and Rheims.

Although the carving seems to be French in style, the paintings were executed by an artist working in the tradition of the Lower Rhine and Westphalia, and can be compared with paintings in Cologne Cathedral and Hofgeismer, from c.1330–50. Because of this apparent discrepancy in style it has been suggested that the leaves of the booklet were originally prepared for wax so that the booklet would have been used for writing in – a slightly later set of writing tablets like this can also be found in the V&A collection (804-1891), with Infancy and Passion scenes on the cover, but most surviving examples have poor quality carvings of secular subjects. In this case the paintings on the inside would be a later addition. However, this need not be so, for it is now recognised that many of the ivories previously attributed to fourteenth-century French ateliers may in fact be the products of other workshops. The mass production of ivories in France led to their wide circulation throughout Europe – and their imitation – especially in Germany (although perhaps the most famous French-inspired ivory of this period is that of the Virgin and Child executed by Giovanni Pisano in 1298 for Pisa Cathedral). While North Italian and English ivories are more easily distinguishable, German and French works are very close in style and minor iconographic differences are sometimes the only way of differentiating between them.

In consequence it may well be that the carving and the paintings are contemporary work, executed around the Lower Rhine c.1330–50, and the Monk on the cover is probably the patron for whom the booklet was intended. The recesses on the leaves are possibly simply an added precaution to protect the paintings rather than for holding wax.

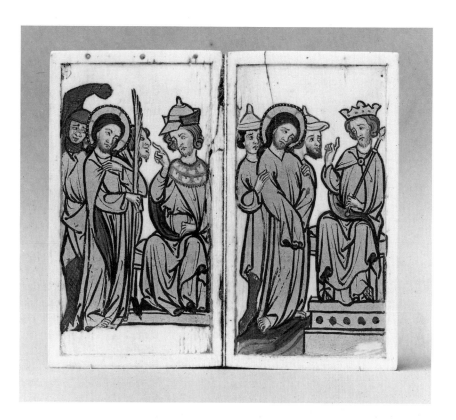

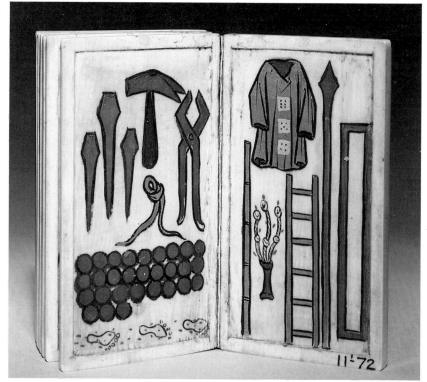

Mirror Case

French; mid-fourteenth century
Ivory; diam 13.5 cm
1617-1855

This is the only surviving example of a mirror case with traces of metal (the original mirror) on the back.

The scene is an allegorical representation of an attack on the Castle of Love. Knights attack the Castle of Love, 'defended' by women, who do not resist too strongly when the knights climb over the battlements and attempt to embrace them. At the top of the Castle the winged God of Love strikes two ladies with his arrows. The corners of the mirror case are formed by lions.

This subject appears frequently on secular ivories in the fourteenth century; the Museum owns two other mirror cases and a casket bearing similar representations. An allegorical siege of the Castle of Love seems to have been frequently enacted during the Middle Ages; Roland of Padua, for instance, records in his Italian chronicles a festival near Treviso where a castle was built, and defended, by the women and girls of the town while being attacked with fruits, perfumes and flowers thrown by the men. This is one of the earliest recorded events of this kind, but we know that the marriage of Henry VII's son, Prince Arthur, in 1501 was celebrated with a Masque of the Mount of Love besieged by knights, and a similar pageant took place regularly in Fribourg up until the eighteenth century. The sources of the subject are obscure, but it was probably derived from a now-lost romance or an oral tradition. Representations of it are not confined to ivories, and as well as tapestries the scene appears in religious manuscripts such as the Peterborough Psalter in Brussels, and the Luttrell Psalter in the British Library, both English works, the former dating from shortly before 1299, the latter from c.1340. The basic elements of the composition vary little from one piece to another, especially among the ivories, but they do vary in details and all retain great liveliness.

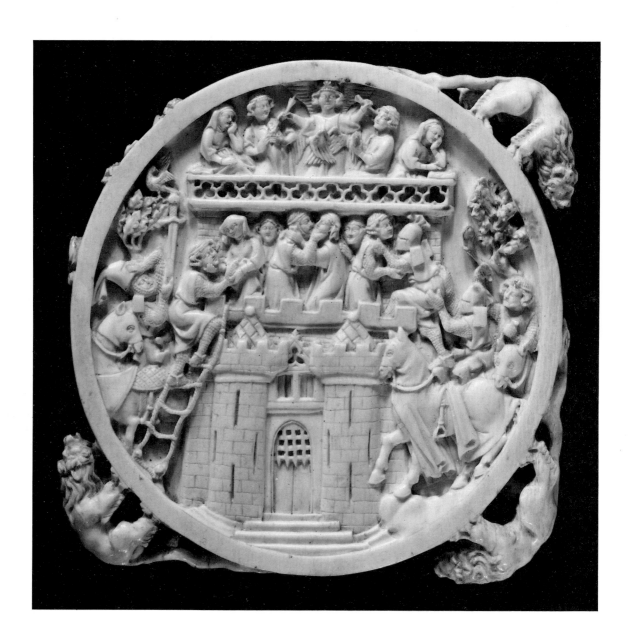

215

The Butler-Bowdon Cope

English; 1330–50
Velvet embroidered with silver and silver-gilt thread and coloured silks in
underside and surface couching, split stitch, laid and couched work, with
some French knots and satin stitches. Many small motifs (the lion masks,
the stars held by the angels, etc) were covered originally with pearls. Small
gold rings and green beads were also used for decoration. The orphreys
and the hood are on a linen ground; 165.5 × 341 cm
T.36-1955

Scenes from the Life of the Virgin; apostles and saints.

Pairs of entwined oak branches rise from the backs of
crouching lions to form three concentric rows of delicate,
multi-foil ogee arches. The corbels are in the form of lion
masks and within the spandrels are seated angels holding
stars. A pair of birds perch on the highest arches at the
centre back above three scenes from the Life of the Virgin:
the Annunciation, with the inscription 'AVE MARIA GRACIA'
and 'AMEN', the Adoration of the Kings, and the Coronation
of the Virgin. Within the lowest arcade are the figures of
twelve saints and apostles: St. Matthew, St. Simon, St.
Thomas, St. James the Great, SS. Peter and Paul (flanking
the Annunciation), St. Matthias, St. James the Less, St.
Phillip, St. Jude and St. Bartholomew. In the row above are
St. Edmund the Confessor, a defaced figure, possibly St.
Nicholas, St. Margaret, SS. John the Evangelist and John
the Baptist (flanking the Adoration), St. Catherine, a
defaced figure, possibly St. Thomas of Canterbury, and St.
Edmund of Bury. In the uppermost row are St. Lawrence,
SS. Mary Magdalene and Helena (flanking the
Coronation), and St. Stephen.

The main orphrey is decorated with saints alternating
with bishops and archbishops, without identifying names
or symbols. They stand within ogee arches separated by
horizontal bands, decorated with lions and rosettes. Within
the spandrels are rampant griffins. The hood (made up with
modern braid) shows a pair of angels with thuribles. The
narrow orphrey round the hem of the cope is decorated with
rosettes and coiling stems enclosing flower heads.

Iconographically and stylistically, the Butler-Bowdon
Cope is very close to a cope from the Chichester-Constable
family now in the Metropolitan Museum, New York – so

close indeed that the two vestments may have been
designed to be used together. Also related iconographically
and in its general decorative scheme is the cope at Vich in
Spain, although the drawing of the figures, which are more
angular and mannered, suggests a slightly later date. The
orphrey is related to that on a cope at Toledo and the figures
of St. Lawrence and St. Margaret are stylistically very close
to those of the same saints on a fragment of an altar frontal at
Dumbarton Oaks, Washington DC.

This cope illustrates the third of the three major
decorative schemes found in English copes of the medieval
period. They were based (in an overlapping chronological
sequence) on rows of scrolling stems (the Jesse cope, 175-
1889), on touching or overlapping geometric shapes (the
Syon and Steeple Aston copes, pp 190 and 198) and, as here,
on an architectural framework of ogee arches. Because the
arches are arranged in concentric rows, as opposed to the
horizontal rows of the first two schemes, they are better
suited to the shape of a cope and, when it was worn, allowed
the figures to stand more happily in relation to the hem. The
embroidery of the cope is as fine as and technically similar to
that of the Life of the Virgin Apparels (p 204).

At some time before 1721 the cope was cut up to make a
chasuble, frontal, stole and maniple. It was re-assembled as
a cope in 1854, when the missing sections were replaced
with painted linen. These were removed when the cope was
acquired by the Museum and it was remounted, with some
minor alterations to the arrangement of the pieces, on velvet
of the sixteenth and seventeenth centuries. Before it came
to the Museum in 1955, the cope had long been in the
possession of the Butler-Bowdon family and their
ancestors.

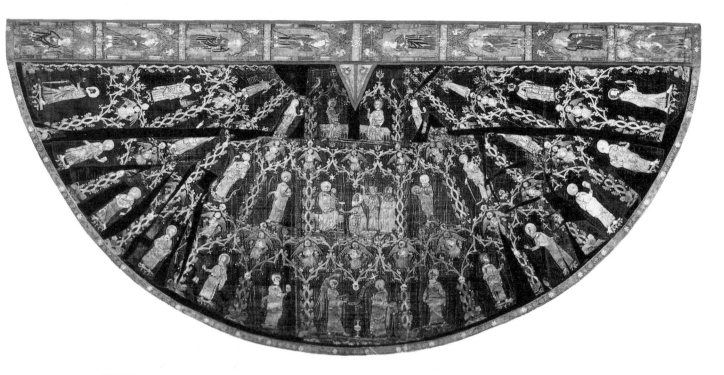

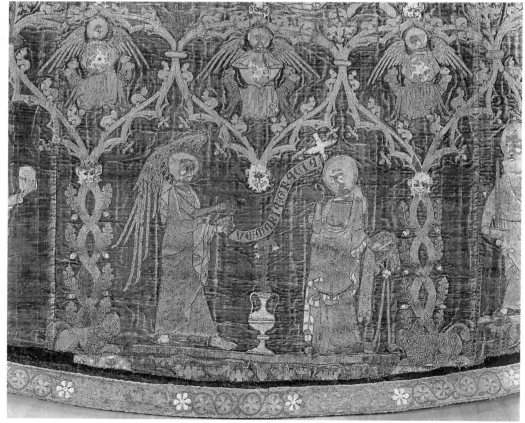

Detail

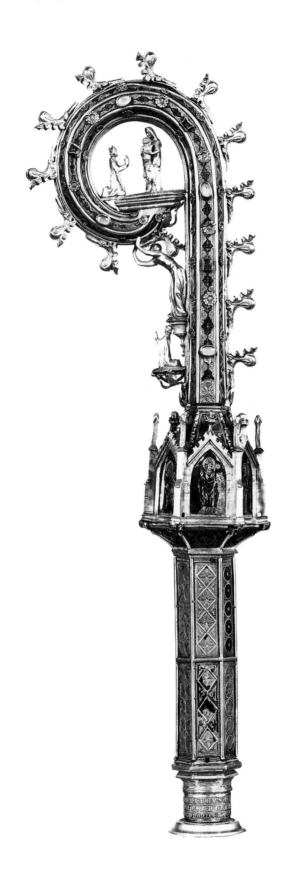

The Reichenau Crozier

Constance(?); 1351
Copper gilt, set with plaques of silver and *basse taille* enamel
h 31.7 cm; w 12.7 cm
7950-1862

The knop is set with enamelled plaques representing the Virgin and Child, the three Magi, Mary Magdalen, and an abbot, perhaps St. Pirmin, first abbot and founder of Reichenau abbey in 724. On the crozier-head the latin inscription indicates that the crozier was made for the abbot Master Eberhard of Brandis in 1351, through his treasurer Nicholas of Gutenberg. Eberhard, abbot of the island monastery of Reichenau on Lake Constance between 1343 and 1379, is probably the mitred figure kneeling to the Virgin and Child within the crook, while the figure of his treasurer, Nicholas, kneels beneath the supporting angel. It is rare to find a piece of goldsmiths' work which bears a date.

The crozier's enamels are very similar to those on the chalice from St. Johann zu Constanz of about 1320, now in the Walters Art Gallery, Baltimore, and comparable croziers of a similar date, although probably of French origin, belong to Cologne Cathedral and to the Bishopric of Haarlem. In the nineteenth century it formed part of the Dugué and Soltikoff collections, before its purchase by the Museum in 1862.

The Ramsey Abbey Censer and Incense Boat

English; c.1375
Silver gilt (censer) and silver parcel-gilt (incense boat)
censer: h 27.6 cm; diam 13.6 cm; incense boat: h 12 cm; l 9.5 cm
M.268-1923 (censer) and M.269-1923 (incense boat)

Incense was used at High Mass and in the course of processions, blessings and other ceremonies, in honour of both persons and inanimate objects, particularly altars. The incense was carried in the boat, and then sprinkled on hot coals held inside the censer. Suspended from its chains, the censer was swung vigorously to circulate the powerful aromatic smoke given off, symbolising the ascent of prayers to God.

This censer and incense boat are the only English examples which have come down from the Middle Ages. They were discovered, together with pottery and some fifteenth-century pewter plates, in 1850 during the draining of Whittlesey Mere, Cambridgeshire, by a man hunting for eels. At each end of the incense boat is a ram rising from waves, and a similar device is stamped on the plates (some of which are in the Peterborough Museum). This device is clearly a rebus for the name Ramsey and seems to indicate that the whole find was once the property of the neighbouring Abbey of Ramsey, unless it be supposed that the pieces bearing the rebus were gifts to the Abbey of Peterborough, from two abbots named Ramsay who presided over it in the mid-fourteenth and late fifteenth century respectively. Like so much medieval English plate the hoard has survived probably through being hidden, almost certainly at the time of the Dissolution of the monasteries in the sixteenth century.

After passing through the collection of Lord Carysfort, the censer and incense boat were acquired for the Museum in 1923 with the aid of a generous donation from Mr C.W. Dyson Perrins, FSA.

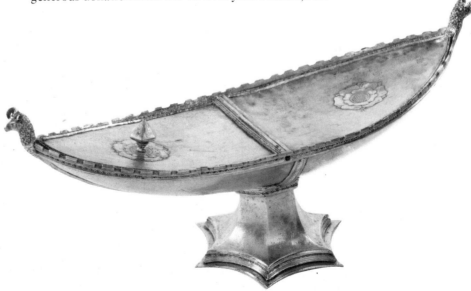

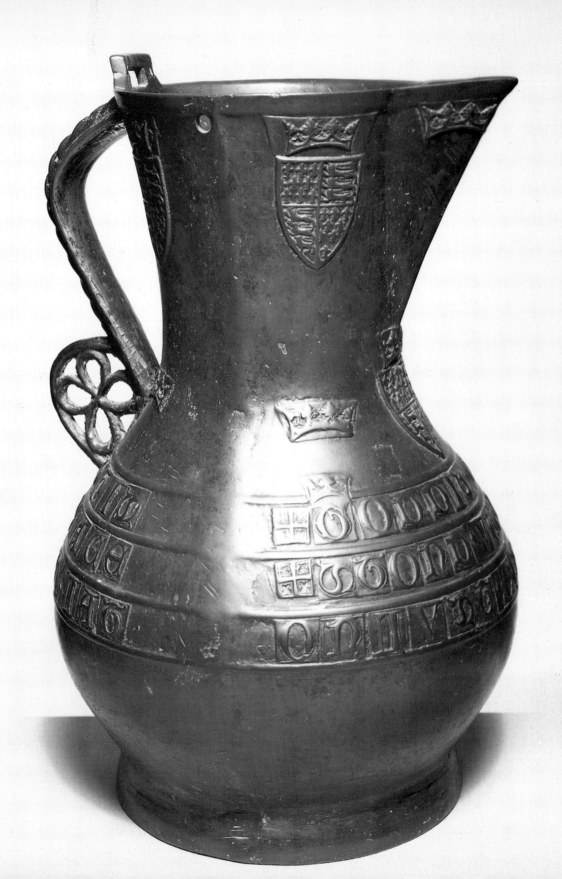

Bronze Jug

English; c.1390
Cast bronze; diam 26 cm; h 40 cm
217-1879

This large jug would have been used for domestic purposes, perhaps to hold ale. It bears the English Royal arms and an inscription, in Lombardic letters, in the English of the day: GODD'S GRACE BE IN THIS PLACE AMEN STOND UTTIR (away) FROM THE FYRE AND LAT ON JUST (let just one) COME NERE.

A more spectacular version of this jug, with a lid, and the badge of King Richard II (d 1400) is preserved in the British Museum. The romantic story of the British Museum jug – found in 1896 amongst the treasure of King Prempeh of the Ashanti, at Kumassi on the Gold Coast – cannot be rivalled by the jug here, whose provenance is unknown, until it was found in a house in Norfolk in 1879. Such pieces would have been made in some numbers by bell-founders, using the same moveable letter moulds for both bells and jugs.

The Studley Bowl

English; late fourteenth century
Silver-gilt; h 14.3 cm
M.1-1914

This covered bowl is one of the earliest pieces of English domestic silversmiths' work to survive. It bears no hall-marks. It was probably intended for porridge and similar foods, and was for a time the property of Studley Royal Church, near Ripon, Yorkshire. It is beautifully decorated with chased and engraved ornament, consisting on each part of a black-letter alphabet, preceded by a cross and followed by various literal symbols and contractions such as were used in contemporary latin manuscripts, all springing from a leafy wreath; on the knob of the cover is the letter 'a'.

The bowl displays great beauty of form and proportion as well as skill in the execution of the ornamental details. Nothing comparable survives. It was given to the Museum in 1914 by Mr Harvey Hadden.

Mazer Bowl and Cover

French; early fifteenth century(?)
Burr maple; h 13.5 cm; diam 20 cm
221-1866

From the twelfth to the sixteenth century and beyond drinking vessels were often made of wood, particularly burr maple, which was rich in colour, resistant to shrinkage and splitting and impervious to moisture. Mazers, as they were called (from *maserle* = the maple tree), were sometimes plain and sometimes elaborately mounted in silver. This example, recorded in the Le Carpentier Sale in Paris in 1866, is a unique survival in that its elaborate decoration is carved from the solid. The only approximate parallel is the so-called drinking bowl of St. Nicholas, executed in Cologne in about 1180, and preserved at Brauweiler. The form of the V&A mazer may be compared with the silver-gilt Studley bowl and cover of the late fourteenth century (p 224) or with a late fifteenth-century Venetian glass bowl and cover (677-1886) also in the V&A. The usual French term for such drinking bowls was *hanap* and they were made by craftsmen known as *hanapiers* or *madriniers* (*madre* = mazer wood).

The bowl and its cover are decorated on the outside with inscriptions in pseudo-Naskhi script, probably derived from a Turkish textile, and with wild flowers, and stem and leaf borders, all carved in low relief. The cover has a finial formed as a knotted stem, on which a monster holds a scroll. Inside the cover is carved a group of Samson and the Lion, with a scroll inscribed 'AVTEM SPI(RI)TV(S) DOMINI IN SAMPS(ONEM) IRRVIT' (Judges, 14, 6) ('And the Spirit of the Lord came mightily upon Samson'): this may be a reference to the invigorating power of wine. Inside the bowl is carved a grotesque head surrounded by lobed tracery. This may have been intended as a surprise to the drinker in the same spirit as a silver-gilt plate on a mazer described at Boston, Lincolnshire, in 1534, decorated with an ape looking at an urinal. Underneath the bowl is a monster and a scroll inscribed 'VNE FOYS FAVLT COMPTER A LOSTE', a version of the French proverb meaning 'Don't reckon without your host', an appropriate sentiment to reveal on finishing the drink he has furnished.

227

The Mérode Cup
Colour plate 22

French; early fifteenth century
Silver-gilt, set with panels of translucent *plique à jour*
enamel (the cellwork of gold); h 17.5 cm; w 9.3 cm
403-1872

This covered beaker has long held an international reputation as one of the finest examples of an extremely rare and difficult type of enamelling, and is delicately pounced with birds, fruit and flowers. The panels pierced in the cup and its cover are filled with a translucent enamel from which the backing has been removed (*émail de plique à jour*), so that when the light is seen through them they have the appearance of stained glass, an effect heightened by the fact that some are in the form of traceried windows. A cup similarly decorated is mentioned in the inventory of the goods of that great patron of the arts, Jean, Duc de Berri, in 1417, but this type of enamel was more commonly used on small jewels.

Formerly owned by the ancient Belgian family of Mérode, from a member of which it was acquired in 1828 by Mr Henry Bevan, whose grandson sold it to the Museum in 1872.

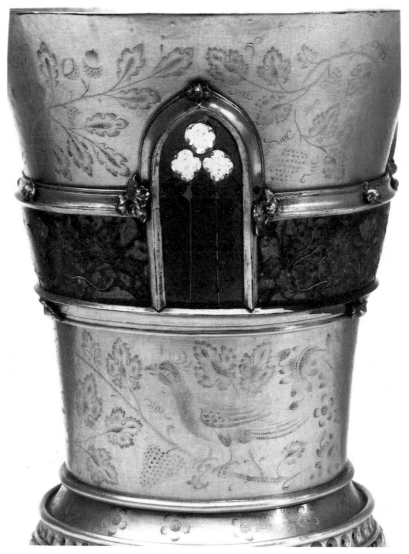

Detail

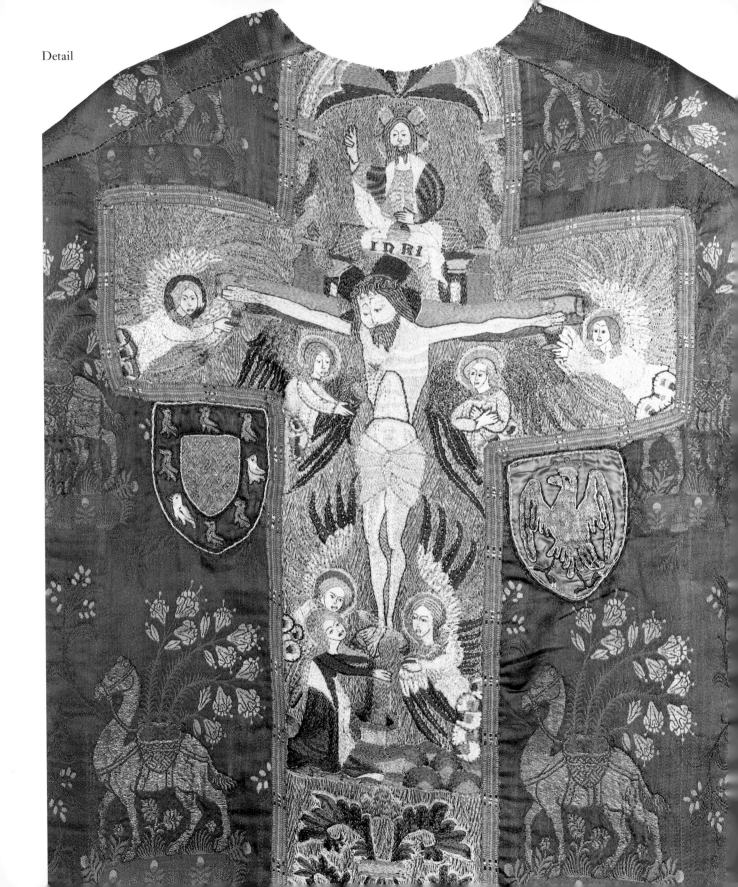

The Erpingham Chasuble
Colour plate 23

Italian/English; early fifteenth century
118 cm × 77 cm
T.256-1967

a) The silk, North Italian, early fifteenth century
Lampas, satin ground woven with silks and brocaded with silver-gilt thread repeat. The late fourteenth and early fifteenth century witnessed one of the most exuberant phases in silk design. Italian silks were exported all over Europe, decorated with huntsmen and falconers, dogs in boats, peacocks and eagles, fawns, unicorns within pallisades, pelicans in their piety, fabulous beasts in combat or confronting one another, the occasional monkey and even moated castles. These are the *motifs* of International Gothic, seen in manuscripts, ivories and misericords. The camels belong to this menagerie but the silk appears to be unique and the quality of the drawing, weaving and dyestuffs is excellent. Such fine silks have chiefly been preserved by the Church and are depicted in contemporary Italian and Flemish paintings on sacred personages but they were also worn by the rich and noble.

b) The embroidery, English, early fifteenth century
Silks and silver-gilt thread on linen in split stitch and underside couching. The embroidery is representative of the rather routine pieces produced in the London workshops in the period 1400–50. The designs, depicting Christ crucified, with God the Father, angels, the mourning Magdalene and five pairs of apostles and female saints beneath ogee arches supported by twisted columns, are derived from fourteenth-century prototypes but they lack the fine details and the moving intensity of the earlier pieces.

To either side of the cross orphrey are applied shields. That on the left is blazoned *vert an escutcheon within an orle of eight martlets argent* for Sir Thomas Erpingham (about 1357–1428). That on the right is composed of Sir Thomas's personal devices, *gules an eagle rising argent crowned or*, bearing on its breast a five petalled rose *gules* inscribed with the word *yenk*. Erpingham used the eagle rising and a Y on his seal; *yenk* (meaning think) was his personal motto and the red rose symbolised his life-long devotion to the House of Lancaster.

Erpingham travelled widely with Henry, Duke of Lancaster, and was with him in his exile in 1398. When Henry returned to England the following year to raise the country against Richard II, Erpingham was one of the commissioners to whom Richard surrendered the crown. He continued to serve the new king, Henry IV, and his son, Henry V, and it was Erpingham who drew up the English battle line at Agincourt and who gave the signal for the start of the battle.

Sir Thomas's loyalty was rewarded with high office and with gifts of land and property in London and Norfolk. He used his wealth and position in patronage of the Church and his personal devices are to be seen in a number of stained glass windows and other ecclesiastical furnishings in Canterbury Cathedral and throughout Norfolk, including the Erpingham Gate before the west front of Norwich Cathedral. Records survive of his gifts of chasubles to Erpingham and to other churches but it is not possible to identify this chasuble amongst them.

The chasuble has been drastically cut down to suit a later style in vestments and some of the fragments of silk have been used to make a matching stole and maniple.

Figures from a Cope or Altar Frontal

English; about 1425
Linen embroidered with silver-gilt and silver thread and coloured silks in surface couching, split, stem and satin stitches, with raised outlines in thicker silk and metal threads, and slight padding
64 × 46 cm (plus renewed background)
T.91-1968

Christ crucified (label inscribed 'INRI') with the Virgin and St. John.

A smaller version of the crucifixion scene, largely based on the same cartoon, appears on a fragment of a late fourteenth-century orphrey in the Museum's collection (1360–1904). The flowery 'island' on which the figures stand is a typical example of a device used in the later fourteenth and fifteenth centuries when large-scale motifs were applied to the silk or velvet grounds of copes, altar frontals and dossals. Similar crucifixion scenes appear, for example, on a dismembered cope of about 1500 in St. John's College, Oxford, and on the sixteenth-century Westmorland Frontal (35-1888, Room 29). The Museum also owns two slightly larger figures of Christ crucified and St. John (T.82-1969) which, when acquired, were mounted on an early sixteenth-century orphrey but which originally formed part of a similar crucifixion scene on a cope or frontal of about 1430–40.

Although well-drawn and executed, the embroidery of the figures is not as technically refined as that of earlier English embroidery. The metal thread is surface couched and is shaded by the use of coloured silks. On the cross, this is carried out in a simple form of the *or nué* technique. The split stitch of the faces still follows the contours of the features but it no longer has the indented spirals on the cheeks and the definition of the features is achieved with the help of slight padding. The haloes of the Virgin and St. John have been covered with a later (probably nineteenth-century) plied gold thread. This has been removed from a small section on the lower right side of St. John's halo to reveal the original, finer gold thread. The embroidery is worked on linen for ease of application to a silk or velvet ground. It is an early illustration of the simpler methods which were to be increasingly used by the embroidery workshops in response to competition from patterned silks imported from Italy and to the upsets of war and of rising labour costs.

When acquired by the Museum, the figures were mounted on poor quality black velvet; they have been remounted on red velvet salvaged from a dismembered Spanish dalmatic of the late sixteenth century.

The figures were purchased at Christie's in 1968, but their earlier history is not known.

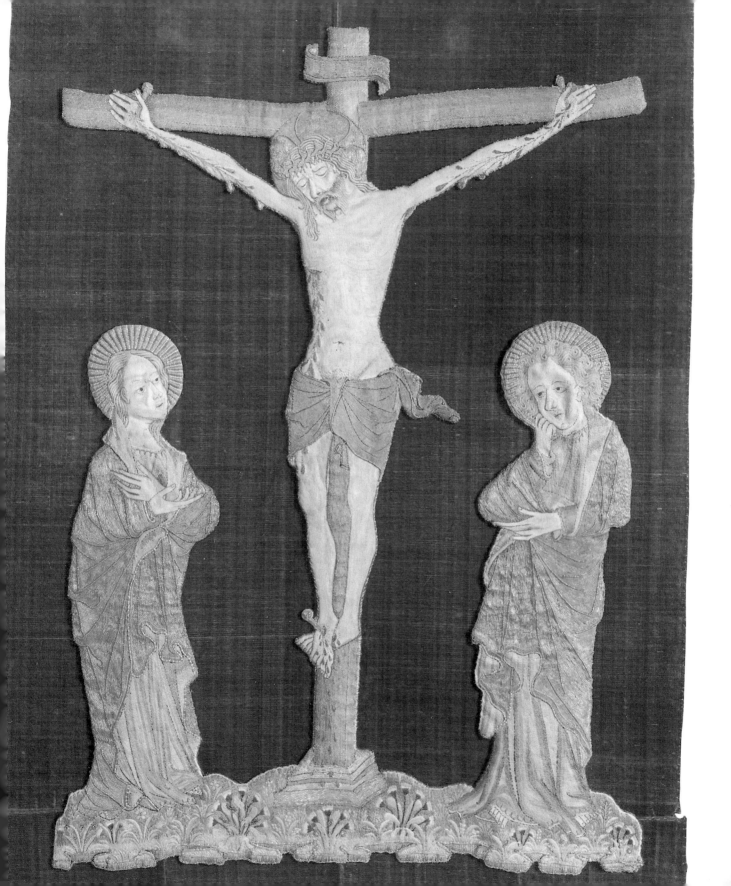

Tapestry : Scenes of the Passion
Colour plate 24

Arras; first quarter of the fifteenth century
Wool, silk, silver and gold thread, woven with six
warp threads to the cm; 112 × 302 cm
T.1-1921

Three scenes from the Passion of Christ, separated by tall rocks set in a continuous landscape, are all that remain from hangings probably depicting the whole Passion Cycle. Known as the *Descent from the Cross, Entombment and Resurrection*, the tapestry actually shows the Lamentation at the foot of the Cross, the preparation for the Entombment, and a Resurrection that is combined with a *Noli me Tangere*, Christ blessing Mary Magdalene as He steps from the tomb.

This unusual representation of the Resurrection might suggest a hypothesis that the tapestry was woven for a church or convent dedicated to Mary Magdalene but for the fact that in the two previous scenes this saint is not given her usual prominence. The double scene could be a conflation of the Resurrection with the visit of the Holy Women to the Sepulchre, as is sometimes found, particularly in German and Bohemian art; but then the figures of the other women would have been deliberately omitted. As the scene stands, except for also portraying the Resurrection, the postures of both figures are perfectly

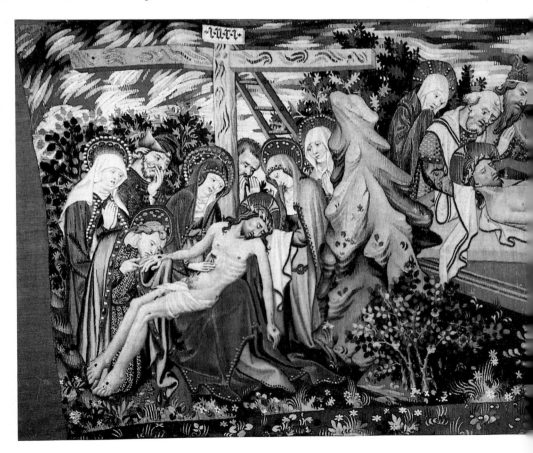

consistent with traditional representations of the Apparition of Christ to Mary Magdalene.

The tapestry is exquisitely and richly woven, with gold thread used not only in ornate haloes and garments, but in the foliage of trees and flowers. This is a much finer tapestry than the only documented Arras tapestry known, the Story of Saints Piat and Eleutherius, made for the Cathedral at Tournai, according to a now vanished inscription, in 1402. Nevertheless, conventional stylisations in both tapestries of sky, foliage, wood, and stone, and similar treatment of hair, haloes and draperies are sufficiently close to imply a common time or place of origin, perhaps both. With tapestry there is often some lapse of time between the painting which serves as a model for a cartoon and the actual weaving; both because it was considered acceptable to make use of earlier paintings, and because popular designs were re-used until they could no longer find a market. In the case of this Passion tapestry, the small double-pointed beard of Christ, a courtly fashion of the late fourteenth century, implies the use of a slightly older painting as a model, while the small plants in the foreground (apart from the lowest tapering strip, added to square the piece) were being produced up to the weaving of the earliest of the Devonshire Hunting Tapestries (Room 38), attributed on costume style to the later 1420s.

Throughout the thirteenth and fourteenth centuries the tapestries of Arras were so famous that 'arras' was synonymous with 'tapestry' in England and in Italy. Of the few surviving tapestries of the early fifteenth century, this piece is one of the most sumptuous and beautifully woven. Given also its affinities with the set of SS. Piat and Eleutherius, it seems most likely to have been woven at Arras.

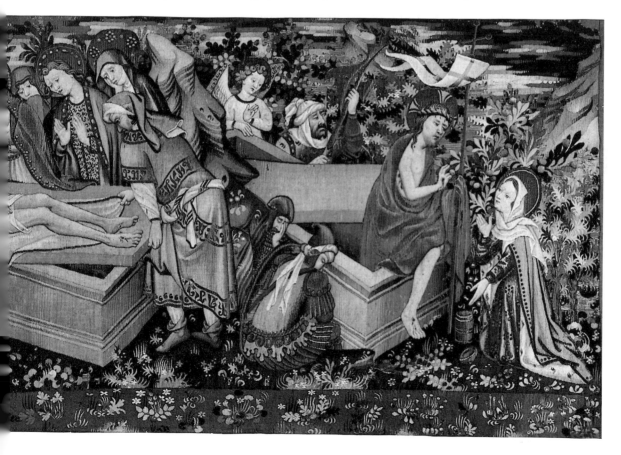

Spoons

a) Franco-Flemish; mid fifteenth century
 Painted enamel on silver, inlaid on the handle
 with niello; l 24.1 cm
 C.2-1935

The scene on the bowl – a monkey riding through a forest –
is clearly part of the same series found on the 'Monkey Cup'
in the Metropolitan Museum in New York. Both probably
derive from the illustrations to a lost romance. The
similarities between the two are so great – both in style and
in the colours used (grey, black, and white with highlights
in gold and silver) – that it seems likely that they are
products of the same workshop and perhaps of the same
commission. Another item, perhaps also from this work-
shop, is the spoon in the Boston Museum of Fine Arts,
enamelled with a fox preaching to an audience of geese. All
are of the type of enamel thought to have been made for the
Burgundian court, which by the late fourteenth century is
recorded as patronising goldsmiths from Brussels, Bruges
and Ghent.

The enamelling technique on all these items is in-
novative, the precursor of the painted enamels produced in
quantity in fifteenth-century Limoges and Venice. The
enamel was painted freely on to the metal base without the
use of *cloisons* or of the engraving needed for *champlevé*
enamel.

b) Venetian?; late fifteenth century
 Silver gilt with translucent enamel; l 17.4 cm
 1392-1888

In the enamel are embedded cut-out silver stars and the
initials Md repeated, no doubt the initials of its original
owner, now unknown. The pair to it is now owned by the
Metropolitan Museum in New York. The technique of
floating silver-gilt motifs – stars, crescents, etc – is rarely
found, but occurs also on a pair of fifteenth-century beakers
in the Kunsthistorisches Museum, Vienna and on the bowl
of a chalice bearing a fifteenth-century Venetian hall-mark,
in the V&A.

Controversy still surrounds the question of where this
type of enamel was made: it has been associated with the
Franco-Flemish spoon on the left, and with centres in
Germany and Venice.

Glossary

ALB An ankle-length, sleeved tunic, generally of white linen, worn by priests and others, often beneath other vestments.

AMICE A square of white linen worn by celebrant priests, formerly on the head, now on the neck and shoulders. In some religious orders, the amice has the form of a hood and is part of the habit.

ANTEPENDIUM A hanging or screen of cloth, metal or wood covering the front of an altar.

APPARELS Rectangular decorative panels placed centrally at the hems, at the necks and on the sleeves of ALBS and DALMATICS.

AQUAMANILE A metal ewer for secular use or for the liturgical ceremony of the washing of the celebrant's hands during the Mass.

ARMA CHRISTI The symbolic 'coat-of-arms' represented by the instruments of the Passion through which Christ triumphed over evil.

ASPERGILLUM A rod having a long handle with a brush or perforated globe at the end for sprinkling holy water at the asperges and blessings.

BASSE-TAILLE ENAMEL An enamelling technique in which a design is cut in low relief in silver or gold and is then covered with translucent enamel and fired to fuse the enamel to the metal.

BOOK OF HOURS A prayer book for daily private devotions developed in the late Middle Ages, containing the Little Office for the Blessed Virgin and usually a liturgical calendar, penitential psalms, litanies, suffrages, the Office of the Dead and sometimes other material.

BROCADING A WEFT which is not carried from selvage to selvage but used only in the width of a motif is brocaded. (Silk, and even more, gold and silver thread was too expensive to waste on the back of a textile.)

BURETTE A vessel to contain the water or wine used in the Holy Communion.

BURSE A flat, stiff wallet used to hold the CORPORAL.

BUSKIN A covering for the foot and leg reaching to the calf or knee, worn by bishops and abbots.

CABOCHON An unfaceted, polished gem.

CAMEO A precious or semi-precious stone carved in relief, usually with more than one layer of colour, so that the figures will contrast in colour with backgrounds.

CENSER A portable vessel in which incense is burned.

CHALICE The cup or goblet used in church ceremony.

CHAMPLEVE ENAMEL An enamelling technique in which a design is scooped out of a copper ground and then filled with opaque enamel and fired, fusing the enamel so that it is flush with the reserved metal.

CHASSE An enclosed box-like reliquary shaped as a house or church.

CHASUBLE The principal vestment worn by the priest for the celebration of the Mass; medieval chasubles were originally of more or less conical form.

CHRISMATORY A box designed to hold the vials for the three holy oils for Baptism, Confirmation and Extreme Unction.

CIBORIUM 1) A covered vessel for the eucharistic wafers; 2) A canopy, usually standing free and on four columns, covering the high altar.

CLOISONNE ENAMEL A technique in which *cloisons* or ribbon-like strips of metal are fastened to a metal base and the areas thus partitioned filled with enamel which is then fired. The piece is polished until the design of the *cloisons* appears.

COMPOUND WEAVES A weave in which there are two WARPS, one to bind and one to make the pattern. The latter was controlled by the figure harness of the drawloom. By the early middle ages compound twill had become the most usual, giving a smooth surface with the different colours brought to the face as required.

CONSECRATION OF THE BREAD AND WINE Transubstantiation, that act whereby the elements of the EUCHARIST are changed into the body and blood of Christ.

COPE Principal vestment worn for various church ceremonies. The cope is a semi-circular cloak, fastened across the chest by a brooch or strip of material, called a MORSE. The front edges are often adorned with ORPHREYS and at the back of the neck there is a triangular or shield-shaped hood, which is, however, vestigial and cannot be used to cover the head.

CORPORAL A white linen cloth (symbolic of the winding sheet in which the body of Christ [*corpus*] was laid in the tomb) on which the HOST and the CHALICE are placed during the Mass.

CROZIER The staff of a bishop, abbot or abbess resembling a shepherd's crook and carried as a symbol of pastoral authority.

CRUCIFIX A cross on which the figure (*corpus*) of Christ is represented.

DALMATIC A shin-length, sleeved tunic worn mainly by deacons assisting the priest at High Mass.

DIPTYCH Paintings, carvings or writings on two hinged tablets, often used as portable altar-pieces.

DOSSAL A hanging behind a seat or altar.

ENAMEL Powdered glass, fired at very high temperatures so that it adheres to a metal surface and can then be polished. The metal surface preferred in the Romanesque period was virtually pure copper. See also CHAMPLEVE and CLOISONNE.

EUCHARIST The sacrament of the Lord's Supper during which the bread and wine are consecrated and distributed. Also called the Blessed or Holy Sacrament.

EVANGELIARY A book also called a Lectionary of the Gospels, which contains the readings from the Gospels arranged according to their use during the liturgical year.

FISTULA A small hollow tube through which the wine was communicated to the people from the ministerial CHALICE.

FLABELLUM A liturgical fan used originally to keep the flies away at the EUCHARIST.

GEMELLION One of a pair of enamelled basins used either in domestic life or in the liturgical washing of the hands.

HOST The eucharistic wafer or bread before or after consecration.

IHS The first three letters of the name Jesus in Greek.

INCENSE BOAT A boat-shaped vessel in which incense is kept.

INTAGLIO The art of engraving on to stone or gems; the opposite of CAMEO.

INRI The abbreviation of Iesus Nazarenus Rex Iudaeorum (Jesus of Nazareth, King of the Jews), the mocking inscription placed above the head of Jesus on the cross.

KNOP A decorative knob, often spherical, usually a feature of the stem of, for example, candlesticks, CHALICES, CROZIERS and cups.

LAMPAS The COMPOUND WEAVES were later developed by dividing the functions of the WEFT as well as the WARP, one WEFT combining with the main or ground WARP, the other with the binding WARP. Thus the ground weave contrasted in texture with the patterned areas – as in the Erpingham CHASUBLE (p 231).

LITURGY The formal, public rites and services of the Christian Church.

MANDORLA An almond-shaped line or series of lines surrounding the body of a person endowed with divine light, usually reserved for Christ or the Virgin.

MANIPLE A narrow strip of material worn over the left forearm by a priest, deacon and sub-deacon.

MASS The church service which commemorates the sacrifice of Jesus Christ with the celebration of the EUCHARIST. A solemn high Mass is celebrated with incense and music, the celebrant is assisted by an additional deacon, sub-deacon and acolytes and much of the service is chanted. A low Mass is celebrated by a single priest. A requiem Mass for the dead may be a high Mass or a low Mass.

MINIVER A kind of fur used as a lining and trimming in ceremonial dress. Although spotted like ermine, it was commonly made of other furs such as squirrel.

MISSAL A book containing the complete text for all the Masses.

MITRE A cap with two points, or horns, worn by bishops and some abbots.

MONSTRANCE A vessel designed to exhibit a relic or to display the consecrated HOST and carry it in procession.

MORSE A clasp used to fasten a COPE, the ceremonial cape worn by a priest or bishop.

MOSAN Works produced in the region of the Meuse (Maas) river basin in the eleventh, twelfth and thirteenth centuries.

NIELLO A process of enriching designs incised on silver by filling the incisions with a black metal alloy made of sulphur, silver and lead.

OR NUE Embroidery technique whereby complex designs are executed by closely couching laid metal threads with multi-coloured silk threads.

ORPHREY Decorative bands, often embroidered, used on CHASUBLE, COPE, DALMATIC, etc. From the fourteenth century onwards, most English CHASUBLES had a cross-shaped ORPHREY on the back and a straight pillar-ORPHREY on the front; DALMATICS and tunicles had pillar-orphreys front and back.

OSTENSORIUM A MONSTRANCE used solely for the consecrated HOST.

PALL 1) A small square of linen used to cover the CHALICE; 2) A heavy cloth, spread over a coffin in a church at a funeral.

PALLIUM A strip of woollen material worn round the shoulders of a bishop as a sign of his office.

PANTOCRATOR Christ, the ruler of all.

PASCHAL CANDLESTICK A very large candlestick for the paschal candle which burns throughout Eastertide (from Holy Saturday to Ascension Day).

PASSION The sufferings undergone by Christ between the night of the Last Supper and His death.

PATEN A circular, slightly concave dish used for the eucharistic wafer.

PAX (Osculatorium) A tablet, introduced in the Middle Ages, which was kissed by the priest and the people before taking communion.

PECTORAL CROSS The cross worn on the chest by bishops and abbots.

PHYLACTERY In the Middle Ages a RELIQUARY, sometimes worn around the neck, usually having four, six or eight lobes which stem from a central cavity containing a relic.

PSALTER A book containing the psalms and often a liturgical calendar, biblical canticles, a litany of the saints and numerous prayers.

PYX Originally a general term for any of several kinds of vessels in which the HOST was kept. The word stems from the ancient pyxis, a covered box, often a jewel case. Today the term is limited to the small vessel in which the consecrated wafer is carried to the sick.

RELIQUARY A shrine for keeping or exhibiting a sacred object or relic.

REPOUSSE A relief pattern formed by hammering out a thin metal from the reverse side.

REREDOS An ornamental hanging or carved screen placed behind an altar, or a painting in the same position.

RESERVATION OF THE BLESSED SACRAMENT The practice of preserving after the celebration of the Holy Sacrament a portion of the consecrated bread so that it might be worshipped in church or taken by a priest for the communion of the sick.

RETABLE 1) An altarpiece or REREDOS; 2) A raised shelf above an altar on which are placed candles and flowers.

RUBRIC In early manuscripts or printed books any part that is in red ink. Hence, in liturgical books the directions for the conduct of a service which were originally written in red.

SACRAMENT One of the seven religious ceremonies recognised by the Roman Catholic Church as having been instituted by Christ, namely Baptism, Confirmation, EUCHARIST, Penance, Extreme Unction, Holy Orders and Matrimony.

SCRIPTORIUM The place where manuscripts were written in a monastery, cathedral or secular workshop.

SITULA A bucket for holy water.

STOLE A narrow strip of material worn over the shoulders by priests and deacons, and falling to the knee or lower.

TABERNACLE A receptacle for the consecrated elements of the EUCHARIST which is often placed on the middle of the altar.

TAU CROSS A staff carried by a bishop or abbot shaped like the letter T or Tau in Greek.

THURIBLE See CENSER

TRUE CROSS The cross, on which Christ was believed to have been crucified, discovered at Jerusalem in the fourth century by St Helena, mother of Constantine the Great.

UNDERSIDE COUCHING An embroidery technique whereby the couching thread is kept entirely on the reverse of the fabric. It passes through to the front, over the laid metal thread on the surface and back through the same hole taking with it a tiny loop of metal thread.

VERMICULE The foliage scroll patterns (like worm patterns) engraved as backgrounds on certain Limoges enamels, and on masonry blocks.

WARP The threads entered in the loom before weaving can begin. There may be two warps in a textile with different functions.

WEFT The threads taken by the weaver's shuttle across the loom. They intersect with the warp to form the textile and, like the warp, may be divided into groups with different functions.

XPS The first two letters and last letter of the Greek word for Christ.

Further Reading

GENERAL SURVEYS

John Beckwith, *The Art of Constantinople*, London, 1961

John Beckwith, *Early Medieval Art*, London, 1964

John Beckwith, *Early Christian and Byzantine Art* (Pelican History of Art), Harmondsworth, 1970

Marie-Madeleine Gauthier, *Les Routes de la Foi: Reliques et reliquaires de Jérusalem à Compostelle*, Fribourg, 1983

Ernst Kitzinger, *Early Medieval Art in the British Museum and British Library*, 3rd, revised edition, London, 1983

Peter Lasko, *Ars Sacra: 800–1200* (Pelican History of Art), Harmondsworth, 1972

Gertrud Schiller, *Iconography of Christian Art*, 2 vols, London, 1971–72 (there are now 5 vols in German)

Hanns Swarzenski, *Monuments of Romanesque Art: The Art of Church Treasures in North-Western Europe*, 2nd edition, London, 1974

Jean Taralon, *Treasures of the Churches of France*, New York, 1966

EXHIBITION CATALOGUES (often standard reference works)

L'Art Roman, Barcelona and Santiago de Compostela, 1961

Europäische Kunst um 1400, Vienna, 1962

Koptische Kunst: Christentum am Nil, Essen, 1963

Byzantine Art, A European Art, Athens, 1964

Karl der Grosse, Aachen, 1965

Les Tresors des Eglises de France, Paris, 1965

Treasures from Medieval France, Cleveland, 1967

L'Europe Gothique XII–XIVe siècles, Paris, 1968

The Year 1200, New York, 1970

Rhein und Maas: Kunst und Kultur 800–1400, Cologne and Brussels, 1972

Art and the Courts: France and England from 1259–1328, Ottawa, 1972

Die Zeit der Staufer, Stuttgart, 1977

Age of Spirituality. Late Antique and Early Christian Art, Third to Seventh Century, New York, 1979

Les Fastes du Gothique: le siècle de Charles V, Paris, 1981

Splendeur de Byzance, Brussels, 1982

English Romanesque Art 1066–1200, London, 1984

The Golden Age of Anglo-Saxon Art 966–1066, London, 1985

Ornamenta Ecclesiae: Kunst und Künstler der Romanik, Cologne, 1985

ENAMELS AND METALWORK

Marian Campbell, *An Introduction to Medieval Enamels*, London, 1983

Mary Chamot, *English Mediaeval Enamels*, London, 1930

Otto von Falke and Erich Meyer, *Romanische Leuchter und Gefässe, Giessgefässe der Gotik* (Bronzegeräte des Mittelalters 1), Berlin, 1935 (reprinted 1983)

Marie-Madeleine Gauthier, *Emaux du moyen âge occidental*, Fribourg, 1972

R.W. Lightbown, *Secular Goldsmiths' Work in Medieval France: A History*, London, 1978

Klaus Wessel, *Byzantine Enamels*, Shannon, 1969

IVORY CARVINGS

John Beckwith, *Ivory Carvings in Early Medieval England*, London, 1972

Danielle Gaborit-Chopin, *Ivoires du Moyen Age*, Fribourg, 1978

Adolph Goldschmidt, *Die Elfenbeinskulpturen aus der Zeit der karolingischen und sächsischen Kaiser, und der romanischen Zeit*, 4 vols, Berlin, 1914–26 (reprinted 1969–75)

Adolph Goldschmidt and Kurt Weitzmann, *Die byzantinische Elfenbeinskulpturen*, 2 vols, Berlin, 1930–34 (reprinted 1979)

Raymond Koechlin, *Les Ivoires Gothiques Français*, 3 vols, Paris, 1924 (reprinted 1968)

M.H. Longhurst, *Catalogue of Carvings in Ivory, Victoria and Albert Museum*, 2 vols, London, 1927–29

Joseph Natanson, *Gothic Ivories of the 13th and 14th centuries*, London, 1951

W.F. Volbach, *Elfenbeinarbeiten der Spätantike und des frühen Mittelalters*, 3rd edition, Mainz, 1976

Paul Williamson, *An Introduction to Medieval Ivory Carvings*, London, 1982

MANUSCRIPTS

J.J.G. Alexander (ed.), *Survey of Manuscripts Illuminated in the British Isles*, London, 1975– (four volumes have appeared so far)

Janet Backhouse, *The Illuminated Manuscript*, Oxford, 1979

Walter Cahn, *Romanesque Bible Illumination*, New York, 1982

John Harthan, *An Introduction to Illuminated Manuscripts*, London, 1983

Florentine Mütherich and Joachim E. Gaehde, *Carolingian Painting*, London, 1977

David M. Robb, *The Art of the Illuminated Manuscript*, London, 1973

D.H. Turner, *Early Gothic Illuminated Manuscripts in England*, The British Library, London, 1979 (first published 1965)

D.H. Turner, *Romanesque Illuminated Manuscripts in the British Museum*, London, 1971

FURTHER READING

Kurt Weitzmann, *Studies in Classical and Byzantine Manuscript Illumination*, Chicago, 1971

Kurt Weitzmann, *Late Antique and Early Christian Book Illumination*, London, 1977

STAINED GLASS

Madeline H. Caviness, *The Early Stained Glass of Canterbury Cathedral*, Princeton, 1977

Madeline H. Caviness, *Stained Glass before 1540, an annotated bibliography*, Boston, 1983

B. Coe, *Stained Glass in England : 1150–1550*, London, 1981

P. Cowen, *A Guide to Stained Glass in Britain*, London, 1985

Louis Grodecki, *Les Vitraux de Saint-Denis*, vol I, Paris, 1976

Louis Grodecki, *Le Vitrail roman*, 2nd edition, Fribourg, 1983

Louis Grodecki and Catherine Brisac, *Gothic Stained Glass 1200–1300*, London, 1985

Bernard Rackham, *A Guide to the Collection of Stained Glass, Victoria and Albert Museum*, London, 1936

TEXTILES

Odile Brel-Bordaz, *Broderies d'ornements liturgiques, XIII-XIVe siècles : Opus Anglicanum*, Paris, 1982

A.G.I. Christie, *English Medieval Embroidery*, Oxford, 1938

Otto von Falke, *Kunstgeschichte der Seidenweberei*, 2 vols, Berlin, 1913

Otto von Falke, *Decorative Silks*, 3rd edition, London, 1936

M. Flury-Lemberg and Karen Stolleis (eds.), *Documenta Textilia : Festschrift für Sigrid Müller-Christensen*, Munich, 1981 (important articles on medieval textiles)

A.F. Kendrick, *Catalogue of Textiles from Burying-Grounds in Egypt, Victoria and Albert Museum*, 3 vols, London, 1920–22

A.F. Kendrick, *Catalogue of Early Medieval Woven Fabrics, Victoria and Albert Museum*, London, 1925

Renate Kroos, *Niedersächsische Bildstickereien des Mittelalters*, Berlin, 1970

London, Victoria and Albert Museum, *Catalogue of English Ecclesiastical Embroideries of the XIII to XVI centuries*, London, 1916

Opus Anglicanum (exhibition catalogue), Victoria and Albert Museum, London, 1963

W.F. Volbach, *Early Decorative Textiles*, Feltham, 1969

There are also many important articles on medieval textiles in the CIETA Bulletin (*Bulletin de Liaison du Centre International d'étude des textiles anciens*).

THE ASSOCIATES OF THE VICTORIA AND ALBERT MUSEUM

The following companies and individuals take a particular interest in the Museum and channel their support through the Museum's charity, The Associates of the V&A.

ASSOCIATES

Arthur Andersen & Co
Bankers Trust
The Baring Foundation
Bonas and Company
Christie's
Citibank NA
Colnaghi & Co
Commercial Union Assurance plc
Conoco (UK) Ltd
Laytons
Charles Letts (Holdings) Ltd
Malmaison Wine Club
The Mid Moss Charitable Trust
Mobil
The National Magazine Company Limited
The Oppenheimer Charitable Trust
Pearsons plc

Rose & Hubble Limited
Russell Bros (Paddington) plc
The Sainsbury Charitable Fund
Sotheby's
John Swire & Sons Limited
Thames Television
Wartski
Wimpey Group Services Limited

INDIVIDUAL BENEFACTORS AND ASSOCIATES

The Sirdar and Begum Aly Aziz
Sir Duncan Oppenheim
Mrs Basil Samuel
Mrs Claire Weldon

SPONSORS

Through the Associates of the V&A, the following companies, organisations and individuals have sponsored Galleries, Exhibitions, Scholarships, Concerts, Catalogues and Receptions at the V&A

The Aquarius Trust
G.P. & J. Baker
Bankers Trust Company
The Baring Foundation
Countryside Commission
Charles of the Ritz
Daily Telegraph
Express Newspapers
Rodney Fitch & Co
The Guardian Evening News
House and Garden
Ilford
Jaeger
Kodak
Lund Humphries
Laytons
Mobil
Mitsui

Marks and Spencer
Mouton Rothschild
Nabisco
Olympus Optical Company
S.J. Phillips
Pirelli (UK) Limited
Rowntree
Royle Print
Sainsburys
The Shell International Petroleum Company
Sotheby's
The Toshiba Corporation
Trusthouse Forte
United Technologies
Gianni Versace
Louis Vuitton

THE FRIENDS OF THE VICTORIA AND ALBERT MUSEUM

Existing within the framework of the Associates, the following Corporate Friends lend their support to the Museum:

Norman Adams Ltd
Alan Hutchison Publishing Company Limited
Albert Amor Limited
Antiques Trade Gazette
Artists Cards Limited
Ashtead Decorative & Fine Arts Society
Black Nadeau Ltd
Blairman & Sons Limited
Blanchards plc
Bluett and Sons Ltd
British Petroleum Company plc
Chase Manhattan Bank NA
Angela Chidgey
Christie's East
Coutts & Co Bankers
Crabtree & Evelyn (Overseas) Limited
Cyril Humphris
Peter Dale Ltd
De Montfort Publishing Ltd
Donohoe
Eldridge London & Company
Elizabeth Arden Ltd
Goldsmiths' Company
Guardian Royal Exchange Assurance plc
Haslam & Whiteway Ltd
Hotspur Limited
S. & H. Jewell Ltd
John Keil Limited
Kennedy Brookes plc
Lane Fine Art Ltd

John Lewis Partnership plc
Ian Logan Limited
London & Provincial Antique Dealers' Association Ltd
Madame Tussaud's Limited
Marks & Spencer plc
Marunishi Shoji Company Ltd
The Medici Society Limited
Milburns Restaurant Ltd
Barbara Minto Limited
The National Magazine Company Limited
Pearsons plc
Phillips Auctioneers
S.J. Phillips Ltd
Raithby Lawrence & Company Ltd
RTZ Services Limited
J. Henry Schroder Wagg & Company Ltd
Spink & Son Ltd
Stair & Company Ltd
The Fine Art Society Limited
Waddington Graphics
The Wellcome Foundation Limited
William Bedford plc
Winifred Williams

Individual Friends support the Museum both financially and by giving voluntary help, thus forming a personal link with the V&A.